Real-World modo®

Real-World modo®

In the Trenches with modo

Wes McDermott

Routledge
Taylor & Francis Group
New York London

First published 2009 by Focal Press

711 Third Avenue, New York, NY 10017, USA
2 Park Square, Milton Park, Abingdon, Oxon OX14 4RN

Routledge is an imprint of the Taylor & Francis Group, an informa business

First issued in hardback 2017

Library of Congress Cataloging-in-Publication Data
McDermott, Wes.
 Real world modo® : the authorized guide : in the trenches with modo / Wes McDermott.
 p. cm.
 Includes bibliographical references and index.
 ISBN 978-0-240-81199-4 (pbk. : alk. paper)
1. Computer animation. 2. Luxology modo (Computer file)
3. Computer graphics. 4. Three-dimensional display systems. I. Title.
 TR897.7.M3893 2009
 006.6'96–dc22

 2009030911

ISBN 13: 978-0-240-81199-4 (pbk)
ISBN 13: 978-1-138-45628-0 (hbk)

Typeset by: diacriTech, India

For my wife, Ann Marie, my daughter, Abby, and my son, Logan.

Contents

Acknowledgments.. **xiii**

Introduction ... **xv**

Chapter 1: Basic Training... **1**

Working as a 3D Artist... 1

 Experience.. 2

 Disciplines ... 2

Education: It's up to You.. 3

Resource Library: The Life Blood of a 3D Artist 4

 Technical Information .. 4

 Assets ... 5

Software: It's Only a Tool .. 6

Learning to See: Switching off Auto Mode 7

 Emotional Content ... 7

 Flipping the Switch .. 8

Summary ... 12

Chapter 2: Becoming a Modonaut.. **13**

Way of the modo: User Interface and Customization 14

 Form and Input Editors .. 15

 Statistics and Information.. 17

 Display.. 19

 Preferences ... 20

The Work Plane ... 24

Action Centers, Snapping, and Falloffs.. 26

 Action Centers ... 26

 Snapping ... 28

 Falloffs... 30

The Tool Pipe... 30

The Shader Tree ... 32

Item List and Groups ... 34

 Item List ... 35

 Groups.. 35

Preset Browser ... 36

Modeling and Animation Toolsets 37

 Animation Tools ... 37

 Modeling Tools .. 41

Painting and Sculpting Toolsets 43

 Painting Tools... 43

 Sculpting Tools .. 47

Vertex Maps .. 48

 Weight Maps .. 49

Rendering... 51

Scripting and Commands .. 52

Modo for Maya Users ... 52

 Differences ... 53

 Commonalities .. 54

The Modo Community ... 55

Summary.. 56

Chapter 3: **Modeling** **57**

Modeling Methods .. 58

 Subdivision Modeling.. 58

 Patch Modeling ... 63

Modeling Reference ... 67

 Backdrop Item ... 67

Making Selections.. 69

 Loop Selections ... 69

 Using the Arrow Keys .. 69

 Select Connected ... 70

 Selection Sets ... 71

Detailing the Mesh... 71

 Adding Detail .. 72

 Shaping the Mesh .. 77

Topology .. 78

 Creating a Clean Geometry 79

 Polygon Flow ... 80

 Edge Loops ... 83

Replicators ... 86

 Groups ... 86

 Vertex Maps ... 87

 Surface Generators .. 87

Working with Hair .. 89

 Creating Hair ... 89

 Styling Hair ... 93

Summary ... 97

Chapter 4: UV Mapping **99**

Understanding UV Space .. 99

 UV Coordinates .. 100

 Maximizing Detail ... 101

 UV Aspect Ratio ... 104

Mapping Out a Strategy ... 109

 Single UV Map ... 109

 Multiple UV Maps ... 110

 Surveying the Model .. 112

 UV Tiles ... 114

UV Unwrap ... 117

 Unwrap Tool ... 117

 UV Relax .. 120

 Understanding UV Seams .. 121

 Unwrapping a Hand .. 124

Summary .. 131

Chapter 5: Texturing .. **133**

Collecting Reference ... 133

Using Texture Maps .. 134

 Setting Material Properties 134

 Map Types .. 136

Contents

The Shader Tree .. 152

 Groups.. 152

 Group Masks ... 154

Texturing Hair ... 156

 Fur Material ... 156

 Using the Strip Type... 158

 Using Gradients .. 159

Summary.. 162

Chapter 6: **Animation**.. **163**

Morph Maps ... 164

 Working with Morph Maps 164

 Adding Morph Deformers 165

 Creating a Controller ... 165

 Creating the User Channels................................... 167

 Creating a Link to the Morph Deformers 168

 Direct Link .. 169

 Configuring the Morph Controller 172

 Adding an Assembly Command.............................. 173

Inverse Kinematics ... 173

 Setting Up IK ... 174

 Rigging the Robot Arm ... 175

Summary.. 186

Chapter 7: **The Camera: Bringing It into Focus** **187**

The Camera... 187

 Focal Length ... 188

 Film Back.. 190

 The Resolution Gate and Film Aspect Ratio 191

 Depth of Field.. 192

 Lens Artifacts.. 193

 Motion Blur .. 206

Matching Real-World Cameras .. 208

 Aspect Ratio ... 209

 Matching the Camera ... 211

Summary.. 217

Chapter 8: Lighting and Rendering .. **219**

Characteristics of Light and Shadow ... 219

Light ... 220

Shadow .. 225

Photometric Lights ... 228

Deep Shadows ... 229

Global Illumination .. 229

Irradiance Caching.. 230

Monte Carlo .. 231

Environment ... 231

Image-Based Lighting .. 232

Using sIBL in 401 ... 236

Lighting Phenomena: Volumetrics and Caustics............................ 237

Volumetrics.. 237

Caustics ... 239

Light Linking ... 240

Studio Lighting: Reflectors ... 242

Render Settings.. 243

Antialiasing... 243

Geometry ... 245

Ray Tracing ... 249

Rendering for Print ... 250

Summary... 252

**Chapter 9: Advanced Lighting and Rendering: Working in
Linear Space**... **253**

Dynamic Range .. 254

Floating Point ... 255

Gamma ... 257

Setting Up a Linear Workflow in Modo... 258

Rendering and Saving in Linear Space 258

Gamma Correcting Renders .. 263

Render Outputs.. 263

Render Passes... 264

Material Masks.. 265

Tone Mapping ... 266

Summary .. 267

Chapter 10: Using modo with Maya **269**

Why Use Maya? .. 269

My Workflow ... 270

FBX ... 270

Working Units.. 272

Animation... 275

Camera ... 275

Adjusting Curves ... 277

MDD ... 279

Summary .. 290

Chapter 11: Creating Real-time Assets........................... **291**

Examples .. 292

Tug Example .. 292

Simple Building Example....................................... 305

Summary .. 323

Bonus Resources .. **325**

Index ... **327**

Acknowledgments

To my Lord and Savior, Jesus Christ, thank You for my blessings and opportunities. Apart from You, I can do nothing. To my wife, Ann Marie, daughter, Abby, and son, Logan, thank you for your encouragement, support, and patience through the long nights and weekends I had while working on this book. I love you guys!

I would like to acknowledge the Real World modo project team. To Katy Spencer, the acquisitions editor, thank you for believing in me and offering support and encouragement throughout this entire project. To Beth Millett, my editor, thank you for showing me the ropes and guiding me through the process of writing a book. You made this project run smoothly. To James Darknell, the technical editor, thank you for lending your technical expertise. I learned much from your comments and suggestions. Writing this book was fun and a positive experience, and I owe that to all of you.

I would like to thank Bob Bennet of Luxology for working with Focal Press and me throughout the process of this book and for providing an endorsement. I would also like to thank the Luxology Dev Team and fellow modonauts on the Luxology Beta forums for always answering my questions. I would like to thank John Kabus of Synapse Gaming for reviewing Chapter 11 and providing an endorsement for the book.

I would like to give a special thanks to my coworkers, my friends at UPS Creative Media, for all of the support and encouragement. You all helped me keep my sanity and my eyes focused on the goal. I would also like to give a special thanks to my entire management team for believing in me and offering encouragement and support. I would especially like to thank Patti Hobbs and Bob Reynolds for all your hard work in securing rights for me to use models I created at UPS in this book. It was a long road, but we got there!

Finally, thank you, the reader, for buying this book. I hope you enjoy it and that it helps you to better understand modo and the 3D process.

Introduction

Trench Warfare

Trench warfare is kind of gruesome topic for an introduction, especially an introduction for a book about 3D software. So what am I talking about? I definitely don't want to compare being a 3D artist to something as horrible and frightening as war, to say in the least. Maybe it's the fact that I just finished watching HBO's *Band of Brothers* series for the first time or that I've been playing *Call of Duty* on Xbox LIVE that's got my mind entrenched in epic battle sequences and an awe-inspiring respect for the comradery of brothers in arms.

There's a particular episode in *Band of Brothers* about the Battle of Bastogne that really resonates in my mind. In this episode, the heroic men of Easy Company are in the dead of winter, pinned down in their foxholes with hardly any supplies, doing what they need to do to not only survive but to complete a mission. Being a 3D artist, working up against a tough deadline, can sometimes feel like I am in the dead of winter, pinned down in the trenches, low on supplies, with a huge deadline exploding all around me like mortar fire. I am doing everything I can to hold the line, but shrapnel is exploding all around me. It's at this point where I, too, need to dig in and do what I need to do to complete the mission, to finish the project on deadline.

Before you start thinking that I'm off my meds and decide to close this book, let's explore this analogy a bit further. Let's say that you being a 3D artist—either working contractually or for a company—is like a soldier. A project is your commanding officer, and it might require you to take the hill or secure the forward line. The gear in your pack is your computer, software, and other equipment like a camera. Your battlefield training is your 3D skill set and experience. Now, there will be times in the heat of "battle," finishing on deadline, where it might feel that you are fighting impossible odds and against a formidable foe, but much like Easy Company in the Battle of Bastogne, you need to dig in deep. You need to pull out of your pack the tools needed for the specific task and rely on your battlefield training to provide you with the skill or technique that works best for the given situation. Your gun might jam, which is a sudden software crash, but your battlefield training will kick in and you'll complete the mission. It might get messy and may not be the perfect solution, but you'll get the job done.

How Is This Book Different?

If you're like me, you're probably at the bookstore standing in the computer graphics aisle, sifting through books, and trying to fill in some of your knowledge gaps. I'm glad you found this book and are reading this section. I think that if you continue reading, you'll find that this book takes a unique look at developing your skills as a 3D artist. I've read dozens—and I mean dozens—of books on 3D over the years, and I know from experience how hard it can be when you're trying to teach yourself. I also know how frustrating it can be when you purchase a book, excited about increasing your skill set, only to find that the book stops short right at that critical moment when the light bulb is about to go off in your brain, and you are left with even more questions than when you started reading.

I'm not saying that this will be the only modo or 3D book you'll ever need. In your career as a 3D artist, or even as a hobbyist, you'll find out that your path to becoming a great 3D artist will be the culmination of gathering various bits of knowledge and experience. I don't work on the West Coast at a prominent visual effects studio, and I'm not creating high-profile imagery for a big-time marketing firm. Not to say that I don't have a great job; but to make the point that I'm just the everyday 3D artist, in the trenches, doing what I know to get the job done, in the best way I know how. You see, I'm like you. I want to be the best I can be. I love working in 3D and I'm very enthusiastic about my job.

This book is about being a 3D artist, and more specifically a 3D artist working from "the trenches" on real-world projects. In this book, you won't find step-by-step tutorials, or what I like to call "3D-by-number." What's the point of me showing you exactly what buttons to press to model X when your project needs you to model Y? Believe me, I've read my fair share of tutorials and books, and while 3D-by-number has its place for the first-time user, it's not what you need when working in the field.

This book is about experience, principles, and techniques, and that's what I'm going to share with you: my understanding and enthusiasm for 3D that I've gained over the years through reading, experimenting, and working in the field. I don't want this book to read like an instruction manual, so I'm going to explain the concepts of working in modo from my perspective, which is that of an artist. I sometimes make the joke at work that I'm severely right-brain handicapped. The fact is that working as a 3D artist is going to get technical, and in the following chapters, I'm going to share with you how I, the right-brained guy, manage to overcome the technical issues that arise on each project.

This book discusses the topics that I couldn't find in any other book, the areas that I have spent many hours researching online in the forums and experimenting with. These topics include learning how to create game assets

beyond just modeling a character, and using modo with other applications like Maya and Mudbox, to establish a linear workflow in modo. As a connoisseur of books on 3D, this book was written to be the guide I was always looking for but could never find.

What I Do

For the past six years, I've been working as a 3D artist/multimedia developer in the communications department for UPS in Louisville, Kentucky. Technically, I work for UPS Airlines, which means most of what I do pertains to flight and aircraft maintenance training. My day-to-day 3D projects might have me modeling aircraft, animating the effects of jet blast, or even creating animated characters of an aircraft package container. The other half of my job is creating multimedia presentations using Flash to create computer-based training modules or CBTs. I use 3D to help create rich, interactive media through Flash and Microsoft's XNA Game Studio.

Working at UPS has taught me a lot about creating images in a corporate environment. Some people might tell you that working for a corporate entity will zap you of your creativity. Well, I guess that could be true, but I don't see it that way. In fact, the way I look at it, creativity is what you make of it. I may not be working on the most exciting projects such as this summer's blockbuster film, but I do get a chance to make each project unique in the way that I choose. In other words, my projects will be as creative as I want them to be. The subject matter may not be the most entertaining, but that's half the challenge.

I started out wanting to be a professional photographer. In fact, I studied commercial photography in college. I took different internships with various studios and also freelanced while working as a staff photographer for my local parks department. I was on my way to becoming a photographer while building a small client base and honing my skills. This, of course, was before the digital revolution rocked the photography industry.

As digital photography began to mature and equipment was becoming cheaper, clients began bringing their work in-house, and jobs were becoming scarce. It was at this point that I started to rethink my career options. Without boring you too much by blabbing on and on about my career path, the short of it is that I had to reconsider my strong objection to using computers to create images. Yeah, I was a purist, which meant I wouldn't think of manipulating an image on the computer. To me, everything had to be done in camera and on film. I still had a love for creating images, so I decided to work with moving images and got yet another internship at a local video production company. It was at this internship that I first saw a 3D program—LightWave 3D 5.0. It blew my mind! I mean, this was it, and this was what I wanted to do. 3D had it all. It was like having my own photography studio in a box; it was simply

amazing. From there, I got hired at the video production company I had been interning with and spent every spare moment learning LightWave and becoming a 3D artist. This brings me to my point, which is adaption. Adapting to your environment is a vital skill to have in your pack. I hated computers, but to continue on and grow as an artist, not to mention make money to survive, I had to embrace my mortal enemy—the computer. After all, I had to eat.

Hello, I am a Mac, and I'm a PC

I always get into a platform war with the Mac guys in the graphics department at work. "Mac is for elitists, Vista sucks" is the kind of banter we yell over our cube walls. It's all in good fun. Actually, I use both Mac and PC. This book was written on a MacBook Pro 2.66 GHz Intel Core 2 Duo with 4 GB ram and NVIDIA 9600 GT 512 MB. At work, I use a MacPro Quad Core Xeon. I used BootCamp to install a Vista 64 partition so that I can run Visual C# Express and XNA Game Studio for certain training projects and Eyeon Fusion, which is not available on Mac, for my compositing work. The great news is that in my experience, I have found modo to run equally well on both PC and Mac platforms. I find that using an Intel Mac gives me the best of both worlds in one box.

Bonus Resources

This book has a companion Web site where you can find useful resources, such as specific scene files for some of the projects discussed. You will also find video walk-throughs as well as bonus videos that will further illustrate the topics covered. These videos will expand on the topics discussed in each chapter by providing a different perspective than can be covered on the printed page. The site can be found at http://wesmcdermott.com. The username for the login is rwmodo, and the password is optimus.

Well, that's it for the introduction. It's now time to flip the page and head into basic training, where we'll take a look at some fundamental concepts of 3D that you'll need to use throughout various tours of duty while working through the everyday challenges that arise in the field of 3D. So grab your gear, soldier, strap on your boots, and follow me into the trenches! We've got a mission to complete.

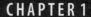

Basic Training

Before we continue with the introduction's analogy of grabbing our gear and heading into the trenches to battle our way through project after project and claim victory over the deadline, we have to go through some basic training. In this chapter, we are going to discuss some concepts that aren't what I'd consider to be the traditional concepts you read about when learning 3D such as the study of traditional art. Studying traditional art such as painting and sculpting will help you tremendously in your 3D art because being a 3D artist is much more than knowing software. Three-dimensional art is about how you interpret the world around you and how you translate that interpretation into 3D space. Instead, the following concepts are about the areas that helped me to learn, grow, and develop as a 3D artist. Let's start with how a 3D artist can be a bit of a jack-of-all-trades.

Working as a 3D Artist

In this section, I'd like to discuss how working as a 3D artist is like being a "jack-of-all-trades." You will need to study the different disciplines in the creative process to get that final render complete. Each project will help you to

gain valuable experiences. I've always felt that your experiences will drive your development as an artist, so let's begin by taking a look at experience.

Experience

As a 3D artist, you will need to continue to grow and adapt to changes in technology. Nothing moves faster than computers and you've got to stay ahead of the curve. For instance, it's a good idea to always keep up with CGI news sites and forums such as CGTalk.com or cgchannel.com. Depending on my schedule, I will try and start my day by visiting a couple of my favorite sites to see if any new techniques have been developed or any new scripts are available. The great benefit from adapting to change is that you gain experience, which is yet another vital tool in your pack. Your experiences not only help to mold your character but also help to develop your style as an artist.

What I'm trying to say is that it's not only about knowing how to use a computer and a particular software package that makes you a 3D artist; it's also the combination of technical skill, experience, and heart that makes you a 3D artist. Heart is who you are and what you put into the work. Your likes, dislikes, and influences will always be reflected in your work, which makes it art instead of computer science. Your experience and heart is also what distinguishes your work from another's. My experiences as a photographer make me a much better 3D artist. Being a photographer taught me a wide range of invaluable skills such as composition and lighting. Because of my experiences, I will approach a project with a different perspective from someone else, just as your experiences will distinguish your art from others. Anyone can learn what buttons to push in a program. The technical part of 3D can be learned, but it's your experiences and your unique perspectives that will make your work standout.

Disciplines

In my current job, I need to handle all aspects of 3D creation such as modeling, texturing, animation, and compositing. Being a 3D artist means you'll have to acquire different skill sets. For instance, you will need to know how to paint textures, which means you'll need to develop sufficient Photoshop skills to create textures for your models. You'll also need to be able to light your scene, which involves an understanding of lighting. You'll need to become your own gaffer. If you're creating your own models, you need to understand form and sculpture. To me, that's what keeps the job interesting. I like having my hands in each stage of the creation process. Even if you work in a facility where you only work, for example, as a modeler, it helps to have an understanding of the entire process. For instance, if you understand the basic concepts of rigging a

character, then your modeling will be more productive since you'll know to model sufficient edge loops in the mesh to handle deformations.

I'll leave this discussion with a spin on the beloved tag line from the GI Joe public-service announcements from my childhood. The more you know about the 3D process the better equipped you'll be to make decisions about creating assets for your project, and knowing is half the battle.

Education: It's up to You

If I were to look back to my time in college and think about the most important concept that I learned, it would have to be that my education is up to me. Now, I'm not saying anything bad about college. College is great, especially if you go to the right schools. I'm just speaking about my own experience. I didn't go to an art school; in fact, it was just a technical school that had a photography and graphic-design program. I was constantly frustrated by the professors, and ultimately I felt that they didn't know what they were talking about.

I soon realized that if I wanted to learn, I have to find the answers myself. It's only now, when I look back, that I see that I was actually learning to think for myself instead of relying on someone else to just give me the answers. When working as a 3D artist, you will need to learn to solve problems, and when dealing with computers you can bet on having problems. You will need to develop your critical thinking along with your traditional art skills. My main point to this is to explain the process I go through with each project. I am teaching myself 3D animation. I say the word teaching, in the present tense, because it's important to stress the fact that I'm still learning. I am always continuing to learn new things and keep my mind fresh. When the day comes that you think you know it all, this is the day you stop learning, and once you stop learning your art won't progress any further.

Always try to push yourself to grow and learn. It's up to you because nobody is going to do it for you. I've had co-workers ask me how did you do this or how did you learn that. There's not a secret formula or magic word to speak and then presto; you know it all and will be able to breeze through each project. For me, and I'd bet every other professional, each new project is going to bring its own set of challenges and problems for you to solve, which in turn will bring valuable experience. That's what keeps the job interesting and makes the work fun.

When I'm given a new project, I take a moment to analyze what it's going to take technically to complete it. Hopefully, there will be some new things that I haven't done before, and I'll be able to acquire new skills. Once I've identified the problem areas, I then turn to research. I hit the Web and the forums and I try to learn everything I can about the techniques I need to learn for the project. Once I've got some direction, I start experimenting by setting up some

simple scenes in 3D. I find that working on an actual project pushes me to learn and can sometimes be more beneficial than just going through tutorials. A major benefit to this is that you'll also be adding to your resources and building up your 3D arsenal, which is what we're going to talk about in the next section.

> 📖 **Tip: Don't Take Yourself Too Seriously** Speaking of education, I want to mention something that I have realized lately, something that has helped me greatly in getting through projects—that is, don't take yourself too seriously. You probably got into producing 3D art because it was fun and interesting. It is so important not to forget that. The day it becomes just a job is the day you should look into a new career. I used to get so obsessed with everything having to be technically correct. While it's very good to always strive to learn new things and research techniques, you'll eventually have to just jump in and get started. You can't worry about not being good enough or not knowing the correct way to do something. There's always more than one way to accomplish a task in a 3D project. You will just have to find the way that works best for you. I used to always find myself saying things like, "I'm not good enough to do that yet." What I realized is that I'll never know until I try. I don't have to be the best 3D artist in the world; I just have to give it my best. I decided not to take myself so seriously and just have fun with it. And you should too.

Resource Library: The Life Blood of a 3D Artist

When I first began learning 3D, I started a file where I kept all of my tutorials. Over the years, this file grew to include texture maps, videos, books, and research on 3D. I now call it my resource library. My library includes technical information and assets that I use on a daily basis. It keeps me from having to remember everything I read. When I research a new technique, it goes into the library and all I have to do is to remember how to find it. In this section, I'd like to discuss the concept of a resource library and how vital it can be to every 3D artist.

Technical Information

We've been talking about education and how the projects you work on can give you invaluable experience, but to be quite honest it's just about impossible to remember everything. With a field as deep as 3D animation, there is going to be tons of technical information. This information can range from knowing how to adjust the shading rate in the render settings, squeezing

a few precious seconds off a render, to quickly being able to set up Inverse Kinematics (IK) and constraints on a rig. The more you learn through gaining experience while working in the trenches, the harder it's going to be to remember everything in your 3D arsenal, not to mention remembering the techniques that you may not use on a daily basis until one day a project gets thrown into your lap and all of a sudden you are trying to remember how you even figured out that technique in the first place. As I said earlier, you don't have to remember every piece of information or every technique. You just have to know where to find it when you need it. Since I first got started with 3D, I have been stock piling techniques, tutorials, and articles and have been bookmarking Web pages into a massive resource library. I've also amassed a huge collection of technical books on everything from animation to compositing to programming and scripting. It all goes into the library. I make notes and categorize techniques so that I can quickly find them when needed. It's been a real lifesaver for several projects; it enables me to dig into my resource library and find the techniques I need.

Assets

Now, a 3D artist's resource library is not only filled with technical information, but also with creative elements such as texture maps and models. I keep a detailed and highly categorized library of texture maps. A texture library can consist of high dynamic range (HDR) imagery, backdrops, seamless maps, and grime textures for roughing up surfaces. I try to keep my texture library as dynamic as possible. Here, "dynamic" means I save each texture at a fairly high resolution because you don't know what the future use for the map will be. If you're working for an HD output, you're going to need to use larger maps; if you plan on utilizing some close-up shots in the project, you'll need higher resolution maps as well. You can always reduce the image size of a map, but it's much more difficult to enlarge a map. Your best bet is to archive your textures in a larger format.

I used to keep a small digital point-and-shoot camera in the glove box of my car. You never know when you're going to run into an interesting texture to grab for the library. Now, I just use my iPhone since it has a small camera. The best part is that it's usually in my pocket and makes it really easy to snap a couple of textures while on the go. For my main texture work, I use a Nikon D90 digital SLR.

Three-dimensional models are another great resource to collect for your library. For each project you work on, you will mostly be creating some elements that you'll be able to use in projects down the road. Preset Browser is a new feature in modo 401 (see Figure 1.1). It allows you to categorize the commonly used elements such as meshes, environments and materials, and ships with some commonly used stock elements that you just simply drag and

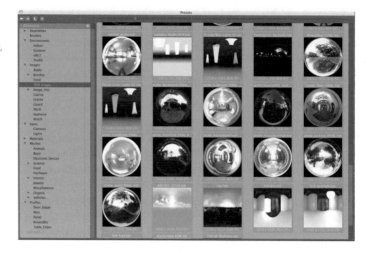

FIG 1.1 The Preset Browser, a new feature in modo 401, is a collection of pre-defined scene assets such as objects, materials, and environments.

drop into your scene, speeding up your workflow. The real power in this tool is that you can add your own objects and scene elements to it, making the Preset Library your main tool for categorizing your 3D elements. It will be a great time-saver when you need information or a model or perhaps even a texture—especially when it comes to meeting deadlines—as your resource library will always be growing.

> 📖 **Tip:** Luxology's Asset Sharing site is a great resource for downloading and uploading meshes, assemblies, textures and materials. The site can be found at www.luxology.com/asset/

Software: It's Only a Tool

In the Introduction, I used the analogy of being a soldier working from the trenches. I mentioned that the gear in your pack represented your computer and the software that you use to create 3D imagery. For this book, modo 401 is the software that we will find in our pack. Throughout my career, I've used several different 3D packages including LightWave, 3ds Max, Maya, and modo, as you have probably have used different packages as well. The funny thing is how we artists can become so emotionally attached to our tools. If you go to any CG forum, you will undoubtedly find a thread somewhere touting that software X is better than Y. In a way, it's understandable. Three-dimensional artists have a lot of time invested in a particular software package. Sometimes there's a bit of nostalgia. I felt bad when I stopped using LightWave. It was the first 3D application that I learned and have spent a lot of time learning the ins and outs of the program. As an artist you have to realize that the software is just a tool. I definitely mean no disrespect to the software engineers who make

our favorite tools. It's absolutely amazing what they have been able to create. I just mean that we shouldn't focus too much on software and instead move our attention to the imagery we are trying to create.

In my opinion, no software is perfect at everything. Each package has its own strengths and weakness. Depending on the type of work you do, you'll want to pick the tool that will work best in a given situation. For instance, you wouldn't want to use a flat-head screwdriver to remove a Phillips-head screw. You might be able to get it to work, but it would probably be a lot of trouble and it would take much longer to remove the screw. As I had mentioned earlier, depending on where you work and what you do, you may only be using software X or you may have to work in a specific pipeline that probably includes proprietary software.

In my workflow, I use modo for modeling, UV map creation, and texturing. I use Maya 2009 for animation and Mudbox for sculpting. I will usually split the rendering between modo and mental ray in Maya depending on the final output. If it's a character animation project, I may just use mental ray since I already had to move my model into Maya. Typically, I'll try and stick with rendering the project using modo, since I find it to be much quicker than setting up mental ray. I've established my own workflow for moving objects from one application to the next, as we will discuss in Chapter 10. Each one of these three programs does certain things very well. For instance, modo 401 has broadened modo's toolset by introducing constraints and IK, but it's still not to the level of Maya for rigging characters. Maya 2009 introduced some new polygon modeling and UV capabilities, but I think that modo's modeling and UV tools are much more advanced. Ultimately it comes down to what you're most familiar with. After all, it's just a tool.

Learning to See: Switching off Auto Mode

Have you ever been driving a daily route such as going to work and realized that you've reached your destination, but you don't remember how you did it? Perhaps you were focused on a meeting and the next thing you know is that you've gotten off on the correct expressway exit, but you don't remember thinking about it. Your brain was running on autopilot. Although this isn't good when driving, it's amazing how our brains can take routine tasks and execute them without conscious thought. It's like your brain is working in auto mode. In this section, I want to talk about this auto mode and how it can sometimes get in the way when creating imagery.

Emotional Content

The human eye is an amazing instrument. Now, I'm not a doctor so I'd have a tough time explaining to someone exactly how an eye works; however, I do

understand an important concept when it comes to the relationship that takes place between our eyes and brain. Our eyes take in light, and that light is processed by our brains into information about what we are seeing. The interesting part is that the brain does what I refer to as a "post-process effect" on the data and that post-process effect is applying emotional content to the data.

For example, let's imagine that we are standing on a mountain top overlooking an amazing vista at sunset. It's quiet and all you can hear is the slow rustle of the wind as the breeze moves through the tree tops. The air has a bit of crispness to it, and as the sun is setting beneath the clouds, the scattering light is washing the sky with vibrant hues of warm colors. As our eyes take in this sunset, our brain interprets the scene as a memorable experience. The brain not only stores the visual information from our eyes, but the sounds, smells, and emotions we felt at that particular moment. These sounds, smells, and emotions are added to the visual information to produce a story, which in this case is stored as a memory in our mind. We remember this story as a spectacular view and don't even notice that over to the far left, there was a garbage can that needed to be emptied, or several feet in front of us someone had emptied his or her cigarette tray onto the ground. We didn't notice these things because after our brain added the emotional aspects, or post-processed the experience, the brain decided to omit entirely that information that didn't translate into the emotions we felt.

A camera is much like our own visual system in the sense that it takes light, translates it into information, and then saves it to a storage device. The difference is that the camera is not going to filter our emotions like the brain does when it saves the scene into our memory. The camera just records to its memory card exactly what you pointed it at. The camera wouldn't have omitted the garbage can and cigarettes on the ground from the scene.

Our emotions are what we use to distinguish our work, but we need to be able to filter our emotions on a conscious level to properly translate an idea from within our minds to a paper, photograph, or a 3D scene. It's essentially like switching off auto mode on a camera and shooting in manual. It's the only way to get the control you need to re-create the scene that your emotions drew you to in the first place.

Flipping the Switch

So, how do you turn off auto mode? There's certainly not a switch on the side of your head. You have to train yourself to look beyond what you think you're seeing. Take a look at Figure 1.2. This is an image that I photographed while visiting my parents several years ago. This image was produced in-camera, which means it wasn't manipulated in a program such as Photoshop. I took the image while walking around in my parent's back yard. I remember liking

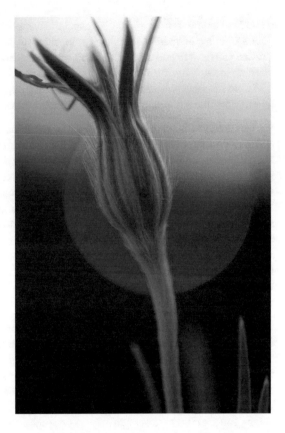

FIG 1.2 This image was created in-camera without any Photoshop retouch. It was shot with Fujichrome Velvia rated at ISO 40.

how the sunlight was highlighting some of the flowers. This was the emotional part that drew me to the scene. If I would have just taken a shot right then, it wouldn't have been dramatic at all; in fact, it would have been boring and probably underexposed because I was facing the sun. What I did was start to look beyond what I was seeing. I used the emotional feeling I had when I saw the sun backlighting the flower bed, but I didn't let those feelings cloud my judgment; instead, I started exploring the emotional content my brain was collecting about the scene by checking different angles on the flowerbed. I then asked myself what exactly is it that I liked about this environment, and I started to explore it fully. By breaking down what I liked about the scene into its simplest form, I was able to get the shot in Figure 1.2.

Switching off auto is not only about looking beyond what you see and exploring your ideas fully. There are other factors that contribute, such as attention to details and the story you are trying to convey. The major difference between photographing a scene and creating a scene in 3D is that with photography you go through a subtractive process of eliminating

distracting elements from a scene to reveal the composition, whereas in 3D your are adding elements to create a composition. In 3D, we start with a blank canvas. You have to add objects, lighting, and environment. This is why learning to see is the most important aspect of doing 3D work. You need to know exactly what you want to include in the image up front. You have to have a clear understanding of the story the image is going to tell.

For example, you need to create a model of some steps, and these steps are going to be apart of an old building scene. For this example, we are going to keep it simple and not worry about the overall project design. We are just going to concentrate on the steps. First we need to know what makes steps old. The worse thing we can do is to rely on what we think old steps look like. Yeah, you've probably seen old steps in your lifetime and you may even have some outside your front door, but as we discussed earlier, you can't trust the image stored in your mind because of the emotional content that got stored with that image in your memory. It's going to be skewed from an emotion. The best thing you can do is to take reference shots of some old steps and study what makes them look old. Hopefully, you might even have some in your reference library to pull from.

Here is where you begin to develop the story for your object through attention to details. In the real world, every object tells a story. As humans, we leave an impression on everything we come in contact with. Think about the wear on the handrail that thousands of people come in contact with while stepping down into the subway station or the finger prints on the drinking glass. Weather and other environmental elements can add to the story of an object. Maybe you are creating an image about a poor shop owner who can't afford to pay for the broken gutter, and on the side of the building you can see water stains running down the brick. Adding the detail of water stains to the brick not only adds to the realism of the 3D object, but it lends itself to the story. In some cases, these details can even be a character in the story of the image you are trying to produce. The point is that these story-driving details are not there by default. You have to know how to see these details in the real world to convey them in 3D.

Going back to our example of creating old steps, you'll need to add the details that make the steps old. If you look at Figure 1.3, you see a shot of some steps. You can notice the wear from people walking up and down the steps. Also, there seems to be a bit more wearing on the left side indicating that people may tend to use the left handrail more than the right. We'll have to remember this when texturing the handrails. I also noticed that the wear is most prominent towards the front of each step. The wear is not evenly distributed and shows a specific pattern of how people are walking up and down the steps.

FIG 1.3 An object in the real world will always show the effect of its environment and it's interaction with people. You should always be looking for ways to bring this interaction into your 3D objects.

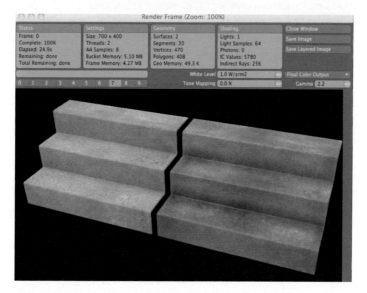

FIG 1.4 Always think about the story your object could be telling through texture detail.

Now you can see how learning to see the fine details can add to the story of your 3D objects, not to mention the realism. If we were creating a staircase in a fancy hotel, we wouldn't see the type of wear we see in Figure 1.3. In a fancy hotel, the shoes that people would probably be wearing would cause different types of scuff marks, not to mention that the steps would be made from a different material all together. Check out Figure 1.4 where you can see a comparison of two sets of CG steps rendered in modo. You can see from the image that the stairs on the left don't have any wear or weathering added and without these details and a developed story for the object, CG stairs end up looking rather CG.

You will always be developing the way you see the world as a 3D artist. Learning to see by switching off auto mode will really come through in your everyday work. It's what moves you from producing 3D work to rendering 3D art.

Summary

Taking control of your own education, creating a resource library, using software as a tool, and learning to see are the concepts that I've learned over the years of teaching myself 3D animation, and which constitute our basic training. In the following chapters, we are going to take a look at creating 3D art with Luxology's modo 401 software. I'm not going to just talk about pushing buttons or inputting number; instead, I'm going to discuss various topics, which include creating 3D models, UV unwrapping, and linear rendering, to name a few. I want to share with you the areas of 3D that I didn't understand when starting out, only getting bits and pieces of information from tutorials and books. My goal is to help you fill in those knowledge gaps.

Becoming a Modonaut

Modonaut: I always thought that was a clever name for an avidmodo user. The first time I heard the term "modonaut" was during one of the modcasts on the Luxology site. In case you're not familiar with the modcast, each week, Brad Peebler, the president of Luxology, serves up a dish of modo lovin' in Luxology's version of a podcast. We'll talk more about modcasts and other modo resources later in the community section of this chapter.

This chapter's focus is to guide you from being a 3D artist to a modo artist—or, as Brad would say, a modonaut. In this chapter, we'll look at using modo from an intermediate standpoint. We won't look at every single tool and explain exactly what it does; that would get boring real quick, and that's what the modo help documents are for. In fact, modo has probably the best help system I've seen yet in a 3D application. I will talk about the areas of modo that I find to be the most relevant to being able to start up the software and take off rendering. I also want to take a look at using modo from the perspective of a user coming from another 3D application and how they might integrate modo into their current pipeline. If you're already familiar with modo you might want to just quickly flip through this chapter and see if something new pops out at you.

Way of the modo: User Interface and Customization

When I went from using LightWave to modo 102, my first thought upon opening modo was confusion. I thought, man this looks kind of difficult to pick up. After messing around a bit in the user interface (UI), I quickly found how intuitive and easy modo can be. Now, this probably is because of the fact that I was previously using LightWave. The reason being, the guys who created modo use to work for NewTek, developing LightWave, and the basic modeling workflow was similar. Earlier, I remember hearing the comment that modo was like LightWave on steroids. Being a Maya user as well, I can see how coming from Maya to modo could be a little confusing, but we'll address that later. If you're sitting at your computer, go ahead and fire up modo and feel free to take a break from reading to mess around with the UI. Again, this isn't a beginner's guide, so I won't be covering how to get around in the UI. If you're unfamiliar with modo's UI, I'd suggest checking the help documents or modo's Getting Started videos.

The modo UI, as shown in Figure 2.1, is already fairly streamlined at the default layout—and for the most part, that's they way I keep it.

FIG 2.1 This is modo's default layout.

What makes modo's UI unique is that you can completely customize it to your own personal workflow. For instance, you can remove all of the panels and viewports, and build your own UI by going to the Layout menu at the top of the interface and selecting Clear.

It is also in the Layout menu that you can either save your custom layouts or return back to the 401 default layout if you delete something by accident. The UI is very pliable, kind of like playing with silly putty. You can detach and dock panels anywhere. You can right-click on any active tab to reveal a drop-down menu that will allow you to reconfigure the panel.

In that same notion, you can also click the right-facing triangles, which are called viewport widgets, in the panels to reveal a similar drop-down menu for changing panels or viewports as well, as shown in Figure 2.2.

The main point I want to make with the modo UI is that you can configure it to best fit the way you work. If you're only doing modeling and UV mapping, then you can create a layout that just contains these toolsets. You can remove all of the other panels and tools that aren't directly related to modeling, such as animation and rendering. You can see in Figure 2.3 an example of such a layout.

Form and Input Editors

I use the Form Editor and the Input Editor a lot and they can be found under the System menu at the top of the interface. The Form Editor is great for adding your scripts to the actual interface, or for even just rearranging some of the tools around, to again best complement your personal workflow; but its best use is in the creation of your own custom Forms, Pie Menus, and Popovers. The way I look at it, Forms are just windows in the interface that have tools or commands associated with them. You can see in Figure 2.4 how the Polygon Form relates to the actual interface.

Pie Menus and Popovers are very similar to what a Maya user would call a Marking Menu. Basically they're just a floating menu that shows up when you use the assigned keyboard shortcut for that menu. For example, I regularly use the Viewport Pie Menu to change views as shown in Figure 2.5.

> 📖 **Tip:** Hitting CTRL+SPACE will bring up the Viewport Pie Menu.

In the Form Editor, you can see a list of the other Pie Menus by looking under the Pie Menu folder. You can create your own Pie menu for tools that you use frequently.

The Input Editor can also be found in the System Menu and its usage is for configuring keyboard shortcuts. I find that the Input Editor can be a bit confusing to use. At the top of the editor, you have drop-down menus for

FIG 2.2 Clicking the right-facing arrow will reveal a drop-down menu, allowing you to reconfigure the panel or viewport.

filtering what you want the Input Editor to display. Let's take a look at the editor together and see if we can find the keyboard shortcuts for the Pie Menus. I'm not sure how the Input Editor filters are set on your system; but to get to the Pie Menus, first change the Edit Mode to Keyboard Shortcuts, since keyboard shortcuts are what we're interested in. Next, change the View Mode to Commands; this will filter the editor to Commands. Finally, change Commands by Group to Popover Forms. Now you will see the keyboard shortcuts on the left under the Trigger column. The Description Column on the far right will show if the form is a Popover or Pie Menu. If you have Show

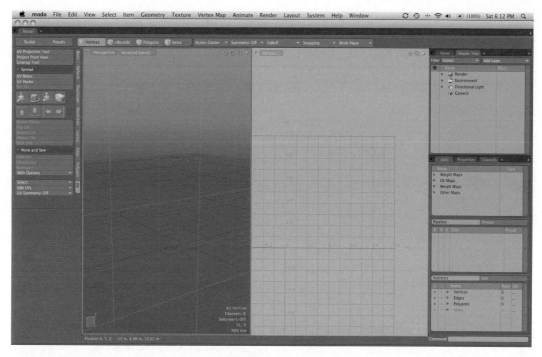

FIG 2.3 This layout has been dramatically streamlined to only contain the modeling and UV toolsets.

Unmapped Commands checked, you'll see numerous Pie Menus, Popups and Popovers. Try and say that three times fast.

> 📖 **Tip:** A great way to find out the keyboard shortcuts for the Pie Menus listed in the Form Editor is to simply use the Input Editor.

Statistics and Information

Another panel I use often is the Statistics and Information Panel that is located on the far right side of the interface on the Lists tab as shown in **Figure 2.6**.

I use the Statistics panel as a quick way to make selections on my geometry, especially to check my mesh for triangles and N-Gons which are polygons with more than four vertices.

N-Gons and Triangles are the Devil!
📖 Well, I guess they're not all bad, but you do want to try and stay away from using N-Gons and triangles in areas where a mesh may deform. Sometimes, you just have to use them, and it's best to place them in an

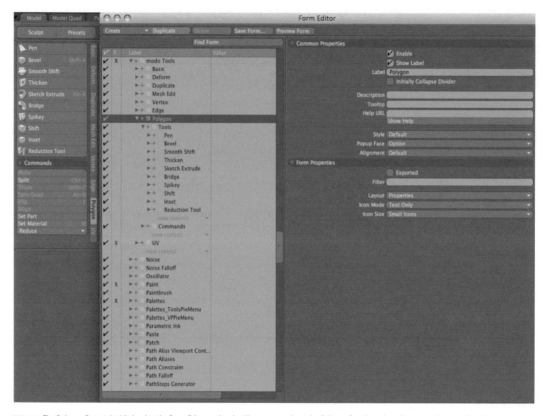

FIG 2.4 The Polygon Form is highlighted in the Form Editor and in the UI you can see how the Polygon Form's tools and commands create the UI.

area that won't show, like behind an ear. It's fine to use them on areas of a mesh that are flat, like a tabletop.

Using the Statistics panel, you can also quickly make selections through Selection Sets, by Materials, as well as through other component criteria, such as Edges and Vertices. For example, create a cylinder, and then go to the Statistics panel; expand the Polygon category, followed by the By Vertex category, and you will see number 2 under the Num column to the left of the >4 category. This number 2 correlates to the two N-Gons that are present in the mesh; and to select these N-Gons, just click the plus button to the far left, as shown in Figure 2.6.

I use the Information panel for what I like to refer to as "debugging polygons". For example, sometimes you might be working in a subdivision mode, and you might get confused if a polygon has three or four vertices. You can quickly select the polygon in question and then check the Information Panel. It will show you lots of important information about that polygon, such as type,

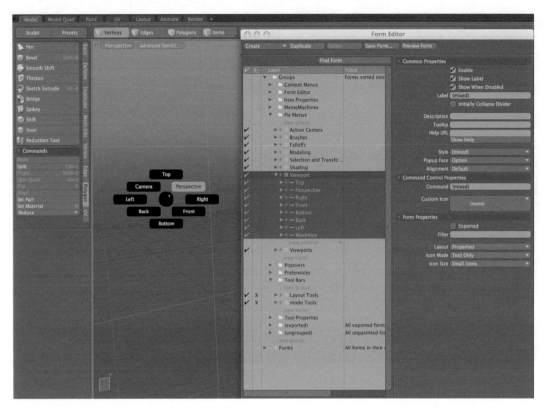

FIG 2.5 The Viewport Pie Menu.

flatness, material, and how many vertices make up that polygon, as shown in Figure 2.7.

> 📖 **Tip:** I also use the Information Panel to align vertices. I will select a vertex, and then go into the Information panel and under the Vertex, Position category; I will then copy the X, Y, or Z value that I want the other vertices to align to, as shown in Figure 2.8. Now that I have the vertex's positional data, I'll select the vertices I want to match to the last vertex selected position, and use the Set Position command found under Geometry, Vertex drop–down menu to align the vertices.

Display

Next, let's take a quick look at the Display tab which is also located on the right side of the interface, as shown in Figure 2.9.

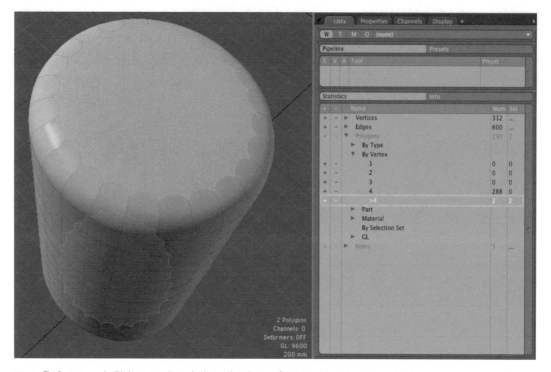

FIG 2.6 The Statistics panel will help you to make quick selections based on specific criteria such as polygons with >4 vertices.

The Display panel allows you to configure the display options the way the 3D items in the scene are shown. For instance, you can hide the pivot and center of an item, change the wireframe colors, or even add a label. This might seem kind of trivial, but when you have a complex scene with numerous items, taking time to configure the display options can help make your scene easier to navigate. Let's again imagine working with a complex scene that may have a lot of high-resolution texture maps. You could set the Draw Style to Shaded and improve the performance of your scene as shown in Figure 2.10. You could also just click the eye icon in the Shader Tree next to the image map for that material; but remember, you're working on a complex scene, and there will probably be lots of image layers you'll have to weed through to get to the image you want to disable. That's where the Display tab settings will come in handy.

Preferences

Finally, I'd like to take a look at the modo Preferences, also found under the System menu, which you'll find may need changing based on project needs. In Figure 2.11, you will see that the preference window allows you to quickly change settings such as Unit System.

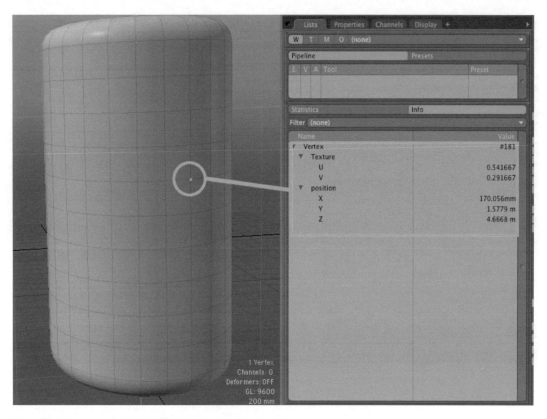

FIG 2.7 The Information panel displays valuable information about selected components.

In the Remapping section, I want to point out that you can set modo's mouse input presets to match the 3D application that you're most familiar with. For instance, I have mine set to Maya (Navigation Only).

> 📖 **Tip:** The Maya (Navigation Only) preset is only available in 401; and although it's a small feature, I thought it was a great addition. Using Navigation Only will map the zoom, drag, and rotate actions in the viewport to Maya's style of navigation; but it will retain modo's default drag selection mode, which is similar to using Drag Select in Maya 2009.

The options to be aware of in the Accuracy and Units category are the Unit System, Default Unit, and Coordinate System's Up Axis. You'll probably be accessing the Unit System and the Default Unit frequently, depending on your project needs. For example, if you need to model something to scale and prefer to work in inches, you'll need to change the Unit System to English and the Default Unit to inches. Internally, modo uses meters, so no matter which unit system you use, modo is going to be internally processing the data in

FIG 2.8 You can use the Information Panel to find out the positional data of a vertex.

FIG 2.9 The Display panel allows you to configure the display options for 3D Items.

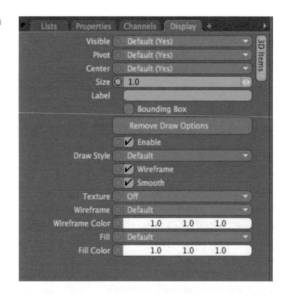

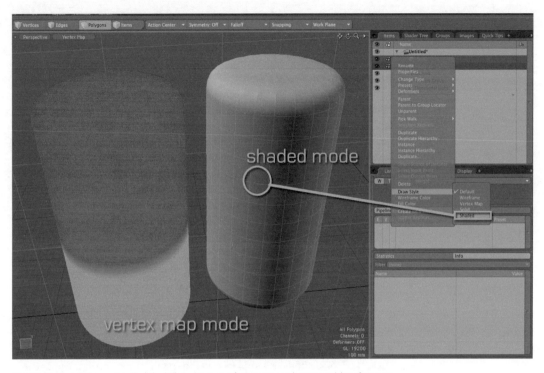

FIG 2.10 The Draw Style was set to Shaded, which can improve performance in complex scene with lots of geometry.

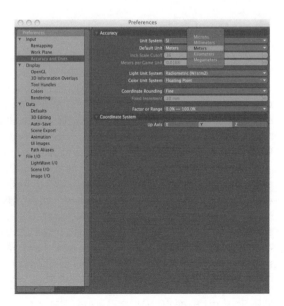

FIG 2.11 In the Preference window you can change settings such as the unit type.

meters. This information will come into play later in Chapter 10 when we talk about using modo with Maya.

You also have the ability to change the Up Axis of the coordinate system to match that of another 3D application that you might use in conjunction with modo. In the OpenGL category, under the Backdrop Item section you have the option to change the Pixel Size. We will talk about this in Chapter 3, but for now just know that this option is used for setting up a relationship between the pixels in a backdrop image that is used as a modeling template to the Unit System's default unit measurement. In other words, if you're using metric and meters, the Pixel Size would default to 1 cm, which actually means each pixel in the backdrop image will represent 1 cm of grid space. In the Rendering Category of the Preference window, we have some heavyweights in the preference world, these are Default Output Gamma and Display Gamma.

> **New to 401**
> 📖 New to 401 is the ability to have the Gamma settings affect the Color Swatches, Picker, and System Color Dialog, which is a very awesome feature and great for enhancing a linear workflow in modo.

We also have the Animation category, in which we can change the Time System and Frames per Second settings, as well as the rotation order and slope type for keyframe interpolation in the Graph Editor. Lastly, the image I/O category allows you to change the compression ratios of JPEG and PNG files when you save to these image formats from the Renderer.

The Work Plane

The Work Plane in modo is a dynamic secondary grid that works as a visual aid to represent the position of drawn items in the 3D viewport. As the viewport is rotated, the work plane will dynamically adjust to present the user with what it thinks is the best position. The Work Plane is used as an aid in the construction of 3D objects, but it can also be used to align objects as well. I mainly use the Work Plane as an alignment tool. For instance, you can align the Work Plane to a selection. Let's say you're working on the roof of a building, and the top of this building isn't flat, but angled. Now, you need to add detail to the top of the angled roof. It would be tough to try and model details on the angled roof. This is where the Work Plane comes in to save the day. All you need to do is to select the component you want to align the Work Plane to, and select Align Work Plane to Selection from the Work Plane drop-down menu located at the top of the interface. Now the Work Plane will snap to that selection, making it easy to draw out new geometry on the angled surface. Once you're done, just select the Reset Work Plane from the Work Plane menu.

You can also use the Align Work Plane to Selection command in conjunction with the To Work Plane Position and Rotation options that are new in 401.

These Work Plane alignment commands work on Items. Go to the Animate tab, on the left of the interface, under the Set commands; you'll see the To Work Plane Position command. If you left-click and hold the button, you'll enter into the To Work Plane Rotation command. As we discussed before, you can align the Work Plane to a selection and then use the To Work Plane Position and Rotation commands to align an item as shown in Figure 2.12.

The point to remember is that the To Work Plane Position and Rotation commands are going to be aligning an item, based off its Center. If you create an object in the Animate tab, be sure that you have properly positioned the item's Center before aligning it to the Work Plane. You can see in Figure 2.13

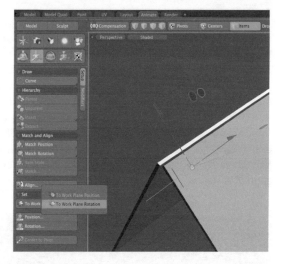

FIG 2.12 The To Work Plane Position and Rotation commands were used to align the item to the angled surface.

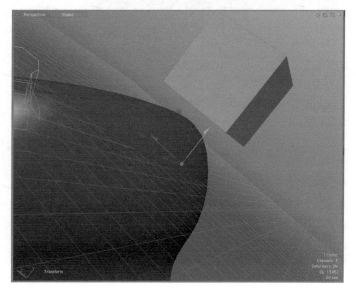

FIG 2.13 The Item's Center was offset so you can see how the alignment is using the Center of the Item.

how the Item's Center was offset and how this affects the alignment of the item to the Work Plane. We'll talk more about Centers and Pivots in Chapter 6.

Action Centers, Snapping, and Falloffs

Action Centers in modo decide the position of the tool handles. The Action Center menu gives you a wide range of options for changing the position of the handles based on a set of parameters, and provides you the ability to customize a tool to meet a specific task. In this section, we'll be discussing Action Centers in conjunction with Falloffs and Snapping.

Action Centers

Understanding Action Centers is vital to being able to work efficiently in modo. There are two basic concepts to understand, which are Center and Axis. The Center is the position of a tool handle in relation to a selection. There are also several other options that you can choose from the Action Center drop-down menu at the top of the interface. While the default option is Automatic, meaning that the Center will automatically center on the selection, there are numerous other options such as Selection, Element, and Origin. For example, **Figure 2.14** shows several polygons selected on an item; you can see that when the Transform tool is activated, the center for the tool handle is aligned to the center of the selection.

FIG 2.14 The tool handle is aligned to the center of the selection.

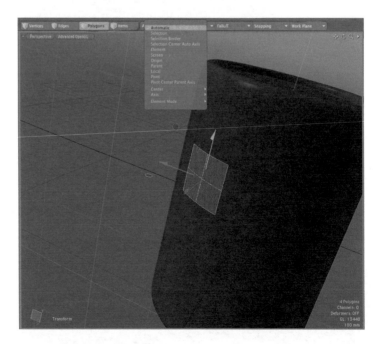

FIG 2.15 The polygon is not being translated in the direction it's facing. Instead, it's moving along the grid's axis, since the tool handle's axis is set to Automatic.

📖 **Tip:** For a quick centering trick, move the mouse to the position where you'd like to set the Center, and left-click. The center will align to the mouse position, which speeds up the modeling process tremendously.

Now, you'll notice from the example that even though the tool handle is centered to the selection, the handle's axis is aligned to the grid or screen. This is where Axis comes in. In modo, you can change the axis upon which the tool handle will orientate itself, which can be configured independent of how you want to set the Center. To illustrate this, fire up modo and draw out a primitive sphere. Now, for example, you want to move one of the polygons near the top half of the sphere along its Normal, which would move the polygon in the direction it's facing. The polygons near the top half of the sphere are angled; but when you select a polygon and activate the Transform tool, the tool's handles are centered to the selection (thanks to the Action Center being set to Automatic), but the tool's axis is aligned to the grid. If we then translate the polygon along the Z axis, you'll see that we're not moving the polygon in the direction that we'd like, as shown in Figure 2.15.

Now if we set the Action Center to Selection, the tool handle's axis will align to the selected polygon which will allow us to translate the polygon along the direction its facing, or along its Normal as shown in Figure 2.16.

FIG 2.16 Since the Action Center was changed to Selection, the polygon is now being translated in the correct direction.

The options that are available under the Action Center menu are actually just tool presets, which are different combinations of the Center and Axis settings wrapped into one tool. You can even configure your own Center and Axis by just using the Center and Axis settings, which are under the presets in the Action Center menu.

> 📖 **Tip:** Action Centers give you specific control on how you transform components and Items in modo. Utilizing Action Centers will greatly increase the speed and accuracy of your modeling workflow.

Snapping

Snapping in modo is pretty straightforward; it's great for aligning geometry when you need to be accurate. Instead of explaining everything about Snapping, I'm going to explain two areas where I mainly use Snapping. In modo 401, there is a new snapping feature called Item Snap. It's a fantastic addition, and easy to use. While in Item mode, hold down the X key, left-click on an Item, and simply drag it to the Item you want to snap to. It's not groundbreaking; but man, did I miss this feature in previous versions. I'm so used to using snapping like this in Maya, and the lack of it in modo was driving me nuts. Item Snap is great for aligning Items, especially when aligning locators for IK rigs or pivots for animation, which we will cover in Chapter 6.

The other area where I find myself using Snapping is in retopology of a mesh. We'll get into topology in detail in the next chapter; but as far as Snapping goes in retopology, I mainly will use the Constrain To option, especially the Background option. The Background option lets you use what's in the background as the element to snap to in the active mesh layer. In 401, there are some new options for Background constraint, which are Vector and Screen Axis. The Vector mode calculates the motion direction of moving vertices for calculating the constraint. To me, it's like using a deformer, and is easier to grasp by looking at an example as shown in **Figure 2.17**.

I use the Screen Axis mode for retopology and general modeling. The Screen Axis constraint fires rays perpendicular to the viewport to find geometry to Constraint To. The advantage is that the Constrain To Background is implemented through the Tool Pipe, so modeling tools such as the Pen Tool, Transforms, and Deformers will work with it. (Find out more on topology in Chapter 3 and be sure to check the book's site for a video on retopology tools in modo.)

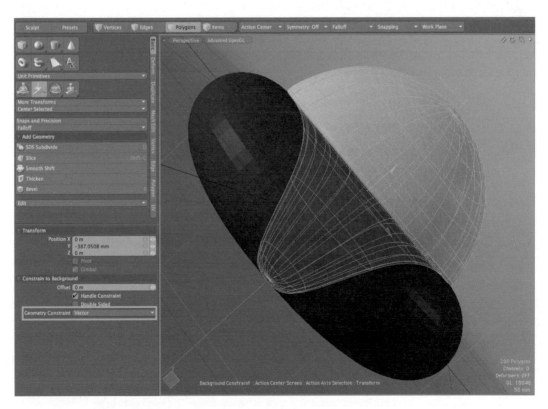

FIG 2.17 You can get some interesting effects using the Snapping>Constrain To: Background in Vertex Mode.

FIG 2.18 You can activate Show Falloff to better visualize how the Falloff will affect a tool.

Falloffs

Falloffs allow you to modify how tools will affect geometry. If you go to the View Menu at the top of the interface and select Show Falloff, when you activate a Falloff followed by a tool, the viewport will then color the vertices to give a visible cue as to how the Falloff will affect the geometry, as shown in Figure 2.18.

If you go to the Falloff drop-down menu near the top of the interface, you will see that there are various methods of Falloffs, which you can apply; and, as with Snapping, the Falloffs are also implemented through the Tool Pipe, so they will have an effect on all tools.

The Tool Pipe

The Tool Pipe is an essential aspect of modo. Most of the tools in modo are made from a combination of functions saved as a preset. The power of Tool Pipe is that in modo tools can be combined to create new tools and new

FIG 2.19 The Bulge Tool is made of a Radial Falloff combined with the Transform Tool.

features can be implemented to affect the current toolset by way of the Tool Pipe. In the Pipe, tools feed downstream from top to bottom with the active tool highlighted at the bottom, as shown in Figure 2.19.

In Figure 2.19, you can also see that the Bulge Tool is made from a Radial Falloff combined with the Transform Tool. You can see that it's possible with the Tool Pipe to create completely new tools. Right-clicking on the Tool Pipe brings up a context menu with several useful options, such as Auto-Active and Select Through. You can save your own presets if you happen to find yourself using a certain combination of Tools. Auto-Drop will drop the tool immediately after pressing the left button on the mouse. For instance, the Transform tool doesn't Auto-Drop by default because you want to reposition the tools' handles so that the tool stays active. For example, if you want to do a series of consecutive polygon extrudes, you could enable the Auto-Drop for the Extrude tool, which will allow you to perform a new extrude after each left-click of the mouse. Building on that thought, instead of enabling Auto-Drop you could enable Select Through. This would allow you to extrude a polygon and then select a different polygon and extrude. Now, you could then change the Action Center to Selection so that the extrusion will take place on the selected polygon's Normal. By doing this, you would be effectively creating a way to quickly

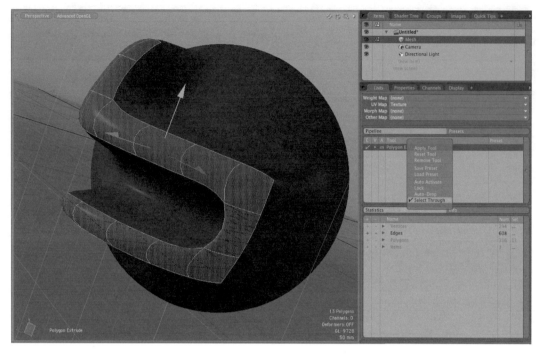

FIG 2.20 Using Select Through in the Tool Pipe will allow you to do consecutive operations of a tool on different selected components.

drag-select several polygons; and upon release of the left mouse button, the polygons will extrude based on their direction, as shown in Figure 2.20.

> 📖 **Tip:** In the Tool Pipe, you can turn the visibility on and off for tool handles. For instance, whenever I use the Drag Tool, I always turn off the visibility of the Transform in the Tool Pipe. I find that the transform handles just get in the way; and by turning them off, I'm able to easily click and drag vertices around in a free-form manner.

The Shader Tree

We'll be discussing the Shader Tree in much greater detail in chapter on texturing and rendering. For now, be aware that the Shader Tree uses a layer-based workflow for designing your materials.

I'll let you refer to the help documents for the basic understanding of how to use the Shader Tree, but I'd like to point out a few things that might help someone coming from another application. The Shader Tree processes materials and shaders from the bottom to the top of the layer stack. A layer, one above another, will overwrite it unless the layer above is assigned to a specific group of polygons by a mask. You can create Material Group to

FIG 2.21 Layer Masks and Group Masks allow you to control how multiple materials affect a surface.

contain Materials for organization and utilize Layer Masks or Group Masks to determine how multiple Materials affect an Item, as shown in Figure 2.21.

You can also add different shaders to the tree and place these shaders into a Material Group to control how a material is shaded. For example, by adding a shader to a Material Group, you could have that material not cast shadows or be invisible to reflection rays. You could even use the shader to add a custom shading rate to the material as shown in Figure 2.22.

Finally, you can add Render Outputs to the Shader Tree to render different passes in a multipass render such as diffuse, specular, and reflection, as shown in Figure 2.23.

Node-Based Shader Layout versus Shader Tree

📖 If you're coming from a node-based shading system such as Maya's Hypergraph, modo's shader tree will seem rather limited at first sight. I do feel that a node-based shader system is more powerful than the Shader Tree in modo when setting up a complex shading network, but I can't discount the Shader Tree's ability to quickly and easily setup shading networks. For example, setting up multipass output in modo is much quicker and easier than in mental ray for Maya.

FIG 2.22 A shader allows you to change how a material will affect the surface of an item.

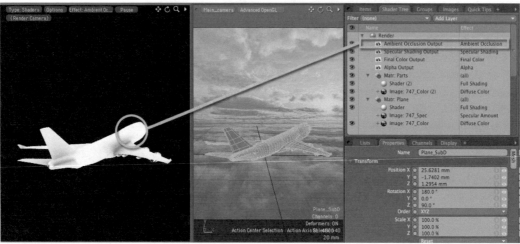

FIG 2.23 Render Outputs are used for setting up multipass renders.
Source: Wes McDermott.

Item List and Groups

The Item List and Groups panels are used for scene organization, layering, and setting up hierarchies between Items and Channels. While the Item List affects single Items, the Groups panel affects multiple Items and Channels.

Item List

The Item List allows you to add new Items to your scene, and control which items are active and which are inactive or in the background.

> 📖 **Tip:** You can determine how the background mesh will be shaded by pressing the O key to bring up a Popover which will allow you to change numerous viewport options, including how Inactive Meshes are shaded.

You can setup simple parent–child relationships by simply dragging and dropping one Item onto another, as shown in Figure 2.24. By doing this, the child mesh item will inherent the position, rotation, and scale values from the parent layer.

You can also control an Item's visibility by clicking on the eye icon to the left. It's fairly simple and works much like Maya's Outliner.

Groups

The Groups panel, which is new in 401, allows you to organize multiple Items and Channels. You can setup a custom group to house any number of Meshes or Items, as well as Channels that you would like to have grouped together for animation purposes. For example, if you were animating a complex scene with numerous items, you could create specific groups for these items that hold only the channels that will be keyframed.

> **New to 401**
> 📖 The Groups panel will help you to organize your scene by breaking it down into Items and Channels.

To add channels to a group, just open the Graph Editor for the Item and drag channels to the Channels category. By setting up this group of channels, you streamline the process of setting keys on specific channels and increase productivity. The Groups panel will also allow you to globally set visibility, wireframe color, and solid color, as well as render state by clicking the icons to

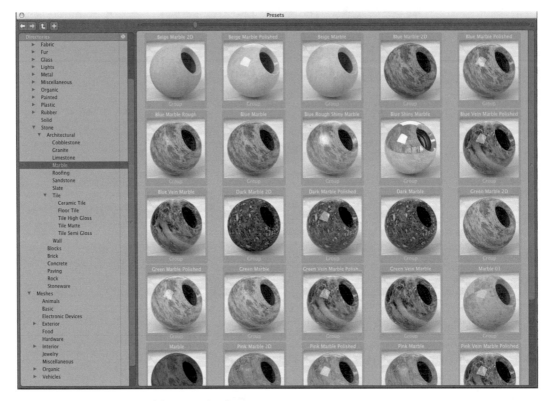

FIG 2.25 The Preset Browser is a library of objects, materials, and environments.

the left of the group. Being able to quickly and globally change display settings such as wireframe color can help organize a complex scene.

Preset Browser

The Preset Browser is a new feature in modo 401, and is probably one of the most exciting new features. Basically, it's a library of objects, materials, and environments, as shown in Figure 2.25.

> **New to 401**
> 📖 The Preset Browser is a powerful way to manage your assets in modo 401.

You can simply drag and drop objects into the scene or material onto objects. The advantage is that you can create your own presets of scene objects, which will readily speed up the process of building a scene. For example, in my job I work a lot with different airplane fleets. I have been adding my fleet models to the Preset Browser; so that when I'm in a pinch, I can quickly add an aircraft to

FIG 2.26 You can create your own presets in the new Preset Browser. *Source*: Wes McDermott.

the scene, as shown in Figure 2.26. Productivity is a big deal in the corporate world. In my current job, I am always looking for ways to streamline processes and workflows.

Modeling and Animation Toolsets

This section is a quick overview of the modeling and animation tools within modo 401. It's mainly for the artist coming from another 3D package who's trying to familiarize themselves with the modo toolset. If you're not new to modo, you may want to skim through this section to see some of the new features 401 have to offer.

Animation Tools

New to 401
Modo 401 has a host of new animation tools, such as Constraints, Channel Links, and Single Joint Planar IK.

With each release, modo is becoming more of a full-featured 3D application. Version 301 introduced animation capabilities to modo, and 401 expands on

these tools tremendously. These tools will be discussed in greater depth in Chapter 6, Animation.

Constraints

There are several types of constraints that you can apply to items such as Position, Direction, and Path, as shown in Figure 2.27.

Channel Links

Using the Channel Links that is similar to Maya's Set Driven Key, you can establish various types of relationships between Items and their Channels, as shown in Figure 2.28.

IK

You can also set up Single Joint Planar IK rigs in modo with Items and Locators. The IK tools in modo are excellent for creating rigs for mechanical objects and characters, as shown in Figure 2.29.

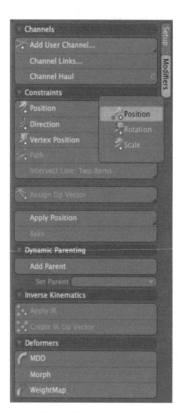

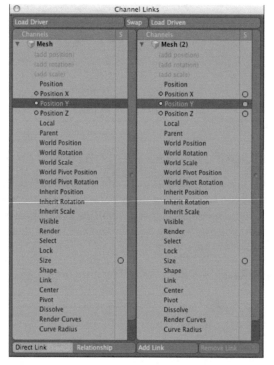

FIG 2.27 The introduction of constraints greatly expands upon modo's animation capabilities.

FIG 2.28 The Channel Link is similar to Maya's Set Driven Key, and allows you to set up relationships between different Items and their Channels.

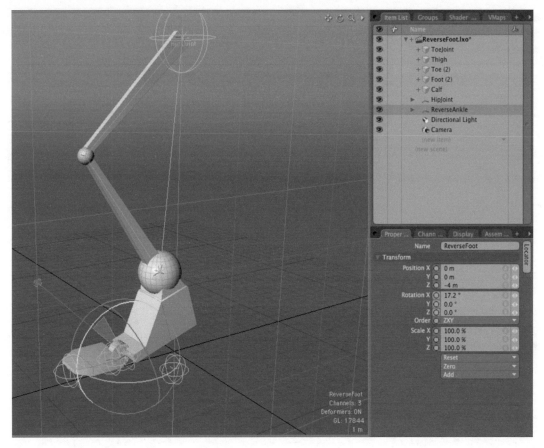

FIG 2.29 You can set up complex rigs for mechanical objects and characters in 401.

Channels

Any channel can be keyframed in modo. Channels that can be keyframed will have a small gray circle next to them; and to set a key, you just need to click the circle. A channel that has keyframes sets at the point in time where the Timeline's play head is sitting; The circle will be red, as shown in Figure 2.30; otherwise, the circle will be green to indicate that this channel is animated.

Morph Maps

Blendshapes are handled uniquely in modo and, in my opinion, much better than 3Ds max and Maya. In modo, Blendshapes are called morphs, and are stored as a vertex map.

You do not have to create a duplicate copy of the mesh and then create a Blendshape Deformer, as in Maya. Using the new User Channels is a great way to associate the morph maps of an item to a user interface with sliders, which

FIG 2.30 Most channels can be keyframed. Keyframed channels are denoted by a red circle.

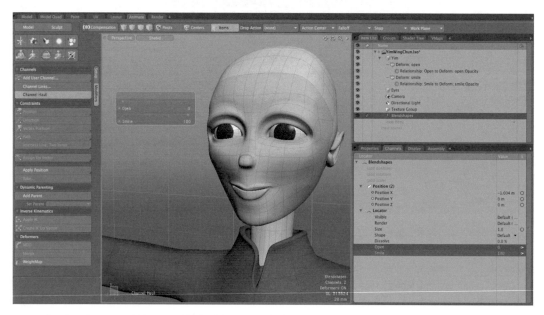

FIG 2.31 User Channels are very useful for setting up keyframes for facial animation.

in turn streamlines the facial animation process in modo 401, as shown in Figure 2.31.

Assemblies

New in version 401 is the ability to create an Assembly. An Assembly can be a predefined rig or hierarchy of components with animation capabilities that, when dropped into a scene, can aid in quickly setting up animation. Chapter 6 discusses how to use an Assembly Command to optimize the use of Channel Haul with User Channels.

New to 401

📖 Assemblies allow you to create a predefined hierarchy of predefined components to help you quickly set up animation controls.

Modeling Tools

We've already discussed some major aspects of the modo modeling workflow, such as Action Centers and the Tool Pipe. The modeling methodology in modo is different from that in other 3D packages that I've used. Modo is a polygon modeler and supports subdivision surfaces, which can be activated by simply pressing the Tab key.

It supports the subdivision of 3-, 4- and >4-sided polygons, and allows you to edit polygons, vertices, and edges. It doesn't support NURBS surfaces (Non Uniform Rational Basis Spline). One of the major differences between modo and other 3D applications is that modo doesn't have construction history.

The lack of construction history in modo doesn't bother me. In fact, I find it a nuisance in Maya to always have to delete history.

Replicators

New to 401

📖 Replicators allow you to render billions of polygons at render time.

Another new feature in 401 is Replicators. They allow you to render billions of polygons by creating duplicates of geometry at render time. Replicators use two items, a Point Source and a Prototype. The Prototype is the geometry being replicated. Although there are controls on the Properties panel for randomizing the Prototype, you can get even more control using a Surface Generator to further randomize the Prototype. In Figure 2.32 you can see Replicators in action.

Hair and Fur

New to 401

📖 Hair and Fur rendering is a major addition to the modo toolset. Specific Sculpting and Hair Guide tools have been added to aid in the grooming of hair.

Also new in 401 is the Hair and Fur Tools, as shown in Figure 2.33.

You can use the fur material to generate anything, from hair to grass or carpet and animal fur. You can even create nose hair like in Figure 2.34. Yuck!

You can create curves in modo to be hair guides, which can then be sculpted with the sculpting tools. In my opinion, modo's greatest strength is in the speed at which the toolset allows you to create.

FIG 2.32 Replicators allow you to render billions of polygons by creating duplicates of geometry at render time.

FIG 2.33 The Hair Tool can be found on the Painting Tab under Hair Tools.

FIG 2.34 The fur material can be used to create even something as disgusting as nose hair!

New to 401
📖 The new fur material will take its coloring from the material an object is applied to—which means you can use any texture layer to vary the fur's color, density, or combing, to name a few. These texture layers can be image maps, gradients, or even procedural textures. For fun, try using a color image to color the fur material.

Painting and Sculpting Toolsets

The painting and sculpting toolset in modo is very robust. In this section, I'd like to give a brief overview of their functionality, as these tools will be covered in-depth in later chapters. Depending on your workflow or current pipeline, you may need to rely on another application for your painting and sculpting requirements. However, it can be a real time-saver when all of the work can stay in one application. By offering both painting and sculpting features integrated throughout the application, modo can help to speed up the creation process by not having to switch applications.

Painting Tools

In modo, you can quickly activate the Paint Viewport by clicking the Paint tab at the top of the interface. The Paint Tools are made up of several brush types

FIG 2.35 By adding a Color Texture, you can begin painting on your object.

similar to what you'd find in Photoshop such as Airbrush, Paintbrush, and Clone. To begin painting on your object, you'll need to create a texture to paint on by going to the Utilities tab and selecting Add Color Texture, as shown in Figure 2.35.

Once you choose a location to save the file, a requester will ask you to pick the size of the texture. You'll want to select the appropriate size based on your project needs, although you can always resize the texture in Photoshop. The texture will be added to the Shader Tree and the Effect will be set to Diffuse Color for painting a color map on your object.

By right-clicking the effect, you'll get a pop-up that will allow you to select from a number of different effect options such as Bump, Reflection Amount, or even Fur Density. If you have the painting viewport set to Advanced OpenGL, you will be able to see effects such as Bump or Specular Amount; they are modulated by the texture map you are painting in real time, as shown in Figure 2.36.

This presents an incredible workflow for texturing your objects, as you can visualize the effects of your maps in real time. The brushes in the Paint Tools can be edited by applying a soft or a hard edge, or by adding a nozzle that will allow you to use a tablet for pressure sensitivity. You can enable things such as Jitter and brush shape presets, and you can even add noise to the brush to break up how the paint is applied to your map.

I've saved the coolest feature for last, Image Ink. Image Ink will allow you to paint images on your objects, as shown in Figure 2.37.

FIG 2.36 Effects such as Bump can be viewed in real time while you paint in modo.

FIG 2.37 Image Ink allows you to use images to paint on your objects.

For instance, if you are creating a wall, you can use a concrete image with Image Ink to paint a concrete texture on your object. However, you can use the brush nozzle to apply noise, or vary the opacity for creating layered effects. For instance, you can use several different concrete images and blend between them by varying how the images are painted on the object. You can get some extremely detailed maps with Image Ink.

Another example would be that you could use a grayscale or color image to paint bump details by setting the image Effect to Bump in the Shader Tree, and check the Use as Mask option in Image Ink. With Use as Mask, Image Ink will then treat the applied image on the brush as a mask, through which you can then paint your bump details. For bump maps, you'll need to set the foreground color to a shade of grey to modulate the bump effect; and since you're using an actual image, you'll be able to get a realistic and organic feel to the bump map, as shown in Figure 2.38.

FIG 2.38 Use of the Use as Mask option allows you to quickly use a grayscale or color image for bump detail, or even grime.

This not only works well with bump detail, but also with painting grime on your diffuse map. In earlier versions of modo, your objects had to have a UV map to paint on an object; but in 401, you don't need a UV map—you can just paint on your objects. It's best to paint with UVs—but if you get in a pinch, this will be a great time-saver.

Sculpting Tools

Sculpting in modo works much like Painting in that you use the same brush system, which includes the same nozzles and the usage of Image Ink. However, there are specific sets of sculpting tools, as shown in Figure 2.39.

Sculpting in modo works differently than in a dedicated sculpting package such as Autodesk's Mudbox or Pixologic's Zbrush, since you'll need to create a displacement map to sculpt on the mesh. This method of sculpting is called image-based sculpting. There is another mode called mesh-based sculpting, in which you can just sculpt on the mesh itself; but you are limited to the number of vertices on the mesh, and you'd need an extremely dense mesh for fine details. Image-based sculpting can actually take advantage of using either a grayscale displacement map or a vector displacement map. With the vector displacement map you get much more flexibility with the sculpting tools, since the sculpt is being driven by vector values instead of the height values of a grayscale displacement map, as shown in Figure 2.40.

FIG 2.39 The sculpting tools in modo allow you to quickly sculpt details in your objects.

FIG 2.40 A vector displacement map utilizes vector (x, y, z) data instead of the height data of a grayscale displacement map.

Personally, I use Mudbox as my main sculpting tool. I find that I like the sculpting workflow and toolset better in Mudbox. In Chapter 10, we'll discuss integrating modo with other packages such as Mudbox. Another one of modo's strengths is flexibility and how it can easily be integrated into a pipeline, where other tools are commonly used. With that said, having modo's sculpting functionality being so heavily integrated within its toolset makes it easier to quickly get details fast.

Using Sculpting Tools for modeling

📖 I will sometimes use the mesh-based sculpting tools while working on my models, such as to smooth out areas or quickly create organic surfaces. I'll sometimes use mesh-based sculpting to quickly rough out a shape and then go back and fine tune the model with the default tools. It's about using the tools at your disposal to quickly and effectively get the job done.

Vertex Maps

There are several types of vertex maps that you can use in modo, with the main ones being UV, weight and morph maps. At the top of the interface,

FIG 2.41 Switching the viewport display to Vertex Map allows you to visualize the vertex map as you edit it.

under the Vertex Map drop down, you can see the various tools and options for working with vertex maps. To visualize the vertex map, you'll need to change the view option in the viewport to Vertex Map as shown in Figure 2.41.

Earlier we discussed morphs and how they were created as a vertex map. In Figure 2.42, you can see an object that has several morphs or Blendshapes applied through the vertex map list. UV maps are probably the main type of vertex map you'll use in modo and we'll be discussing them in Chapter 4.

Weight Maps

A weight map is a specific type of vertex map. It holds a specific value for each vertex in the form of a percentage that ranges from positive to negative values. When viewing a vertex map in the viewport, positive values will display a shade of red and become more saturated as the values reach closer to 100 percent. Negative values work the same, but will display a shade of dark blue while becoming more saturated as the negative value becomes larger. You can use the Weight Map Tool to quickly add weighting to your selection.

Weight Maps can be used to control how a tool affects an object such as when the Transform tool is used in conjunction with the Vertex Map Falloff as shown in Figure 2.43.

FIG 2.42 Morphs are stored as a vertex map in modo.

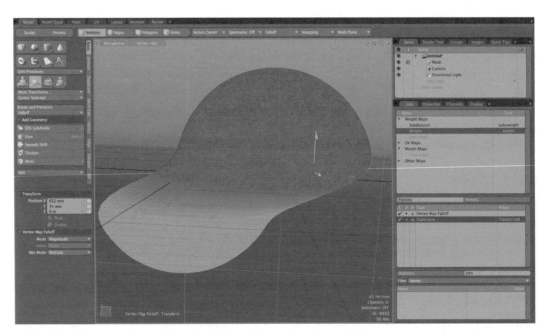

FIG 2.43 Weight maps can be used to control how a tool affects an object.

📖 **Tip:** Weight maps can be used to modulate how a material affects a surface. You can even use them to determine where hair will grow.

Rendering

The rendering engine in modo 401 is not only capable of creating incredibly high-quality imagery, but is also easy to use. I also use mental ray in Maya, and the setup time and technical knowledge one needs to posses to get quality renders from mental ray is astronomically higher when compared to modo.

Mental Ray Versus Modo Renderer

📖 In my opinion, setting up mental ray in Maya takes much more time and effort to get the same quality render using modo 401. In fact, I feel that the modo renderer is much better and faster than mental ray.

The modo renderer works in full floating point with support for HDRI and physically-based shading, while consistent with accurate lighting models such as Physical Sky and Sun along with photometric lighting with the IES standard, which stands for Illuminating Engineering Society as shown in Figure 2.44.

The render also utilizes micropoly tessellation for rendering extremely fine displacement map details, as shown in Figure 2.45.

You also have the ability to bake textures and lighting for use in games, and to bring maps into other packages. Finally, the Preview Renderer is an amazing time-saver while working out material settings. It's capable of rendering your

FIG 2.44 Physical Sky and Sun can be compared to mental ray's physical sky.

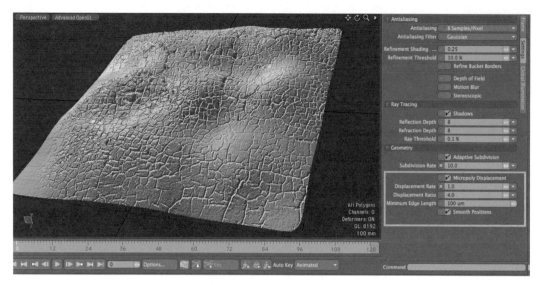

FIG 2.45 Micropoly tessellation results in extremely fine displacement map details.

scene in real time, so you're not left with any surprises when you're ready for the final render.

Scripting and Commands

In modo, you can create your own scripts using Python, Perl, or Lua programming languages. You can use the Command History panel to view the history of executed commands, view commands, view scripts, and the results of commands. The Command input field at the bottom of the interface allows you to enter the system commands.

If you're not much on scripting, you can use the Record Macro feature found under the System menu at the top of the interface. For example, let's say you are creating a series of windows on a building. You can record a macro of a complex bevel operation to create the window. Now to create the other windows, you just need to select a new polygon and replay the macro, and presto: instant window.

Modo for Maya Users

In this section, I'd like to explain modo from a Maya user's perspective. I'm not comparing the two applications, but only identifying similarities of the modo and Maya UI. In my day-to-day tasks, I use Maya as well as modo. I was using modo first; so when I brought Maya into my current pipeline, it was kind of a

shock to the system. Now that I'm familiar with both of the applications, I can see not only a lot of differences, but a lot of similarities as well.

Differences

The nodal system of Maya is the biggest difference between Maya and modo. As I mentioned earlier, modo doesn't use a node system. In modo, an object is an Item, just like an object in Maya is a Node. Although not technically a node, modo's Items seem very similar to this structure, as shown in Figure 2.46.

In modo, the Properties, Channels, and Display panels contain much of the same information that is contained on the Transform and Shape nodes of an object in Maya. One difference is that the modo Item doesn't have a Shading Group node where a material is applied; instead, the material can be found in the Shader Tree. However, using the Statistics panel, under the Polygons drop-down menu, you can see the materials associated with this object.

Another huge difference is that modo doesn't have a construction history. When you draw a primitive in modo, you can adjust properties such as width, height, and segments; but once the object is created, you no longer have access to those creation properties.

FIG 2.46 Here you can see that the transform properties on the shape node of an object in Maya are the same as under the Properties panel in modo.

Commonalities

Now let's look at some commonly used panels in Maya, and what their counterparts in modo are. The Item List in modo is comparable to the Outliner in Maya, as shown in Figure 2.47.

Maya's Channel Box is similar to modo's Channels panel, as shown in Figure 2.48.

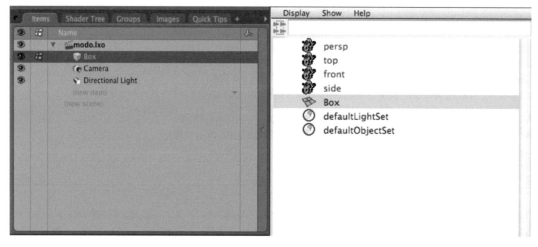

FIG 2.47 Maya's Outline is similar to modo's Item List.

FIG 2.48 Maya's Channel Box contains information similar to that found on the Channels panel in modo.

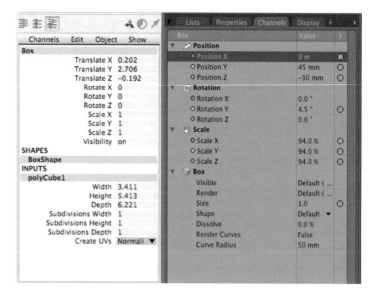

FIG 2.49 The Tools panel is like Maya's shelf.

The Shader Tree in modo is the Hypershade in Maya. Just as you can enter MEL (Maya Embedded Language) commands in the input field at the bottom of the interface in Maya, you can use the Command input field in modo to run system commands as well. There is no Script Editor in modo, as there is in Maya. However, you use the Command History panel to view command history. Maya's shelf system can be thought of as the Tools panel in modo, as shown in **Figure 2.49**.

In modo, you can use the Form Editor to add your own tools and scripts to the Tools panel, as you would add scripts and tools to Maya Shelf. As mentioned earlier, modo has user-configurable popover menus that give the same functionality as Marking Menus in Maya. The more I've gotten to know Maya, the more similarities in the overall structure I find between the two applications.

The Modo Community

As your final step to becoming a full-fledged modonaut, you'll need to go to Luxology.com and register in the Forums. I encourage you to check the community forums on Lux's site often. The modo community is a fantastic group of talented artists who are more than willing to lend a hand. There is also a modo forum up on CGTalk, which can be tremendously helpful.

You'll also find on the Luxology site some beneficial modo resources such as Luxology.TV, which is a huge library of tutorial videos; and you'll definitely want to chime in each week for the modcast, which you can subscribe to through the site or iTunes. You will also find the Luxology Asset Sharing site, where modo community members can download and upload assets such as materials, meshes, assemblies, and textures. The Asset Sharing site has contents that can be rated, so you'll know the quality of the assets before downloading. Another couple of great modo community resources are VertexMonkey.com and modonize.com. These sites host tutorials, articles, and modo scripts that you can download to further extend its capabilities. The best thing you can do to further your knowledge is to participate in the community.

Visit the forums often and not only ask questions, but take time to answer other people's questions as well.

Summary

I hope that if you're coming from another 3D application, you've happened to have a few light bulbs light up; or even if you're familiar with modo, you found some of the 401 features interesting. In this chapter, I outlined the basic workflow and toolset within modo. We also discussed some of the animation tools that are present in modo 401, such as IK and Constraints. Finally, we discussed some key differences and commonalities between Maya and modo.

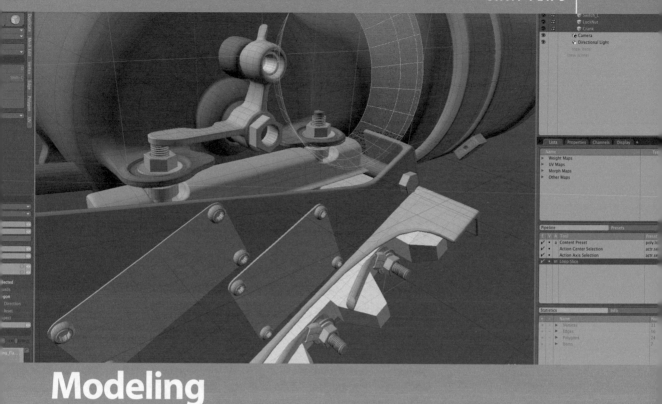

Modeling

odeling is an essential part of the 3D process. You will always need to create geometry for your 3D projects. Even if you are reusing or purchasing a model, chances are that you'll need to make some changes to the mesh to adapt it to your scene. I enjoy the modeling process. Although it can be tedious at times, I enjoy putting on some headphones and working through the process of creating a model; however, that wasn't always the case. When I first started with 3D, I had a tough time grasping the modeling process. I couldn't understand how to create objects. Through patience and lots of practice, I began to better understand the workflow.

In this chapter, I want to share with you the areas of the modeling process that became important for me in my understanding of creating 3D objects. This chapter doesn't contain any step-by-step tutorial on how to model this or how to model that. Years ago, I found a tutorial for modeling characters. It was a good tutorial and by following it meticulously, I was able to create a character. Although, I didn't fully understand the process, I was still able to follow the steps. However, I soon found that I became "locked" to this tutorial. I couldn't create a character on my own. I had to always follow these

steps. I learned to push the buttons, but I didn't understand the reasons why. Almost every instructional 3D book that I've picked up in my career, and I've picked up a lot, has always explained modeling with step-by-step tutorials. Don't get me wrong, tutorials are a great way of learning, and I seek out new tutorials every day to further expand my knowledge of 3D, but for this book I want to do something different. I want to talk about the methodology of modeling instead of the step-by-step process. I don't want to teach you how to model a specific object. Instead, I want to share the aspects of modeling that I've learned that helped me to fully understand the process. The key is that once you understand the process, you can model anything in your own unique way. Let's begin by looking at different modeling methods.

Modeling Methods

In this section, we're going to look at different methods for creating geometry. Each of these methods is polygonal based. Some 3D applications use a mixture of creation methods such as NURBS. NURBS stands for non-uniform rational B-spline and uses curves instead of polygons to create surfaces. NURBS can be used to create smooth organic surfaces; however, the industry has moved to using subdivision modeling with polygons as the preferred method for creating organic models such as characters. Modo is a polygonal modeler that supports subdivision surfaces, and we will begin by taking a look at subdivision modeling.

Subdivision Modeling

Subdivision modeling is the process of taking a base polygon object and adding divisions until the object is smooth, as shown in Figure 3.1. This figure shows the progression of the SDS Subdivide tool as it applies a refinement scheme to the mesh, which then subdivides it while creating new vertices and new faces.

The benefit to working with subdivisions is that you can work with a base object that is low in polygon count or in resolution, and add detail through subdividing the mesh as needed. This makes it easier to manipulate the object. In Figure 3.2 you can see a hand model before it is subdivided.

By simply hitting the Tab key, the object will be subdivided and the number of subdivisions is controlled on the Properties for the mesh as shown in Figure 3.3.

As you can see from the image, the poly count has risen dramatically from 1,508 to 96,576, but the object is nice and smooth.

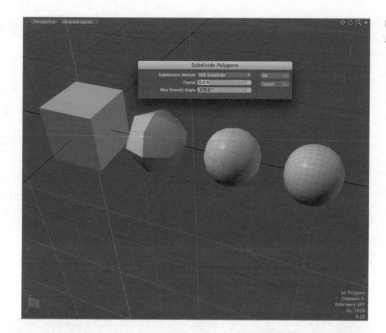

FIG 3.1 A box was subdivided to create a smooth surface.

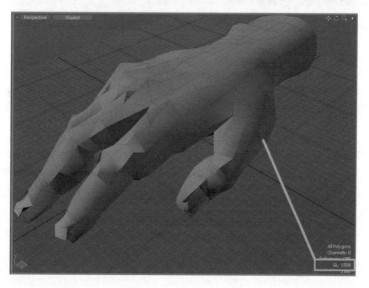

FIG 3.2 This hand model contains 1,508 polygons before subdivision.

The key to subdivision modeling is to start with a simple base object and then add detail as it is needed. You can move from a polygon to a subdivision surface by pressing the Tab key, which allows you to manage the poly count while working with a base mesh that is manageable. Now, let's look at the two methods that I use when creating models in modo.

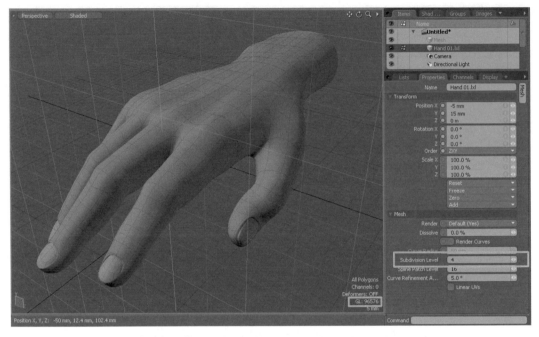

FIG 3.3 In this image, you can see that the mesh is subdivided at a level of 4, which equates to 96,576 polys in the GL viewport.

Box Method

With subdivision modeling, you start with a base object and increase the subdivision level as detail is added. With the box method, you start with a simple box mesh, add detail, and translate the polygons of the box to "bring out" the shape of the object you are trying to create. The point is that you start with a simple shape with and make it more complex as you refine the base object. Now, the base shape doesn't have to be a box. It can actually be any shape. Think about objects in real life and how these objects can be broken down into a simple form. For instance, just looking around the room I see a TV, which is rectangular in shape. I also see a water bottle that is cylindrical in shape. Breaking down an object that you want to create into its simplest form makes it much easier to visualize how to create the object in modo. Every object has a basic geometric form, or is made up of several geometric forms. For example, in Figure 3.4 you can see a character-head model that was created from a box. The box was subdivided to create more details and as I worked to "mold" the box into the shape of a head, I continued to add subdivisions when needed. The advantage about using the box method is that there isn't a specific formula to follow. You are starting with a shape and refining this shape to create the model. It's completely based off your own interpretation of the shapes you're trying to model. There isn't a right or wrong way of doing it, and the entire process is a matter of subdividing and refining.

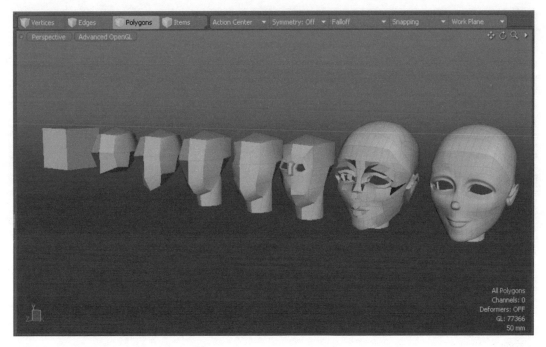

FIG 3.4 The box method was used to create the cartoon-head model.

📖 The box modeling method is a process of starting with a base shape, detailing the shape by adding subdivisions, refining the shape by manipulating the vertices on the mesh, and then repeating the process of subdividing and refining.

Point Method

With the point method, you are not starting with a base shape. This method has you building a mesh vertex-by-vertex, in which you're not trying to build up detail as with the box method, but instead adding the detail as you build the mesh outwardly. I find that this method aids me in developing precise geometry such as when modeling from an image reference. In Figure 3.5, you can see how the eye area of a mesh is being constructed with the point method. Notice that the detail is being constructed outwardly as more polygons are added to the mesh and that the polygons are aligned with the background reference image.

We'll talk more about adding detail to the mesh in a later section. For now, we'll look at using the Pen tool for creating vertices. The Pen tool has several useful options, but we'll look at creating geometry with the Type set to Polygon and Make Quads active.

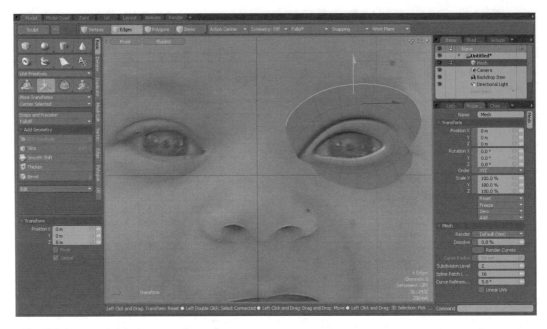

FIG 3.5 With the point method, detail is constructed outwardly.

The principle to the point method is to create geometry point-by-point. Since you are working detail outwardly, it's easy to add more geometry than is needed, which would create a very dense mesh. Having too many polygons can be difficult to manage in the modeling process as well as when it comes time to create a UV map for texturing. You can always go back and remove edges, but it is best to be aware of how much detail you are creating.

I said that the point method is commonly used with a background image, so once I have the reference image setup up, which will be covered later, I then use the Pen tool to draw out vertices. With the Make Quads option active, the tool will make a polygon for every fourth vertex that is created. Quad polygons will be further discussed in the Topology section, but for now understand that a quad polygon is a poly that is made up of four vertices. In Figure 3.6, you can see how I've used the Pen tool with Make Quads activated to create the geometry around the eye of the backdrop image.

When creating geometry, you'll want to try and create only enough geometry to create the shape because, as I said earlier, it's very easy to create the mesh too dense. For example, in Figure 3.7 you can see that the eye on the left has more polygons than is needed to create the eye.

> 📖 The key to the point method is to only add enough geometry to create the shape you're after. The goal should be to define the shape with as few polygons as possible.

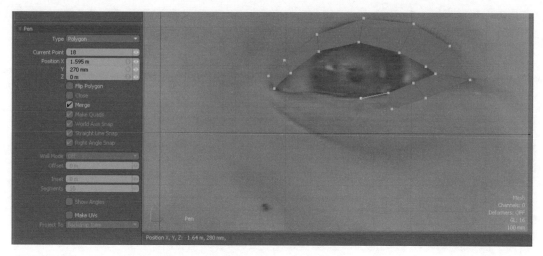

FIG 3.6 I use the Pen tool to create geometry when using the point method.

FIG 3.7 The eye on the left has too many polygons and will become harder to manage as more resolution is added.

In this section, we've looked at two methods to producing a model. Next we'll discuss a different approach to creating models using curves.

Patch Modeling

Patch modeling is the process of using curves to define a cage and then creating a surface by patching the curves with the Patch tool found on the Curves Palette. Once you've patched the curves, you will then have a Surface that is still editable with the Patch tool. Sometimes it can be hard to define a shape using the box or point method, and this is where the Patch method comes in handy.

Building the Cage

To begin, you'll need to define a cage made of curves. To do that, I use the Curve tool that can be found in the Curve Palette as shown in Figure 3.8.

From there, I'll duplicate the curve to begin to build a cage as shown in Figure 3.9.

FIG 3.8 The first step is to create a curve.

FIG 3.9 The curve is duplicated to start the building of a cage.

The cage of curves will need to be closed into a grid of four intersecting curves as shown in Figure 3.10. This is because to create a valid Patch, you'll need to select either three or four curves.

To close the curves, I select two vertices and use the Make Closed Curves command found on the Curves Palette.

Defining the Patch

Once all the curves have been closed into four intersecting curves, you can now patch the curves using the Patch tool. Once activated, the tool will display a blue square for each curve. To patch the surface, you'll just need to select the curves in a clockwise or counter-clockwise order as shown in Figure 3.11. If you select the curves in the wrong order, the surface will be flipped; however, this isn't much of an issue since you can flip the surface in the Patch tool. Once the curves are patched, you will have a surface that can be edited using the Patch tool.

After I've created the shape I wanted using a Spline Patch, I'll convert the patch to a polygon through the Patch tool. You'll just need to select Freeze and then adjust the Perpendicular and Parallel input fields to determine how the perpendicular and parallel cross sections will be divided. By inputting a value of 1, you will be creating one polygon for each cross section.

Finally, you can use the Extend mode of the Patch tool to extend the patch, creating additional geometry as shown in Figure 3.12.

FIG 3.10 The curves are then closed into four intersecting splines.

FIG 3.11 Select splines clockwise to create a Spline Patch.

FIG 3.12 The Patch tool can also be used to extend the patch and to create more resolutions.

In this section, I've discussed three methods for creating geometry. These are the three methods that I use in my everyday modeling tasks. Each one has its own advantages. The box method is good for starting with a basic shape that's close to the object you want to model, while the point method is good for matching the background reference. Patching is an excellent method for creating irregular shapes. Building a cage of curves helps me to visualize the object in 3D. I have found that the secret to modeling is to break down the item that you want to create into its simplest form. By doing this, it will be easier to determine a method to use when modeling the object.

Modeling Reference

It's always a good idea to have lots of image references of the object you are trying to model. If the model is small, such as a computer mouse, it's very beneficial to have the object sitting at your desk while you're creating the model. Studying the object as it exists in reality will help in translating the object to 3D space in modo.

Backdrop Item

Usually, you'll want to use an image template to guide you in the modeling process. In modo, you can use a Backdrop item to import an image into the viewport. If you need to create an object to scale, then you'll need to understand how to properly set the pixel size for the Backdrop item in the modo Preferences under the OpenGL category. The pixel size setting determines how much space a pixel will represent in the 3D viewport. To better understand how the pixel size is determined, let's look at an example. For this discussion, I took a photo of a tape measure and cropped it in Photoshop to a size of 596 pixels wide. In modo, I created a Backdrop item and set it to use the ruler image as shown in Figure 3.13.

To set the pixel size, I set the Unit System to English and the Default Unit to Feet in the Accuracy and Units preference. Next, I took the number 12, as 12 inches is a foot since I'm working in the English measurement system, and divided it by the ruler image's width of 596 pixels (12/596 = 0.0201). The result of this is 0.0201, which is the value I need to place in the pixel size input field.

Now, if I draw out a box in modo to match the backdrop item reference image, the box will be one foot or approximately 11.993 inches as shown in Figure 3.14.

By appropriately setting the pixel size for the backdrop item, I've set my scene to match the real-world size in which I wanted to model my ruler.

FIG 3.13 This image shows a backdrop item in modo.

FIG 3.14 Setting the pixel size determines how much space a pixel will occupy in 3D space.

Making Selections

In this section, I'd like to discuss the methods I commonly use to make selections. Being able to quickly select mesh components will help you speed up your modeling tasks.

Loop Selections

To make a loop selection, you need to select a polygon and simply press the L key as shown in Figure 3.15. By selecting a second polygon, you're telling the modo the direction in which the loop should flow. You can make loop selections with vertices as well as with edges; however, with edges you only need to double-click a single edge to select an edge loop as shown in Figure 3.16.

Using the Arrow Keys

Using the Arrow keys, you can further manipulate your selections. For instance, if you select two faces and repeatedly press the Up arrow key you will be able to select the next polygon in the loop in a consecutive manner. Pressing the Down arrow key will deselect the polygon in the same manner. Using the Left and Right arrow keys will allow you to perform what is called a "pick walk", which is selecting the next consecutive loop with each stroke of the left or right arrow key. If you hold the Shift key and press the Up and Down arrows keys you will be able to expand and contract your selections. There are several instances where using the Arrow keys to select the loops will help you to quickly make selections. It's something that you'll find yourself using all the

FIG 3.15 You can select a component and press the L key to make loop selections.

FIG 3.16 Double-clicking a single edge will select an edge loop.

FIG 3.17 This example shows that using the Up arrow key I was able to add polygons to my selection consecutively as they are in the edge loop.

time. For example, Figure 3.17 shows a portion of polygons selected on the ear. Instead of using the L key to select the entire loop, which isn't what I want, I select two polygons and by pressing the Up arrow key, I was able to quickly add to the selection of polygons in the loop.

📖 **Tip:** You can also use the Up arrow key to select every other component. By selecting a polygon, edge, or a vertex and then skipping over to the next component in the loop, you will then be able to use the Up arrow to select every other component in the loop. You can actually select every third or fourth polygon, as modo is smart enough to recognize the pattern.

Select Connected

I constantly use the Select Connected command. Instead of doing a lasso select around a group of polygons, I will simply select a polygon and press the Right-Bracket key. This will select all of the polygons that are connected to the first polygon you selected. This is very handy for trying to select an entire mesh made from multiple groups of mesh items. For example, imagine a character model that has several different mesh items such as a head mesh, shirt mesh, and jacket mesh. If I lasso select all of these meshes, there is a chance that I will miss some of the polygons that make up this model as shown in Figure 3.18. To ensure that I don't leave out any polygons, I will press the Right-Bracket key to make sure that I have selected every polygon.

FIG 3.18 I will press the Right-Bracket key after every lasso selection just to make sure I've selected every polygon in the mesh.

Selection Sets

Sometimes you can find yourself having to make a complex selection. In cases like this, it would be a good idea to save this selection. To create a set, select a group of polygons and choose Selection Sets from the Select menu at the top of the modo user interface (UI). From there, a dialog box will appear that will allow you to name, rename, remove, or add to a selection set.

Using the Statistics Panel, as discussed in the previous chapter, you can recall these selections again by choosing to filter the selections based on Polygon/Selection Sets in the Statistics Panel as shown in Figure 3.19.

Selections Sets can also be used for much more than just saving selections. You can also use them in the Shader Tree for masking materials. This will be discussed in Chapter 5 on Texturing.

Detailing the Mesh

My workflow for modeling is to subdivide to add detail and then manipulate the vertices to further refine the form. In this section, I'll be discussing the methods for adding subdivisions or resolution to the mesh. These tools are used for creating the shape of the mesh. Later, we'll discuss how to make sure

FIG 3.19 The Statistics Panel can be used by the Selection Sets to filter selections.

that the topology of the mesh is optimized. Let's begin by looking at adding detail.

Adding Detail

Adding detail to a mesh is the process of subdividing the mesh to increase the number of polygons you have to work with. By increasing the number of polygons, you are increasing the resolution of the mesh. As I said earlier, you should only add detail to the mesh when it's needed. The fewer polygons you can use to define a shape, the easier the model will be to manage. In this section, I want to discuss the main commands I used for adding detail.

Subdivide

The SDS Subdivide tool can be activated by pressing Shift+D on the keyboard. This will bring up a dialog box that will give you options for adding divisions to the mesh. I use this tool mainly with the Faceted option to quickly increase the detail in the mesh without changing its shape as shown in Figure 3.20.

If I were to use the SDS Subdivide option, the tool will apply a Smoothing Angle to the mesh, which causes the mesh to not only get subdivided, but smoothed as well as shown in Figure 3.21.

FIG 3.20 The Faceted option will add subdivisions to your mesh without changing its shape.

FIG 3.21 Using the SDS Subdivide option will 'round out' the mesh, as it is subdivided based off the smoothing angle chosen.

Extending to Add Detail

This section's focus is to add detail to the mesh by extending polygons or edges. The tools discussed below can be activated using a context menu. The menu will adapt to the component that the mouse is currently over, for example, edge, vertex, or polygon, and can be activated by right-clicking on a component. I use these context menus exclusively while modeling to speed up my workflow. Here, we will discuss the Extrude, Bevel, and Bridge tools.

Extrude

I use the extrude tool to "pull out" geometry from the mesh as shown in Figure 3.22. By Shift+left-clicking the selected polygons or edges, I can continue to extrude the geometry without dropping the tool. By middle-clicking the polygons, modo will then extrude the polygons again based off the last extrusion as shown in Figure 3.23.

When using the Extrude tool on edges, you will have the ability to not only extend the edge, but also to scale the base edge, which in turn bevels the edge as shown in Figure 3.24.

Bevel

The Bevel tool works the same as the Extrude tool. The difference is that with the Bevel tool you also have the ability to scale the beveled polygons or edges as shown in Figure 3.25. As you can see in Figure 3.25, the edges are only beveled. They are not extruded as with the polygons.

The Bevel tool is an option to Group Polygons. If this option is not active, then the bevel will take place on the individual polygons selected, as shown in Figure 3.26.

FIG 3.22 I use the Extrude tool to extend detail from the mesh.

FIG 3.23 Middle-clicking the extruded polygons with the Extrude tool active will extend the polygons by the amount of the last extrusion.

FIG 3.24 When extruding an edge, you have the ability to extend and bevel the edge.

FIG 3.25 The Bevel tool works the same as the Extrude tool with the added benefit of being able to scale the polygons.

FIG 3.26 By disabling Group Polygons, the bevel will occur on each face selected instead of as a group.

> **New to 401**
> 📖 In 401, you can use profiles with various tools such as the Bevel tool. Using a Profile with the Bevel tool is like using a template of a predefined set of bevels. They allow you to quickly create an ornate bevel as shown in Figure 3.27.

Bridge

The Bridge tool is used to connect the polygons. To use the tool, select two polygons and right-click and choose Bridge from the context menu to activate the tool.

From the Bridge tool properties, you can select how many divisions will be added to the connected polygons and how the connection will be interpolated. For instance, you can add some twisting to the connected polygons as shown in Figure 3.28.

Dividing to Add Detail

The focus in this section will be on how to further divide existing polygons and edges to increase the mesh's resolution. The three main tools I use for this are Loop Slice, Slice, and Edge Slice.

Loop Slice

Loop Slice takes a polygon loop selection and adds a division to the middle of the selection as shown in Figure 3.29. You also have options such as adding more than one division by increasing the Count in the Loop Slice tool options

FIG 3.27 Using Profiles with the Bevel tool allows you to quickly create a detailed bevel.

as well as by controlling the offset for each division by adjusting the sliders as also shown in Figure 3.29.

Slice tool

The Slice tool allows you to drag out an area to be sliced. I will set the viewport to an orthogonal view such as right or left before using the tool to make it easier to drag out the slice.

Often, working with Subdivision surfaces in modo will result in the object being too rounded. There are times when I need to 'tighten up' to corners. So, I will commonly use either Loop Slice or the Slice tool to add an extra edge close to the area I want to tighten up, as shown in Figure 3.30.

Edge Slice

The Edge Slice tool will allow you to add an edge by clicking from edge to edge. I mostly use the Edge Slice tool for defining edge loops on a mesh. For example, in Figure 3.31, I used the tool to help me create the edge loop from the

FIG 3.28 Twist added to the connected polygons.

nose, running along the edge of the mouth to underneath the lower lip. We'll discuss this in more depth in the section on topology.

I find that with modeling, you don't have to know a large number of tools. As you can see, adding detail to the mesh can be done with a few simple tools.

Shaping the Mesh

Shaping and refining the form of the mesh goes hand in hand with adding detail. Once you've added a new detail to the model, you'll have to reposition the vertices to make sure that the overall shape you're trying to create is retained. For instance, earlier I talked about using the box method to create a cartoon head as shown in Figure 3.4. I began this process with a few subdivisions. I then transformed the vertices on the mesh to mimic the shape of a head. Each time I added detail to the mesh, I would then work through the vertices on the model to further refine the head shape. The main tool I use for this process is Soft Drag.

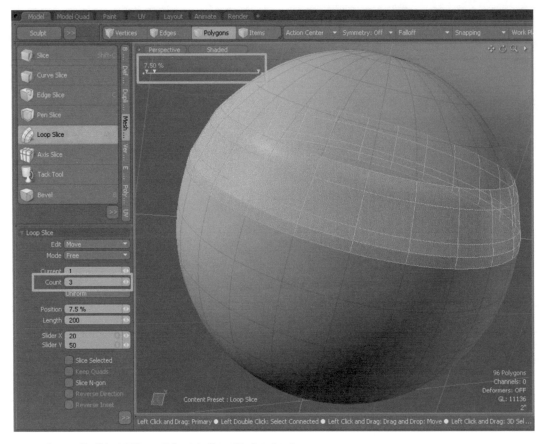

FIG 3.29 You can add additional divisions and adjust their offsets within the tools options.

Soft Drag

Soft Drag is simply the Transform tool with a Screen Falloff. It allows you to just left-click and drag a vertex. Using the right mouse button, you can adjust the size of the falloff, which affects how many vertices are transformed by the tool as shown in Figure 3.32. Manipulating vertices with the Soft Drag tool is very organic and it allows me to quickly refine a mesh into the shape I want to create. Also notice in Figure 3.32 that I have turned off the tools visibility in the Tool Pipe so that the tool handles don't get in the way as I am moving vertices.

Topology

When speaking of topology, I am referring to how the polygons that make up an object are arranged. In this section, we'll discuss the importance of the way the polygons are arranged in a mesh as well as the techniques to adjust the topology. To begin, let's first look at creating clean geometry.

FIG 3.30 Using the Loop Slice tool, I was able to tighten up the edge.

FIG 3.31 The Edge Slice tool is good for creating edge loops.

Creating a Clean Geometry

By creating a clean geometry, I am talking about creating polygons that will deform well and won't cause rendering artifacts. A mesh that is made of quad polygons, which are polygons made of four vertices, is the best type of polygon to use in your models. Now it's not terrible to use triangles, which are polygons made of three vertices or even N-gons, which are polygons made of more than four vertices. However, you have to know when it's acceptable to use them. The issue with using triangles or N-gons, is that they don't deform

FIG 3.32 Using the Soft Drag tool is a quick and an intuitive way to refine the shape of an object.

well and can cause rendering artifacts in the areas of a mesh that are deformed. For example, an area on a character such as the elbow will receive a lot of deformation when the character's arms are animated as shown in Figure 3.33.

If you need to use triangles or N-gons, and sometimes it can be unavoidable, it's best to try and use them in areas that are not easily visible such as in the ear in a head model as shown in Figure 3.34.

Polygon Flow

Polygon Flow is the direction in which the polygons are arranged on the mesh. You'll want the polygons in your mesh to flow in the direction in which they'll be deformed. For example, with a head model that is going to have a morph for opening and closing the mouth, you'll want the polygons to flow along the jaw area of the mesh as shown in Figure 3.35.

In Figure 3.36, you can see another example of how using the correct polygon flow can help with deformations. In the figure, you can see the selected polygons moving around the chest, up through the shoulder. In Figure 3.37, you can see how the polygons deform well when animated in Maya.

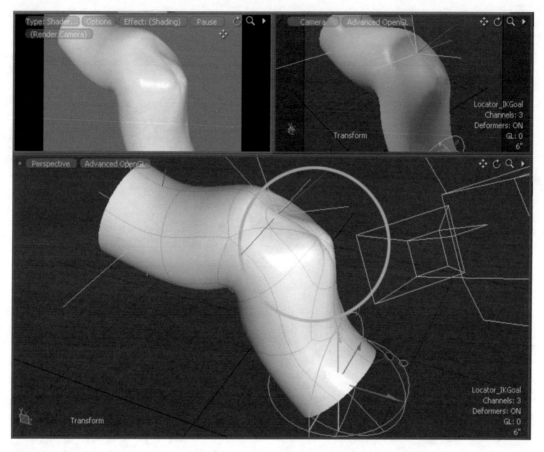

FIG 3.33 Triangles are not good to have in areas that are being deformed, such as joints on a character.

Not only is it good to pay attention to polygon flow for animation, but when sculpting polygons as well.

Spin Quads

To get the polygons to flow in the correct direction, I will use the Spin command by selecting two polygons and pressing the v key. My workflow is to work at building up the shape of the model and then adjust the flow of the polygons using the Spin command. In Figure 3.38, you can see two selections. The top-selected polygons have been adjusted using the Spin command to create a better flow, and the bottom selection shows the polygons that I have selected to spin.

Not only can you use the Spin command to change the direction in which polygons flow, but you can also use it to reduce polygons. Anytime you see polygons arranged in such a way that the edges form a Y, you can spin the

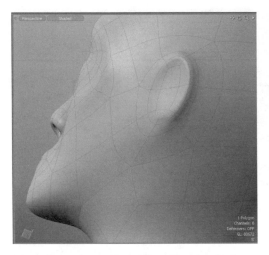

FIG 3.34 If you need to use a triangle or N-gon, try and place them in areas that are easily visible or won't deform.

FIG 3.35 The selected polygons flow in the direction of the jawbone.

FIG 3.36 The selected polygons flow in the direction of the shoulder.

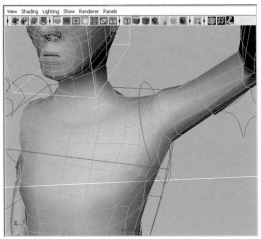

FIG 3.37 The polygons are flowing in the direction in which they will be deformed, causing them to deform well.

polygons and then merge the two polygons that are turned into each other. This will eliminate one of the polygons as shown in Figure 3.39.

To further illustrate the point of using the Spin command to improve polygon flow, let's look at an example. In Figure 3.40, you can see a red curve that

FIG 3.38 By using the Spin command, I was able to change the direction in which the polygons flow.

FIG 3.39 You can use the Spin command to reduce polygons.

illustrates the direction I want the polygons to flow, and I've circled the selected polygons that flow in the wrong direction. To create the proper flow, I used Spin on the selected polygons until their edges were oriented in the correct direction as shown in **Figure** 3.41.

In **Figures** 3.42 and 3.43, you can see how using these same techniques, I was able to redistribute the flow of the polygons and create a better topology for the face.

Edge Loops

Edge loops are defined by the flow of polygons. In **Figure** 3.44, you can see the edge loops selected on the model. Notice that because of the polygon flow, the edge loops define the chest and the abdomen area. There are also

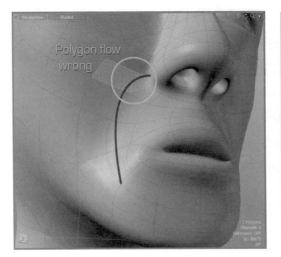

FIG 3.40 The red curve illustrates the direction in which I'd like the polygons to flow.

FIG 3.41 Using Spin on the selected polygons allowed me to change the polygon flow.

FIG 3.42 Polygons were selected and merged to fix the topology.

FIG 3.43 In this image, I've selected the polygons that show the new topology that was created.

FIG 3.44 There need to be adequate edge loops to support the areas where the model will be deformed.

FIG 3.45 The edge loops selected indicate the flow of polygons.

adequate edges around the areas where the legs attach to the hips. This will lead to good deformations in the model.

The main point to producing a mesh with good topology is that you'll want the topology to lend itself to the shape you are creating. For instance, when modeling an arm, you not only want there to be sufficient edge loops for deformations, but you'll also want the polygon flow to run in the direction of the underlying muscles as shown in **Figure 3.45**.

Replicators

In the earlier chapter, I briefly discussed using Replicators and how they work. Although Replicators create geometry at render time, I still consider setting them up as part of the modeling stage. I like to think of it as procedural modeling. In this section, I'd like to discuss how you can use multiple Replicators to distribute several objects across a surface. We are going to use Groups to further randomize the objects that are used by the Replicators, and Weight Maps to control the surface on which the Replicator will distribute the items in the Group. To illustrate the usage of Replicators, I've created a quick scene where I will create two Replicators to distribute a Group made of plant objects and a Group made of rocks. You can easily add a Replicator to an object by choosing Add Replicator under the Item menu at the top of the UI.

Groups

You can use Groups to create a group of different objects that the Replicator will use to distribute the objects in the Group across a surface. This is good because it will further randomize your scene. To begin, I dragged in some plant geometry from modo's Preset Library and created a Group of these items as shown in **Figure 3.46**. I made sure that the Centers for these mesh items rested

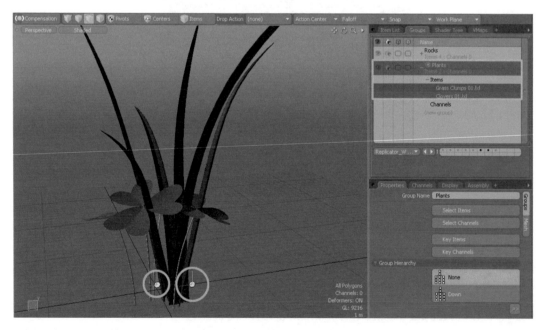

FIG 3.46 A Group was created from the plant objects and their centers were set to rest on the world grid.

on world origin. If the Centers were either below or too high above the world grid, the objects would appear to float or sit below the ground source.

Next, I created a ground plane for the plants to rest on. I duplicated this ground mesh to have a Point Source for the rocks. Both of these ground planes are occupying the same space. I then gave each ground plane its own material, so that each ground plane could have its own Surface Generator and Weight Map texture.

Vertex Maps

You can use Weight Maps to modulate the Surface Generator. Adding positive weight values to the map will dictate where the Surface Generator will distribute geometry. In Figure 3.47, you can see the Weight Map for the plants. The positive values, which are colored red, indicate where I'd like to have the plants placed. To create these maps, I used the Weight tool with an Airbrush Falloff. This allowed me to paint the weights onto the map.

To create a Weight Map for the plants, I painted the weights onto the entire surface of the ground plane and then used the Math tool to subtract the rock weights from the ground weights as shown in Figure 3.48.

To have the Weight Maps modulate the Replicators, you need to create a Weight Map Texture in the Shader Tree, select the appropriate Weight Map in the Properties Panel, and set the Weight Map Textures effect to Surface Particle Density.

Surface Generators

A Surface Generator will give you much more control on how Replicator objects are distributed across a surface. Normally, a Replicator will distribute objects across a surface according to its vertices. The Surface Generator will allow you to create a more random look to the Replicator. By adjusting the

FIG 3.47 The positive weights (red) indicate where I want to place the plants.

FIG 3.48 The Math tool was used to subtract the rock weights from the plant weights. By doing this, plants will not show up where the rocks are and vice versa.

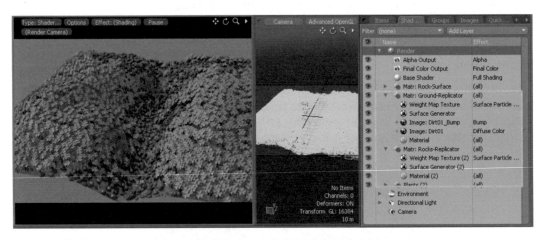

FIG 3.49 The effect of using Replicators with Groups, and the Shader Tree setup for both the rocks and the plants.

average spacing and scale factor on the Surface Generator, I was able to distribute the Replicator objects across the surface and the Weight Map Texture acts as a mask, only placing objects where I painted positive weight values. Finally, the Surface Generator is set as the Point Source on the Replicators.

In Figure 3.49, you can see the effect of using Replicators with Groups, and the Shader Tree setup for both the rocks and the plants.

Working with Hair

In this section, I'd like to discuss working with the new Hair tools within modo by taking a look at adding hair to a character model as shown in Figure 3.50. In modo, adding hair is an easy process and its actually quite fun to experiment with new hair styles. In this chapter, we will only discuss creating hair. In Chapter 5, I will discuss the texturing of hair and fur.

Creating Hair

Creating hair in your scene is simple in that the only requirement is to add a Fur Material layer to a Material that you want to add hair to. From there, you can create Hair Guides to control how the hair is created on the object. Let's first take a look at the Fur Material.

Fur Material

To create hair, you will need to add a Fur Material to your material in the Shader Tree as shown in Figure 3.51. You add the Fur Material in the same way you add any other layer type in the Shader Tree. The Fur Material will instantly add fur to the material as shown in Figure 3.52. In Figure 3.52, you can see the scalp area of the model selected. This is the area where the Fur will be applied to, since the Fur Material is placed within the Material Group for the selection.

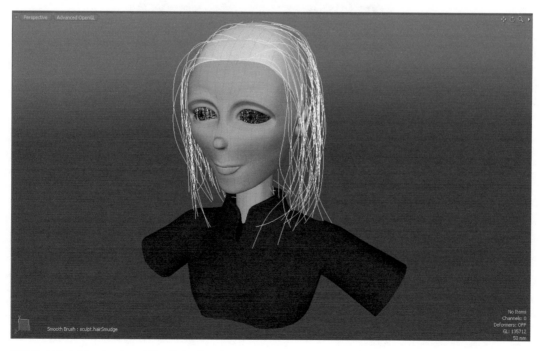

FIG 3.50 Adding hair to a character model is easily done in modo.

FIG 3.51 To create fur, you need to add a Fur Material in the Shader Tree.

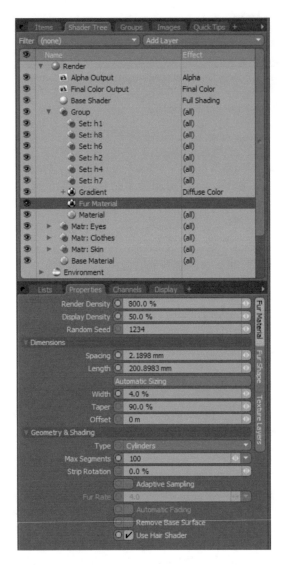

The Fur Material itself has controls for defining the Dimensions, Shading, and Shape of the fur as shown in Figure 3.53. However, when working with long hair, you will need to use Hair Guides in conjunction with the Fur Material settings to control the shape of the hair.

Before I get into Hair Guides, let's take a look at how I setup the material and Fur Material for the character. I wanted to have the hair part in the middle of the model's head, and I wanted the strands of hair to layer as it went from the

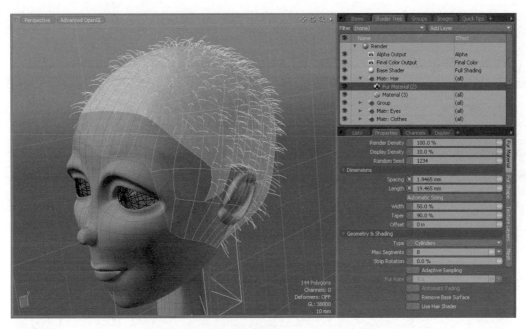

FIG 3.52 The fur will be applied to the Material Group that the Fur Material resides in.

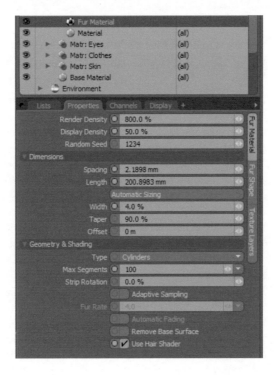

FIG 3.53 The Fur Material controls the Dimensions, Shading, and Shape of the fur.

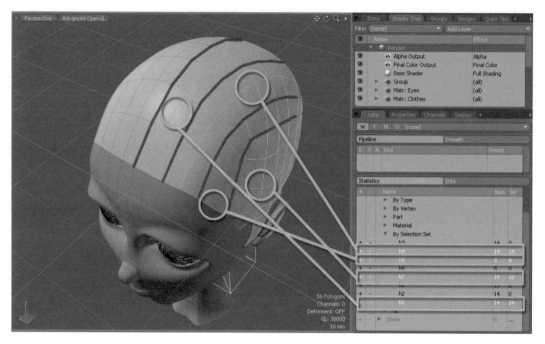

FIG 3.54 The Selections Sets that were created on the model.

part down to the sides of the head. What I did was to select a row of polygons from the front of the head to the back and created a selection set as shown in Figure 3.54.

I then repeated this for the other side of the head. Now, I have several Selection Sets indicating the polygons on the head that I wanted to add specific strands of hair. In the Shader Tree, I created a Group for each Selection Set and then grouped all of them into another Group, which will act as a container for all of my Selection Set Groups. In the container Group, I added a Material and a Fur Material. The key to this setup is that each Group inside the container Group was set to one of the Selections Sets that I had created by changing its Polygon Tag Type to Selection Set. In Figure 3.55, you can see the overall setup in the Shader Tree as well as a Group with its Polygon Tag Type set to Selection Set. At this point, I'm ready to create the Hair Guides.

Hair Guides

The Hair Guide tool can be found on the Sculpt and Paint Panel. Using the Statistics Panel (under Polygon from the Selection Set drop down) I selected one of the Selection Sets by hitting the plus sign next to the set. With the selection on, I then clicked the Hair Guides tool and simply left-clicked and dragged out some of the hair guides as shown in Figure 3.56. You can also see in Figure 3.56 that I had Gravity enabled for the Blend Mode, which causes

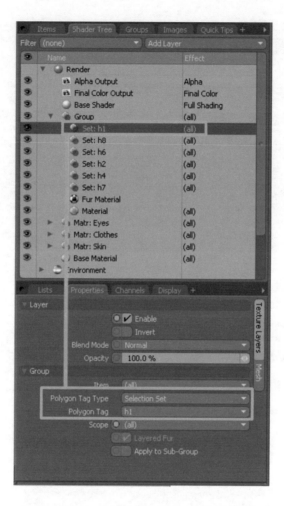

FIG 3.55 Notice that that each Group has its Polygon Tag Type set to Selection Set and that the Fur Material resides in the container Group.

the hair to bend downwards, and Detect Collisions enabled so that as the hair 'grows out' from the selection it will take into consideration the geometry that it comes in contact with. Detect Collisions will help in stopping the hair from penetrating through the mesh.

I then repeated the above steps to create the rest of the Hair Guides as shown in Figure 3.57. Now that the Hair Guides have been created and the guides are linked to the Fur Material by the use of Groups targeting the specific Selection Sets, I'm ready to get to styling.

Styling Hair

You can style the hair using modo's brush system in the form of the Hair tools. You can also paint texture maps to control properties like Fur Vector and Direction. Let's look at the Hair tool first.

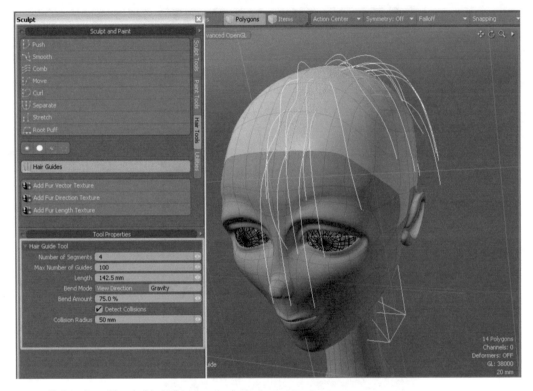

FIG 3.56 The hair is "grown" from the Selection Set.

FIG 3.57 With the Hair Guides created, all that's left is to style the hair.

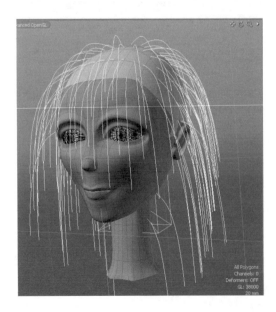

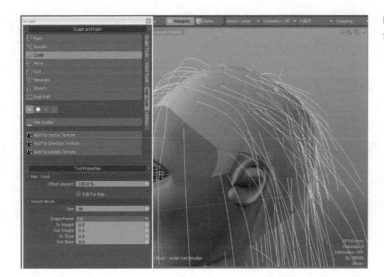

FIG 3.58 The Hair tools work similarly to modo's painting and sculpting tools.

Hair tools

With the Hair tools, you are literally 'brushing' the hair into place using a set of brush tools that work like modo's Sculpting brushes. The Hair tools are found on the Sculpt and Paint Tab. To get styling, select a tool such as Comb, select a brush, and begin painting the Hair Guides into place as shown in Figure 3.58.

Fur Material

Although you can use the Hair tools to brush the hair into place, you will also need to setup the Fur Material to get the Hair Guides to follow the shape you want. When using Hair Guides, you will need to set the Guides on the Fur Shape Tab. The Guides options tell the Fur Material how Hair Guides will affect it. For instance, I choose to use the Range option because it will control the fur growth directly. I also changed the Jitter and Bend settings to get the hair to fall correctly. For instance, by increasing the Flex setting, I was able to get the hair to lay flatter on the head as shown in Figure 3.59. We will discuss more about the Fur Material settings in Chapter 5 when I discuss texturing the hair. For now, just understand that you may have to adjust settings like the Flex and Length during the styling stage to get the hair to fall correctly.

Fur Maps

You can paint textures called Fur Maps to also control hair styling. There are three types of maps you can create, which are Fur Vector, Direction, and Length. I find that the Fur Vector map is the best to work with since it controls the fur length and direction in one image. You can create a Fur Vector Map by clicking the Add Fur Vector Texture in the Hair tools tab as shown in Figure 3.60.

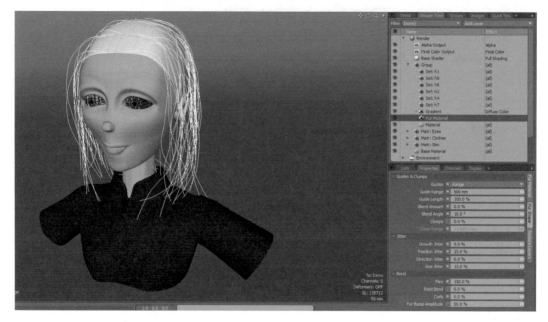

FIG 3.59 Increasing the Flex setting will cause the hair to lay more flat on the head.

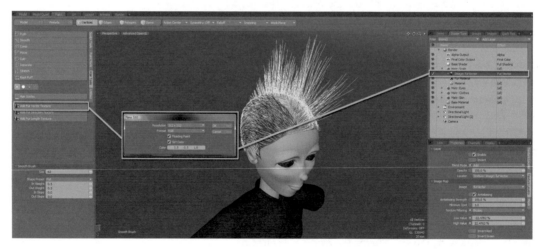

FIG 3.60 Fur Vector Maps are created on the Hair tools tab.

You will then be prompted to create a new still image that will be placed in the Shader Tree with its Effect set to Fur Vector.

You then can use the Hair tools with Edit Fur Map selected to edit the map as shown in **Figure 3.61**.

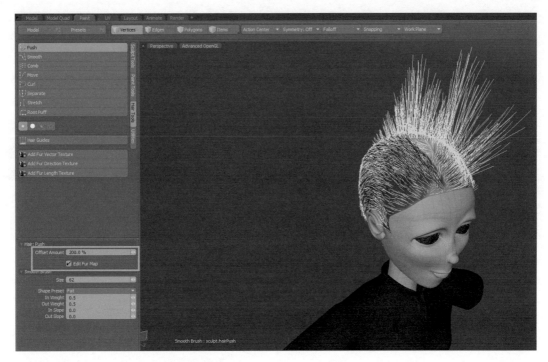

FIG 3.61 I painted a Mohawk using a Vector Fur Map.

Styling hair in modo is quite fun and it can be addicting to want to render everything with hair. The hair and fur system in modo is very well integrated into the applications, and it makes creating hair for your models a simple process.

Summary

In this chapter, I wanted to share with you the concepts that I use when modeling. For me, modeling is an enjoyable aspect of 3D. The two main principles that I always stick to for each modeling project are to always break complex objects down into simple shapes and add only enough resolution that's needed to create the shape to a mesh. My overall workflow is to divide and refine, keeping the mesh as simple and manageable as possible, while working hard to only use quad polygons and hiding those pesky triangles and N-gons.

UV Mapping

U V mapping is the process of defining texture coordinates for a mesh. These texture coordinates determine how and where a texture will be applied to a surface. I used to find UV mapping to be a very difficult aspect of 3D, but modo makes it quite simple once you understand some key factors to creating UV coordinates. In this chapter, we'll be discussing the fundamentals of UV space and how to work with UV coordinates.

UV mapping begins with determining a plan for how you will create the maps. However, to be able to create a successful plan, you will need to have a thorough understanding of UV space. We'll begin this chapter with a discussion on UV space and then move on into determining a mapping plan.

Understanding UV Space

In this section, we're going to examine the UV Space and how it can be best utilized to get the most details in our maps.

Items in the modo scene exist in a 3D space that is defined by X, Y, and Z coordinates. However, UV maps exist in a 2D space, and are defined by

U and V. UV doesn't actually stand for anything, as it's named to differentiate it from other coordinates. "U" refers to the horizontal coordinates of the UV space, and "V" to the vertical coordinates.

The purpose of the UV map is to take a 3D object's vertices and lay them out in such a manner that an image can be applied to the 3D object. It's like wrapping a present. The sheet of wrapping paper is the image, and the present is the 3D object that you want to apply the wrapping paper to. So, the question is: how do you apply the wrapping paper? If you're like me, wrapping a present is a difficult ordeal. The paper gets torn, and I always end up wasting too much of it. My wife tells me how to apply the wrapping paper; but in 3D, the UV coordinates tell the image how to apply to the model. A UV coordinate is like a thumbtack that pins a specific point on the image to a specific vertex on the object. In Figure 4.1 you can see that each UV coordinate relates to a specific vertex on the object. This UV coordinate tells which part of the image gets pinned to the corresponding vertex.

UV Coordinates

The next part to understand is that UV coordinates are floating point values, meaning they move from 0.0 to 1.0; and it is in this numeric range that the 2D

FIG 4.1 Each UV coordinate represents a vertex on a 3D object, and pins a portion of the image to that vertex.

FIG 4.2 UV Space is defined numerically as 0.0 to 1.0.

UV space is defined. It's like plotting a graph. The bottom left corner is 0.0, or the origin; and as you move towards the right, horizontally along the U direction, the value increases until you get to 1.0. The same goes for the V direction, except for that you are moving vertically from the lower left corner until you reach 1.0, as shown in Figure 4.2.

It is also important to understand that the aspect ratio of this space is 1:1, or square, which means that the width equals the height. This will be explained in depth a little later. All of the UV coordinates for the UV map should fall within this 0–1 range. Any coordinates that fall outside this range will repeat the texture that is applied. In Figure 4.3 you can see that to create the brick wall, the UV coordinates were extended to 4.0 and 6.0.

The number of times an image is tiled is set by adjusting the Horizontal and Vertical Wrap settings found in the Texture Locator's Properties, as shown in Figure 4.4.

Maximizing Detail

Now that we've determined what UV space is and how it is measured, we can talk about how to maximize detail in our maps by utilizing the UV space appropriately. An image map has a fixed resolution measured in pixels. For instance, a 1K image map is made of 1024 × 1024 pixels. In a UV map, the space that the UV coordinates occupy in the 0–1 range will determine how much of the 1024 pixel image is applied to the model. This is very important to understand, and is best explained by seeing it. In Figure 4.5, you can see a cube

FIG 4.3 UV coordinates that extend beyond the 0–1 range will repeat the texture.

FIG 4.4 Changing the Horizontal and Vertical Wrap settings and Repeat values will tile the texture.

with a texture map applied. I selected one of the polygons; and in the UV Editor, I scaled down these UV coordinates so that they didn't take up much space in the UV range. Notice that the texture area that corresponds to the scaled UV coordinates is much larger and pixilated than the rest of the texture

FIG 4.5 The UV coordinates are taking up less space in the texture map.

FIG 4.6 The UV coordinates are only using 90 × 120 pixels of the 1K resolution map.

map. This is happening because the UV coordinates have been scaled down and are now taking up much less space on the texture map.

Remember that the texture map is a 1K map, if a UV coordinate were to fill the entire UV space; the UV coordinate would be utilizing the entire 1024 pixel resolution in the image. However, since I have resized the UV coordinate of one polygon to be smaller, those coordinates are now only utilizing 90 × 120 pixels of the 1K texture map, as shown in Figure 4.6.

To maximize the detail in your texture maps, you will need to make sure that the UV coordinates are taking up adequate space in the UV map to utilize as much as the resolution in the image. This not only comes into play with color

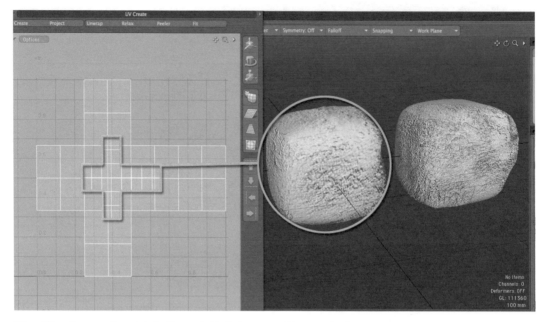

FIG 4.7 UV coordinates must be maximized to fill as much of the 0–1 space as possible to retain detail in your maps.

map resolution, but also with bump and displacement resolution. If you are creating a displacement map on an object and the UV coordinates are not sized correctly to utilize the entire resolution in the displacement map, you will have poor results in the render, as shown in Figure 4.7. Notice that the highlighted UV coordinates are much smaller and, therefore, use less resolution in the displacement map, which ultimately results in a poor displacement. The ball on the right has its UV coordinates maximized in the UV space, and is using most of the resolution in the displacement map. The result is fine displacement details.

UV Aspect Ratio

Now that we understand that the size of UV coordinates will dictate how much resolution is used in the texture map, I want to address the concept of matching object and UV space aspect ratio (UVAR). An aspect ratio is simply a ratio of the width divided by the height. Now, UV space is always square, so it has an aspect ratio of 1:1. This works well with meshes that have a square aspect ratio; which is to say that when its UV coordinates are maximized to fill the 0–1 space, the coordinates will fit as shown in Figure 4.8.

Now, let's take a look at the fuselage of the plane. It's long and cylindrical in shape. In Figure 4.9, you can see the UV coordinates for the fuselage; and because of its aspect ratio, when sized to fit the U space, it takes up only half

FIG 4.8 The tail of the plane fits into the 0–1 range when the UV coordinates are resized.
Source: Wes McDermott.

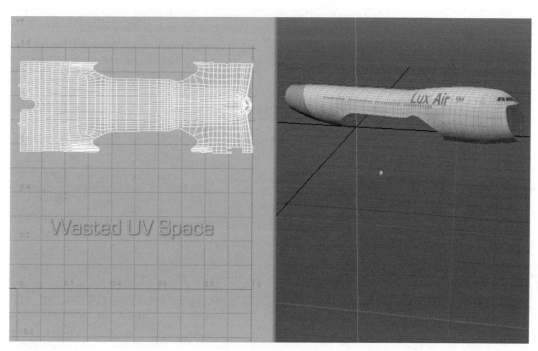

FIG 4.9 Because of its shape, the fuselage can't fill the entire 0–1 space.
Source: Wes McDermott.

the UV space, or half the image map. This isn't bad, but I could run into an issue where I may need to increase the image map's resolution to get more pixels in the area of the fuselage. Depending on the project, this may or may not be an issue; but using a higher resolution image map puts more strain on memory requirements.

The fuselage is the main focus of my model, so I'll want to devote as much resolution as possible to this area of the model. I could fit the UVs nonproportionally to fill the UV space; but since the aspect ratio of the fuselage and UV space don't match, it will cause distortion in my image map when it is applied to the model, as shown in Figure 4.10.

To fix this distortion, I'll need to create a texture map that is in the correct aspect ratio. To do this, I first add a Checker Procedural layer to my material, as shown in Figure 4.11. Notice that the checker pattern exhibits the same distortion. Also notice that the texture's size is the same on X, Y, and Z, as highlighted in the figure.

To determine the UVAR, I will adjust the size of the Checker texture on the X axis until the checker's become square and it no longer looks squashed as shown in Figure 4.12.

X axis was chosen because the fuselage is horizontally wider than it is tall. If it were taller than wider, I would have needed to adjust the Y axis. Since we're dealing with 2D when referring the UV space and image maps, we needn't have to worry about the Z axis. It ended up that the X axis needs to be

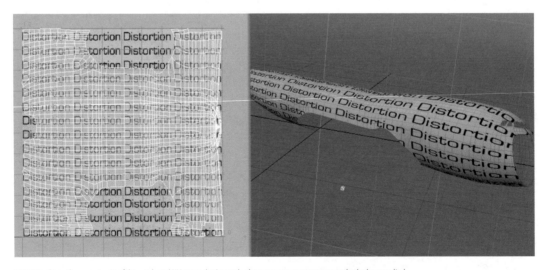

FIG 4.10 Since the aspect ratio of the mesh and UV space don't match, the texture map appears squashed when applied.
Source: Wes McDermott.

106

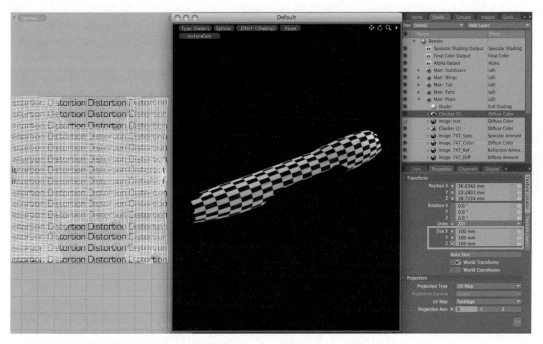

FIG 4.11 A procedural texture is added to the material, and it exhibits the same distortion.
Source: Wes McDermott.

FIG 4.12 The checker pattern's size needs to be adjusted on the X axis until the distortion is removed.
Source: Wes McDermott.

adjusted to 40 mm, or 2.5 times smaller than the Y, to remove the distortion in the checker pattern. Now if I divide Y axis by X axis I get the UVAR, which in this case is 2.5. It's a little confusing because you are adjusting the X axis to be smaller, although the width is larger than the height.

It seems like the X axis should be larger since the width is larger. Do not think X axis is width and Y axis is height. The values are reversed in that when I adjusted the X axis, I was really adjusting the height of my image map, and vice versa for a mesh that is taller than wider.

Finally, to get the correct aspect ratio for my texture map, you take the target map resolution and divide it by the UVAR. For example, I wanted my target map size to be 1024; so I divided 1024 by 2.5 to get 410. This means that I need to create a texture for the fuselage that is 1024 × 410. In Figure 4.13, you can see the new texture with the correct aspect ratio applied, and that the squashed text has been fixed.

Another bonus is that the UVs fully utilize the texture map, which is smaller than the 1024 × 1024 map and is therefore more efficient, because smaller maps take up less memory while rendering. The UVs are filling the entire 0–1 space and thus are making full used of the texture map's resolution.

You may not always want to use multiple UV maps. Your project may require that you use only a single UV map; and in that case, you'd have to make decisions on how large of a resolution to use, as well as which portions of the UV coordinates need to take up most space in the UV map. This is where UV planning comes into play, and is what we'll be discussing next.

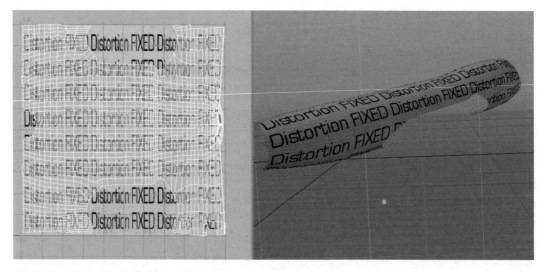

FIG 4.13 The squashed text has been fixed because of applying a texture map that matches the UVAR.
Source: Wes McDermott.

Mapping Out a Strategy

In this section, we're going to discuss mapping strategies. There are different ways to handle UV mapping. For instance, you could unwrap your entire mesh into one UV map, or use multiple UV maps for each section of the model. Each one of these methods can have their own advantages and disadvantages. Your project should dictate which method you use. For example, if you are creating content for a game engine, you'll want to minimize the number of textures you'll need to load, and using multiple UV maps with multiple textures may not be the most optimized way of working. Let's begin by exploring single UV maps and multiple UV maps.

Single UV Map

With a single UV map, you will place all of the model's UV coordinates into one map, as shown in **Figure 4.14**.

I find that the benefit to this is that you can create one material and one color map for the entire mesh. This minimizes the amount of textures that needs to be created, and makes the scene very manageable since there aren't multiple surfaces with many color and UV maps to keep track of, as shown in **Figure 4.15**. The surface attribute maps such as reflection, diffuse, and specular all use the same UV map as well.

FIG 4.14 All of the model's UV coordinates are in one UV map.
Source: Wes McDermott.

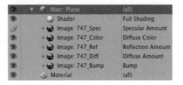

FIG 4.15 The model has one material and one UV map. The image maps for color, diffuse, specular, and reflection all point to the same UV map.

109

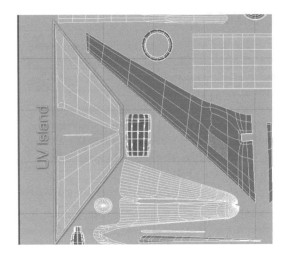

FIG 4.16 UV islands are grouped areas of UV coordinates for a given section on a model.
Source: Wes McDermott.

However, you can run into a sizing issue if you have a complex model, such as the plane shown in Figure 4.14 that has many UV islands, which are grouped areas of UV coordinates for a given section on the model, as shown in Figure 4.16. You may have a hard time allocating enough UV space for each UV island. As discussed earlier, the smaller the area of 0–1 space the UV coordinates take up, the fewer pixels they will occupy in the texture map, which will cause the map to look blurry in the render due to the size differences of the UV islands in the 0–1 space, as shown in Figure 4.17.

The key to using a single UV map is to decide what are the most important parts of the model are, and to make sure that these areas occupy the majority of UV space. For example, in Figure 4.18, I have a game asset that I had created for a project at work. The model utilizes one UV map for the color and normal maps.

The main part of this model is the tug's body, so I decided to make sure that the UV coordinates for this part of the model take up the most space in the UV map. In the game, the wheels of the tug are hardly visible, so I was able to allow the wheel's UV coordinates to be very small in the UV map. Since they are not readily visible, they needn't have to occupy that much resolution in the texture map. Again, this is a great way to minimize the overhead of keeping track of numerous UV maps, and is efficient for games since you are lowering the number of image maps that you need to texture the model.

Multiple UV Maps

The benefit to using multiple UV maps is that you won't run into the issue of not having enough space in the UV map to give adequate resolution for a particular UV island. In Figure 4.19, you can see that using a separate UV map

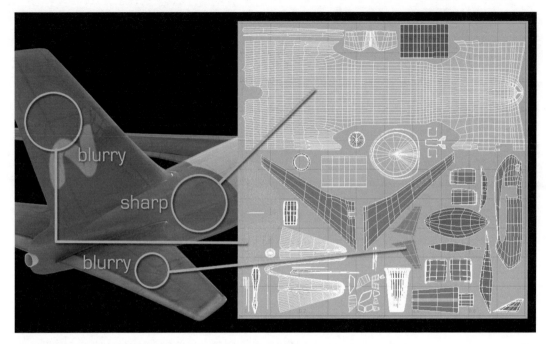

FIG 4.17 The UV coordinates for the tail are not taking up sufficient enough space in the texture map.
Source: Wes McDermott.

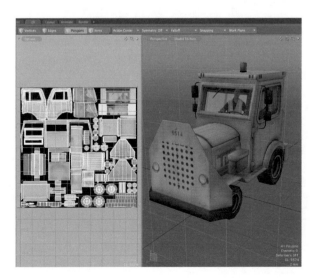

FIG 4.18 The game model is using one UV map.
Source: Wes McDermott.

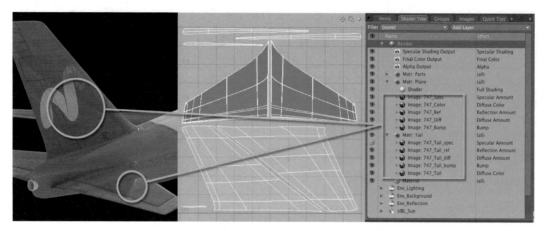

FIG 4.19 The blurriness in the texture has been fixed using a separate UV map, and by giving the UV islands more space.
Source: Wes McDermott.

for the tail and stabilizers, I was able to retain more information in the applied texture maps and fix the blurry problems in the render from Figure 4.17.

I used a separate Material Group in the Shader Tree for the tail and stabilizer polygons. I had to create additional texture maps for the new surface; but since I'm only working with 1K texture maps, the memory overhead isn't too bad. However, imagine if I was using 4K maps. This could become the bottleneck in the pipeline, which is having too many large texture maps to be stored in memory when rendering.

As you can see, there are pluses and minus to using single and multiple UV maps. It really comes down to your project and model that you're mapping. Now that we've discussed the basic principles of UV space, it's time to get to setting up a strategy and that begins by surveying the model.

Surveying the Model

Before you begin to map your model, you need to set up a plan. This plan involves making some decisions on how you're going to map the model. As we've seen, the smaller a UV island is in UV space, the less resolution it will use in the texture map. So, you need to decide the most important areas of the mesh, and make sure that they occupy enough of the UV space to retain the detail you require. This is where we survey the model. In Figure 4.20, you can see the UV border edges selected. These edges show how the mesh's UV edges were split up to create separate UV islands for different body parts on the model.

The model shown in Figure 4.20 is a base mesh that I'd like to use for a digital sculpt, so I know that I will want to make sure that each area that is UV mapped will adequately fill the UV space. Next, I need to take a look at the shape of the

FIG 4.20 The UV edges show how the model was split up to create the UV islands for specific portions of the model.
Source: Wes McDermott.

FIG 4.21 The colored areas on the mesh represent the areas that need to be UV mapped.
Source: Wes McDermott.

model; and since it has a human shape, it would make sense to divide the UV map up into areas like the head, arms, hands, and so on, as shown in Figure 4.21.

Now that I've determined the areas of the model that I want to map, I'll need to determine how much space I want these areas to occupy in UV space. For

instance, the head area is very important, and I plan to add a lot of details when sculpting, so I will create a separate UV map for the head as shown in Figure 4.22. That way the head UV coordinates will contain sufficient resolution in the displacement map. Other parts such as the hands can be grouped together in one UV map, as also illustrated in Figure 4.22.

It all comes down to looking at the shape of the model, determining the most important areas of that model, and developing a plan that will allow the areas identified to occupy the appropriate UV space.

UV Tiles

UV tiles are a special way to layout UV coordinates for file formats that don't support multiple UV maps, such as OBJ. However, they are much more useful than that. They are also used in Autodesk Mudbox and Maya, and shouldn't be mistaken for UV tiling, as shown in Figure 4.4. In Figure 4.23, you can see a mesh that has had its UV islands arranged into tiles.

UV tiles allow you to maximize the 0–1 space for each UV island. If you look back at Figure 4.23, you can see that each UV island fills as much of the 0–1 space as possible. As we discussed earlier, the UV coordinates are maximized in the UV space, and are using as much of the texture resolution as possible. If your project workflow or pipeline has you using Mudbox for sculpting, UV tiles are the best option for UV layout.

Separating a model's UV islands into tiles within modo is very simple. All you need to do is select the UV island, activate the transform tool, and type in the

FIG 4.22 UV map for the head and the UV map for the hands.
Source: Wes McDermott.

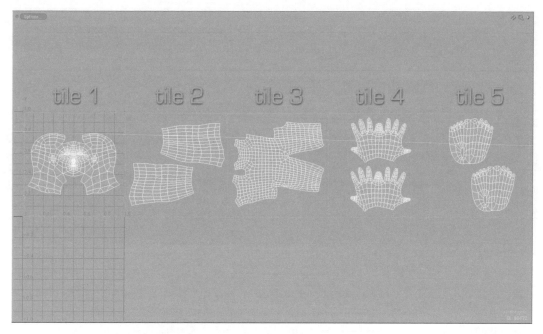

FIG 4.23 This object has its UV coordinates arranged into tiles for use in Mudbox.
Source: Wes McDermott.

FIG 4.24 You can offset the UV coordinates using the Transform tool.
Source: Wes McDermott.

value in which you want to offset the UVs in the Transform tool's U input field, as shown in Figure 4.24. As you can see in Figure 4.24, a value of 1.0 was used to offset the UV coordinates to the first tile. The next tile would fall at a UV offset of 2.0, and the next at 3.0, and so on.

If you are planning to export to Mudbox, you'll need to leave some space around the UV borders of each UV Island, and make sure that each UV Island's

FIG 4.25 Using a UV offset, you can apply the displacement images saved from Mudbox. Notice that the seams in the UV borders are not visible.
Source: Wes McDermott.

FIG 4.26 The Matrix 0 2 Offset U channel can be used to offset the Texture Locator. In this image, you can see that a value of −1.0 will offset the Texture Locator to use the UV coordinates in the second tile.
Source: Wes McDermott.

borders are not resting right on the 0 or 1 values in UV space, to prevent map extraction errors in Mudbox.

It is a simple process to import your sculpted Mudbox mesh into modo for rendering. When working with UV tiles within Mudbox, upon saving your scene, Mudbox will save a separate displacement or texture map for each UV tile.

You can load these images into modo and apply a UV offset in each image's Texture Locator to target a specific tile in the UV map. In Figure 4.25, you can see that I applied the separate tile maps saved from Mudbox, and applied them to the UV tiles in modo by adding a texture layer in the Shader Tree for each tile map from Mudbox and applying a UV offset in the layers Texture Locator. The good news is that the seams from the UV borders of each tile won't be visible when the maps are applied.

Also take note that in Figure 4.25, I changed the Displacement Rate and Ratio in the Render Settings to create enough polygon subdivisions at render time to match the subdivision level used in the Mudbox sculpt. In Mudbox, I subdivided the mesh to approximately 650,000 polygons; and in modo, I was able to get very close to that same level of subdivision as can be seen in Figure 4.25. It is important to be aware of the number of polygons in your scene and get that number to match the Mudbox subdivision as closely as possible in order to have the render look like the sculpt in Mudbox. In Chapter 8, we will deal with Render Settings, such as Micropoly Displacement.

To apply the UV offsets, you will need to select the image in the Shader Tree; and on the Properties panel, set the Horizontal and Vertical Repeat to Reset. Next, with the image still selected, go to the Channels Panel and scroll down to the Matrix 0 2 Offset U channel, which is found under the Texture Locator for the image. The Matrix 0 2 Offset U channel will apply an offset to the Texture Locator in the U direction of the UV map. It will allow you to target the tile on which the image map is to be applied, as shown in Figure 4.26.

The value you input into the Matrix 0 2 Offset U channel will be a negative value, and will correspond to the tile you want to target, minus 1. For example, the first tile, which is positioned in the 0–1 space, has a value of 0.0. The next tile, which corresponds to the second image, would have a value of -1.0, and the third image would have a value of -2.0.

Using UV tiles, you can create models that will be compatible with both Mudbox and Maya pipeline. Depending on where you work or on your particular workflow, this could be very important. In my case, I'm not particularly fond of modo's sculpting toolset, and prefer to work in Mudbox.

UV Unwrap

Being able to successfully unwrap a model is the key to eliminating distortions when applying an image map to the model. We will be discussing the usage of the Unwrap and UV Relax tools.

Unwrap Tool

The Unwrap tool is used to unwrap your models. It works by taking an initial projection and a user-determined seam to unwrap the model. The initial

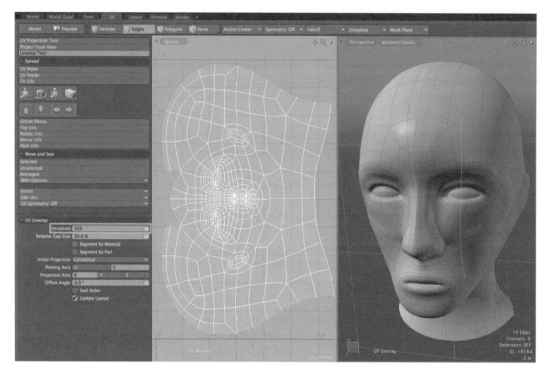

FIG 4.27 The iterations value controls the amount of unwrap.
Source: Wes McDermott.

projection setting chosen should match the object. For instance, if you're unwrapping a head, you would want to use a cylindrical initial projection, since the head is roundish in shape. The key to learning how to use the Unwrap tool is in understanding UV seams. In addition to using an initial projection, the Unwrap tool also looks at the edges you have selected on the model when calculating the unwrap. From there, you can adjust the iterations to control the amount of unwrap that takes place, as shown in Figure 4.27.

The pinning axis determines the UV axis to be favored in the unwrap, and can aid in the alignment of UV coordinates in UV space. The same is true for the Projection Axis—but it relates to how the projection is aligned in the XYZ space, which ultimately affects how the UV coordinates are aligned in UV space, as shown in Figure 4.28. For example, since the head is cylindrical and aligned to the Y axis, the projection axis is set to the Y.

A couple of other settings worth mentioning are the Relative Gap Size and Seal Holes. By changing the Relative Gap Size, you will increase the spacing between UV islands. Remember earlier when I mentioned you will need to increase the space between the UV islands when using Mudbox; this setting can help you do that. In Figure 4.29, you can see how the increase in the Relative

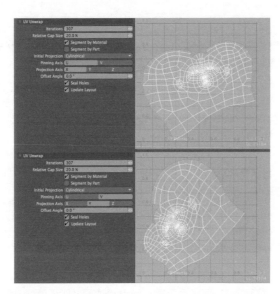

FIG 4.28 The projection axis determines the axis that the projection is aligned to, while the pinning axis determines whether it is the U or the V axis that the unwrap is aligned to.
Source: Wes McDermott.

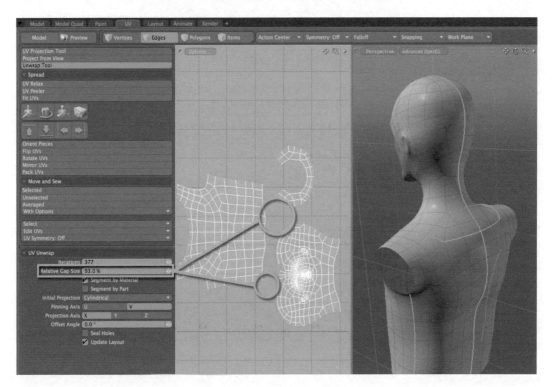

FIG 4.29 Increasing the Relative Gap Size will increase the space between the UV Islands.
Source: Wes McDermott.

Gap Size is changing the distance between UV islands. Also note that I have Segment by Material selected, which will divide the UV coordinates into UV islands based on the materials in the model.

Finally, Seal Holes can help improve the unwrapping if your model has holes, such as open areas for eyes. Holes in the model can sometimes produce unfavorable results; so using Seal Holes will create virtual polygons, as shown in Figure 4.30.

UV Relax

The Relax tool is used to remove or smooth out the overlappings in the UV coordinates. I use the Relax tool with the pinning feature to smooth the UV coordinates. To use the pinning feature, set the Mode to Unwrap and have Interactive enabled. You can then middle-click on a vertex within the UV map,

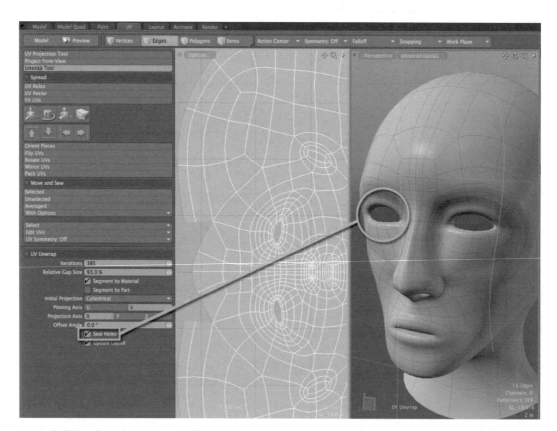

FIG 4.30 Seal Holes will create virtual polygons that fill the holes in your mesh.
Source: Wes McDermott.

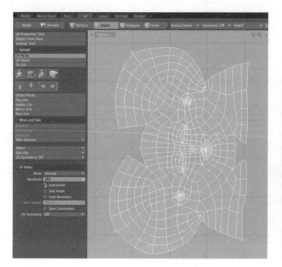

FIG 4.31 The UV Relax tool can be used to pin vertices to fully control how the UV coordinates are smoothed.
Source: Wes McDermott.

FIG 4.32 The eye areas stills have some overlapping UVs, and are shown in red.
Source: Wes McDermott.

causing a blue square to appear, which then pins the vertex. You can then click and drag the pinned vertex to smooth the UV map, as shown in Figure 4.31.

Although I've relaxed the UV coordinates, there are still a few areas around the eyes that are overlapping, as shown in Figure 4.32.

I can add a few more pins and drag towards the overlapping to completely relax this area. The current pins I've already set will hold the rest of the UV coordinates in place, as shown in Figure 4.33.

Another great use of the Relax tool is to use the Unwrap mode to smooth out distortions and overlapping polygons that can occur when translating 2D UV space from 3D XYZ space. For example, in Figure 4.34 you can see how the Relax tool was used to relax the UVs for the finger mesh. This example shows how the overlapping polygons were smoothed out using the Unwrap Mode along with Lock Boundary activated, so that only the UVs inside the UV border would be relaxed and the UV border would remain unaffected.

The Unwrap tool will get you most of the way, but the Relax tool will help you with that last bit of overlapping UV coordinates.

Understanding UV Seams

I mentioned earlier that the key to the Unwrap tool was in understanding UV seams. I also said that the Unwrap tool looks at the selected edges when determining how to unwrap the model. Let's take a moment and talk about

FIG 4.33 Adding additional pins allowed me to further relax the overlapping around the eyes. *Source*: Wes McDermott.

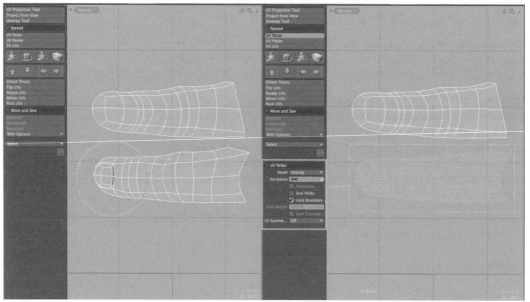

FIG 4.34 The overlapping UVs were removed using the Relax tool. *Source*: Wes McDermott.

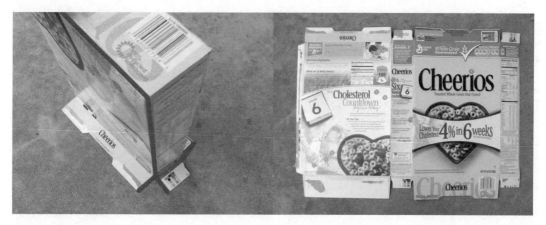

FIG 4.35 The red lines on the left indicate the seams where the box was cut open.

what that actually means. When I was first learning modo, I found that it was tough to grasp the Unwrap tool because I didn't know how to select the seams. First off, a seam is simply the area where the unwrap begins to unfold the mesh. To unwrap a model, you need to know how to cut it open, so to speak. Think about flattening a box. In Figure 4.35, you can see a cereal box that has been broken down.

The red lines indicate where the box was glued together and the areas that I tore open to flatten the box. If this were a 3D model, the red lines would be the UV seams. They would be the edges that I selected on the model before activating the Unwrap Tool.

In Figure 4.36, you can see a 3D model that is similar to the cereal box. In the 3D viewport, you can see the edges that I selected to produce the unwrap of the UV coordinates shown in the UV Editor.

The edges that I selected tell the Unwrap tool where I want to place the seams. Being able to decide how an object is unwrapped is very important when is comes to texturing. In Figure 4.37, you can see the same model unwrapped, but with different selected edges. You can see that the effect of the unwrap is much different in these two UV maps.

The edges that I selected for the second unwrap didn't unwrap the model in an appropriate way for texturing a cereal box. The first map was unwrapped in a manner like a cereal box would unfold in the real world. This allowed me to easily add texture maps to the front and back of the box, as shown in Figure 4.38.

Before I unwrap a model, I will imagine how I might unfold the object in reality. I think about where I need to cut in the model to unfold it. If you visualize cutting the object, it will help you to determine what edges you need to select on the model.

FIG 4.36 To unwrap this model, the edges were selected first, indicating where to place the seams.

FIG 4.37 The edges selected for this unwrap didn't cut the model in a way appropriate for texturing a cereal box.

FIG 4.38 The front, back, and side of the box relating to the UV coordinates.

Unwrapping a Hand

In this section, I'd like to take a look at a practical example of unwrapping an object. I find that hands can be difficult to unwrap, so that's what we will focus on in this example. We will use a combination of the Project from View tool and the Relax tool, and I will also cover the importance of discontinuous UVs.

Analyze the Mesh

To begin, let's analyze the hand model. It has a top and a bottom part. Four fingers extend out in a parallel fashion from the base of the hand. The thumb however, extends out perpendicular to the base of the hand and is angled downwards, as shown in **Figure 4.39**.

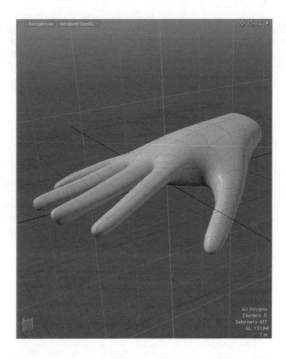

FIG 4.39 The first step is to analyze the model.
Source: Wes McDermott.

Because the thumb is angled differently than the rest of the fingers, I will need to work with it a bit differently, as you will see later. Based on the fact that the hand can be divided into a top and bottom, I will use a planar projection on the hand, initially using the Project From View tool.

Cutting Up the Model

Next, I will determine how I can divide the model. To begin, I need to start with a projection, so I set the 3D viewport to Top and use the Project from the View tool to set an initial projection down the Y axis, as shown in Figure 4.40.

Now that I have the initial projection, I can work on further refining the UV map of the model using the Relax tool. However, I will need to cut the model into sections I can relax. I said before that I wanted to divide the model into top and bottom parts of the hand. Also, since the thumb is angled differently than the rest of the hand, it will need to be separated into its own section as well. In Figure 4.41, you can see how I divided the hand into separate UV islands.

Discontinuous UVs

The object was divided into sections with the help of discontinuous UVs. Discontinuous UVs produce vertices that hold multiple UV values.
UV coordinates are stored in the vertex; but with discontinuous UVs, a single vertex can exist in multiple locations on a single UV map, based on which polygon is attached to. It is therefore not continuous, as it is no longer

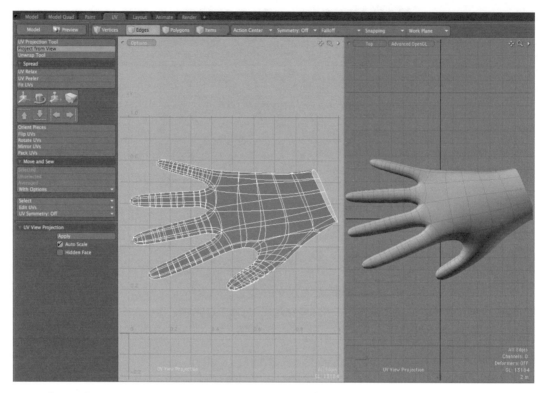

FIG 4.40 The Project from View tool was used to create the initial projection.
Source: Wes McDermott.

FIG 4.41 The hand was divided into sections before unwrapping.
Source: Wes McDermott.

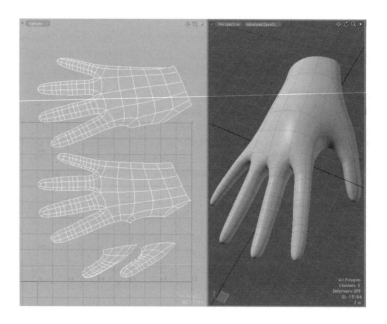

connected to the rest of the UVs. In modo, discontinuous UVs are handled very well, as you can see that the hand object is a single mesh; and to separate the UV coordinates into separate UV islands, I didn't have to unweld the object's vertices to separate the UVs. So, to divide up the mesh, I selected the faces for the top part of the hand and activated the Move tool, with Tear Off enabled. This allowed me to separate the top part of the hand UVs from the rest of the UV coordinates, as shown in Figure 4.42. Using Tear Off allowed me to separate the selected UVs from the rest of the UV coordinates. These UVs are now discontinuous from the rest of the coordinates. I used the same approach to separate the rest of the model into the top, bottom, and thumb parts of the hand. By separating the model's UV coordinates into individual UV islands, I'll be able to properly unwrap the model.

Relaxing the UVs

Now that the UVs have been separated into UV islands, I can begin the process of refining the UVs of the model. To do this, I selected a UV island, such as the top part of the hand, and then used the Relax tool to spread out the UV coordinates so that no UVs were overlapping. I used the Pin feature of the

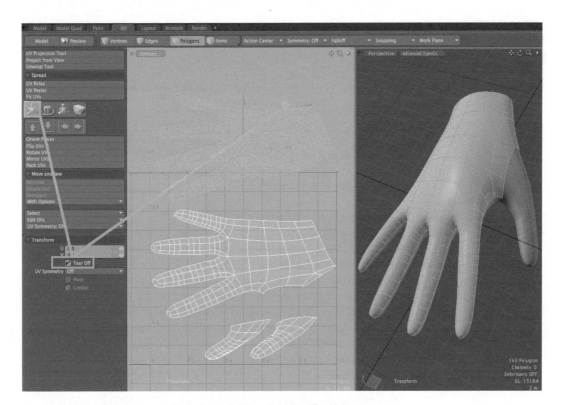

FIG 4.42 The hand was divided into separate UV islands using the Move tool with Tear Off enabled.
Source: Wes McDermott.

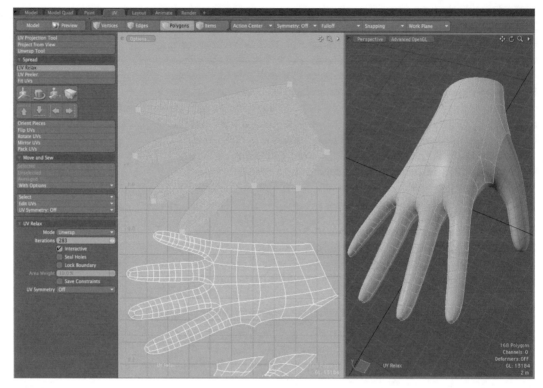

FIG 4.43 The Relax tool with the pinning feature was used to smooth the UV coordinates for each UV island.
Source: Wes McDermott.

Relax tool, as described earlier, to pin down a UV coordinate and relax the UVs, as shown in Figure 4.43. I used this same technique with the rest of the UV islands to fully map the hand.

Combining the UV Islands

Now that the UV islands have been successfully refined, I will combine them into one UV island to minimize the seams in the map. To do this, I will select the edges along the edge of the UV island for the top part of the hand, from the base to the pinky finger, as shown in Figure 4.44. Notice that as I select the edges in the UV Editor, the matching UV borders on the bottom of the hand are also being highlighted in light blue. The light blue selected edges indicate the seam edges from where the UV coordinates were continuous. Remember, when we selected the faces and moved them using Tear Off, we created a discontinuous edge. The light blue edges tell us that they match with the selected edges.

To merge the UV islands, I will simply use the Move and Sew tool with the selected option, as shown in Figure 4.45. This will effectively merge the two UV

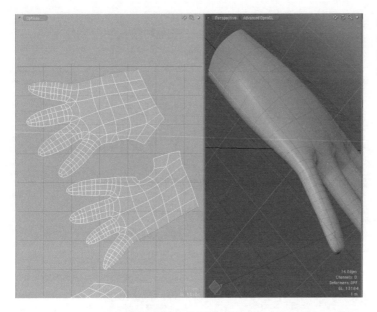

FIG 4.44 The selected edges indicate the point where I want to merge the UV islands together.
Source: Wes McDermott.

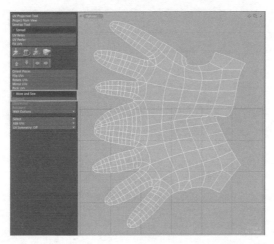

FIG 4.45 The Move and Sew tool was used to merge the UV Islands.
Source: Wes McDermott.

islands into one and remove a seam. In this case, there was a small bit of UV overlap where the seam was eliminated; so I simply selected some polygons around the overlapping area and used the Relax tool with Interactive disabled, as shown in Figure 4.46.

I repeated the same steps to attach the thumb UV coordinates. Once all of UVs were combined into one UV island, I used the Fit UVs command to fit the UVs to the 0–1 space. Finally, I used the Relax tool one last time with the Lock Boundary option enabled to further relax the UVs without changing the UV borders, as shown in Figure 4.47.

FIG 4.46 The Relax tool with Interactive disabled was used to remove the overlapping polygons.
Source: Wes McDermott.

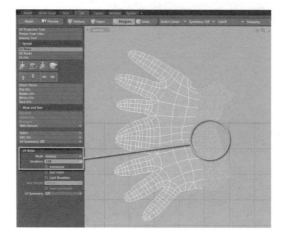

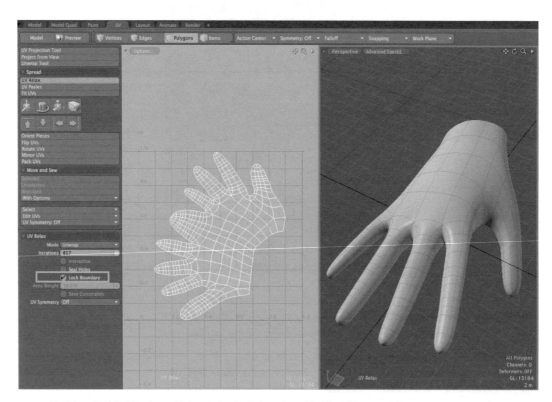

FIG 4.47 The Relax tool with Lock Boundary enabled was used to do a final smoothing of the UV coordinates.
Source: Wes McDermott.

UV unwrapping is not really a complicated process. It's actually rather simple once you understand how to cut up a mesh and where to place the seams, it's more time consuming than anything. Just remember that visualizing how a real object would be cut up to flatten it out will help you decide how to unfold your mesh in 3D.

Summary

UV mapping is the process of translating an object that exists in 3D space to a 2D space, which is described in the UV map. In this chapter, we've discussed the importance of mapping out a strategy, maximizing the details, and UV aspect ratio. The overall process can be summed up in three steps. Step one is to create a mapping strategy. Step two is to create the initial projection, such as using the Unwrap tool; and step three involves refining the UVs, so that distortions and overlapping polygons are removed.

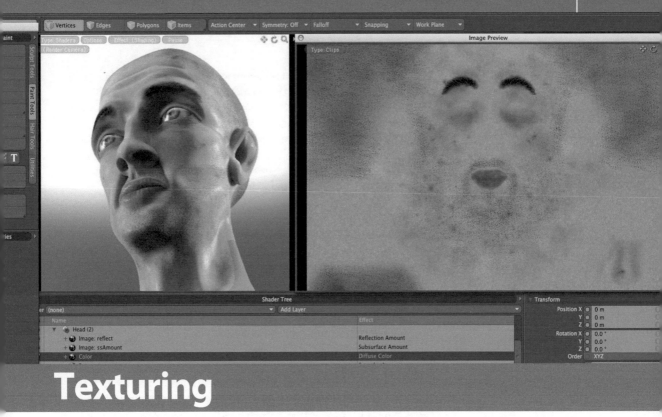

Texturing

Texturing is more than just adding maps to a model and surfacing the objects in your scene. It's also about setting up an object's material so that it reacts properly to light and mimics the real-world surface you are trying to create. I'm not going to discuss methods for specifically creating a surface such as metal. Instead, I want to share my own workflow for adding textures to a model through texture maps. Let's begin by discussing where texturing starts, which is collecting reference.

Collecting Reference

Before you begin any texturing, you'll need to study the real-world surface you're trying to recreate. This study includes taking photos and asking questions about the surface. For instance, if I want to create a rusty metal door or a brick surface, I'll photograph several reference photos of these items as they exist in reality. By doing this, I will not only have base photos from which I can build textures, but I will also be able to study how the material interacts with light. Next, I will ask myself questions about the surface's properties, such as does it absorb light or reflect it, is it transparent, and what is its base color.

I will also ask questions about its environment, such as is the surface exposed to weather or human contact. Environmental questions will help me to determine the type of wear and dirt the surface will typically have. Finally, I will ask questions about how the surface feels, such as is it smooth or rough. These questions help me to determine the type of bump map that will be required for texturing. This "surface interview" will help you to become more familiar with the material you want to create and will give you a direction to head in before you even turn on the computer.

> 📖 **Tip:** Although creating 3D art takes place on computer, the artistic part of the process takes place even before the computer is even turned on, such as studying the material you want to create or storyboarding an idea. A computer can't make these types of decisions for you.

Once you've studied the surface and have taken reference photos, you're now ready to begin to setup the material in modo and paint texture maps, which will be discussed in the next section.

Using Texture Maps

Using images to describe the properties of a material is exclusively the way I work in modo. I rarely will use a procedural texture to define any property of my material. The reason being is that I also rely on other 3D applications. In my 3D pipeline, only using texture maps, I can ensure compatibility with the surfaces as I export my models created in modo. However, if you want to use a procedural texture, you can bake that procedural out into a texture map. In this section, I will discuss each different map that I generally create when surfacing a model. Let's begin by taking a look at setting the base properties of the materials.

Setting Material Properties

Before I begin painting any map, I first adjust the material properties such as diffuse, specular, and reflection amounts for which I'll be creating maps. This way, I can work out how the model will react to light before I spend time creating detailed maps. Also, at this stage I can use modo's Preview window to get real-time feedback on the settings I am working with. It is also at this "pretexturing" stage that I will setup and finalize the lighting in my scene. It is important to apply textures using the lighting you'll be using in the final render, because you wouldn't want to spend a lot of time setting up the material to properly interact with a given light rig, only to completely change the rig and have to readjust material settings again. Once the lighting for the scene has been setup, the model is now ready to begin the surfacing process. I will usually set the Diffuse Color for the material to a generic color that won't

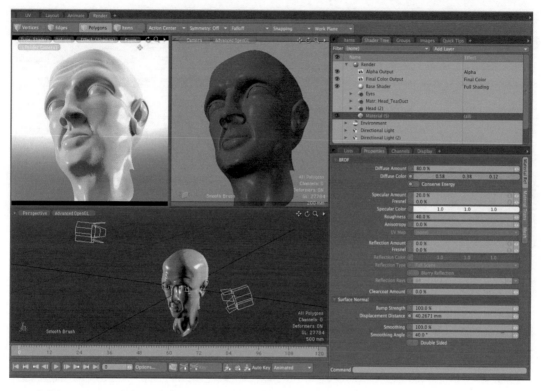

FIG 5.1 Before creating textures, the lighting for the scene has already been developed and the base material is set to a generic color.

be too distracting while I am adjusting the material's properties. In Figure 5.1, you can see a scene that is ready for texturing to begin.

It's at this point that the reference I have collected earlier will come into use. For each texture map that I create, I will use the reference images and the "surface interview" that I conducted to determine the value to be given to that surface property. The value that is input for the surface property will then become the base value that is used when creating the texture map. Let's look at an example. I have created a simple scene composed of two spheres and a single directional light with each sphere assigned its own material. In Figure 5.2, you can see that with the first sphere I have determined that I want the Specular Amount to have a value of 20 percent.

Now, I want to paint a map that modulates the Specular Amount, but I still want to maintain the base value of 20 percent that I set initially on the material property. To accomplish this, I am going to use the 20 percent base value in my texture map. To do this in Photoshop, I just need to input the 20 percent value into the Balance input field and set the Saturation to 0 in the Color Picker. This will produce a gray value in my specular texture map that will

FIG 5.2 The Specular Amount has been set to 20 percent.

represent the base 20 percent value that I set in the material's Specular Amount property.

In Figure 5.3, you can see that an image created in Photoshop representing the 20 percent value has now been applied to the material and that its effect has been set to Specular Amount. Notice that the specular highlight matches the second sphere, which has a material with a Specular Amount of 20 percent as well.

This is the method that I use to translate the initial values set in the material to the texture map. I do this for each type of surface property that I want to make a map for; for example, Reflection Amount, Specular Amount, or Subsurface Amount, to name a few.

Map Types

I typically create my textures in Photoshop, but I also rely heavily on modo's Paint tools to create maps and modify maps that I started in Photoshop. All of the maps we're going to look at, with the exception of the color map, will

FIG 5.3 The image created in Photoshop to modulate the Specular Amount matches the Specular Amount of the second sphere, which has a material with a Specular Amount of 20 percent.

describe the way the model's material interacts with light. Each map contains grayscale values that determine how the map affects the material. For instance, with a specular map, the white areas in the map will represent specular areas on the surface, whereas the black areas represent nonspecular areas. While the images can be RGB, it's best to create these maps as grayscale because color information is not needed and grayscale map will take up less rendering resources than an RGB map. One last thing to mention before we take a look at the maps is the maps' resolution. The resolution of your maps is determined by your project needs. Typically, I will start my maps at twice the resolution I need. For instance, when I'm rendering for video resolution at 720 × 480, I will create my maps at 1440 × 960. This way, I can fill the frame with my model at 720 pixels wide and not have the render look pixilated because of the lack of image resolution. I can always resize my maps to a smaller resolution if needed, but you can't enlarge a map without losing quality. To illustrate the different types of maps, I'm going to use a model that I have created to explore creating a skin texture. Let's take a look at the color map for this model.

Color Maps

A color map is the texture map that adds the color information to your model as shown in Figure 5.4. This map is created in RGB color. The Effect setting for this map in the Shader Tree is Diffuse Color.

The key to this map is to not include any lighting, specularity, or reflection values in this map. The map should look flat. The first step to creating any map is to export the UVs to an EPS so that they can be used in Photoshop as a template to paint over. In modo, you can export the UVs using the Export UVs to EPS command found under the Texture menu at the top of the modo UI. In Figure 5.5, you can see the UV layer in Photoshop that acts like a guide for painting.

Creating a color map is not very complex. You don't have to be an amazing artist; you just have to be able to draw lines and dots. For instance in Figure 5.6, I've outlined the areas of the image that were created by dots and lines.

Diffuse Maps

In modo, the Diffuse Amount acts as a multiplier for the Diffuse Color. Basically, it darkens a surface. It is meant to represent the amount of light

FIG 5.4 The Color Map holds the color information for the surface.

FIG 5.5 I keep the UVs on the topmost layer in Photoshop to act as a guide layer for painting.

that is absorbed or reflected from a surface. It should also be noted that when using image maps for reflection amount, setting diffuse to "conserve energy" will properly and appropriately modulate the diffuse value, producing what many call a "physical" surface for physical accuracy. (Actually it does so with and without texture maps.) Diffuse maps are grayscale maps where white areas denote higher diffuse values and black areas translate to lower diffuse values. Generally, I use the Diffuse Amount to enhance the reflection properties by keeping the reflections from looking washed out. In Figure 5.7, you can see that the second cylinder has a low Diffuse Amount of 0 percent, while the first cylinder has the default Diffuse Amount of 80 percent and both objects have high reflection settings. Notice that the cylinder with the high Diffuse Amount looks washed out and the reflections look rather weak.

Another use of the Diffuse Amount is to add dirt or grime to a surface. In Figure 5.8, you can see how I used an image map set to Diffuse Amount to create dirt on the surface. The white areas in the map will translate to a higher Diffuse Amount, while the darker values will lower the Diffuse Amount.

In regards to my head model, I used a diffuse map to regulate the affects of the specular and reflection maps so that the surface doesn't become too bright or oversaturated as shown in Figure 5.9.

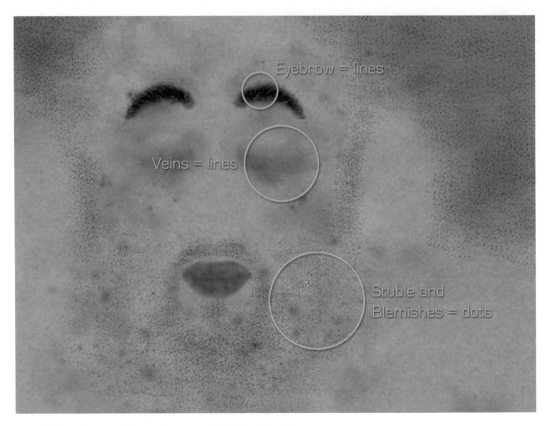

Eyebrow = lines

Veins = lines

Stuble and
Blemishes = dots

FIG 5.6 This image shows areas of the map that were created by drawing lines and dots.

Specular Maps

In 3D, the specular setting is used to create the appearance of a specular highlight. It's actually a fake, created to only give the appearance of specularity on a surface. The reason behind this is to introduce specular highlights to a surface without having to ray trace the scene, thus improving render times. In reality, a specular highlight is actually a reflection. When I am working on a scene that is being rendered in 32 bit linear floating point, as will be discussed in Chapters 8 and 9, I won't use a specular map. Instead, I use a reflection map to handle my specular highlights. Specular maps are grayscale maps as well, where white areas denote higher specular values and black areas translate to no specularity on the surface. It's always important to add detail to a specular map. Nothing screams CG more than a clean unaltered specular highlight. In Figure 5.10, you can see that I painted a quick specular map to modulate the specular highlight on the surface. Notice how the map breaks ups the specular highlight and gives the impression that the surface is rough. I also created a specular color map, which tints the highlight as shown in

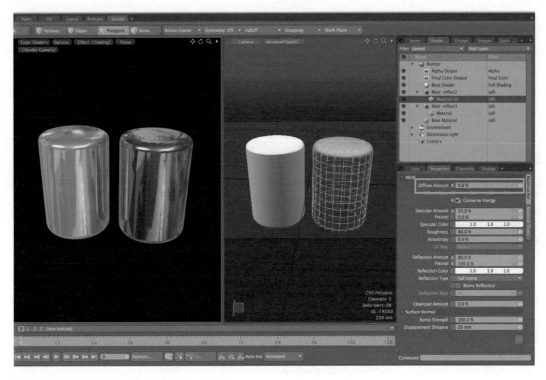

FIG 5.7 Lowering the Diffuse Amount will enhance the reflections.

Figure 5.11. Metal will usually have a specular highlight that is tinted to the color of the metal. It's a subtle effect, but it's in the subtleties where most texture effects become successful.

To create these maps, I used modo's paint tools. First I added a blank color texture with its Format set to Grey and its size set to 512 through the Add Color Texture command found on the Utilities tab on the Sculpt and Paint Panel. I didn't need a larger map, so a size of 512 would suffice. Also, I changed the Format to Grey since I don't need the extra memory overhead associated with an RGB map. Next, I set the map's Effect to Specular Amount in the Shader Tree and then used the Paint Brush tool to paint the map. To break up the highlight, I used a Procedural Brush Nozzle, which is a great way to add noise to your paint strokes. For the FG Color value for the Paint Brush, I wanted to work with the default 20 percent Specular Amount found on the Material, so I used the HSB (Hue, Saturation, and Balance) mode on the System Color Picker to set the Balance to 20 percent and the Saturation to 0. Now, I will be painting with a value that matches the material's original Specular Amount, which is what I selected for the base specularity of the model. Remember, I just want to break up the highlight and that is why I decided to stick to the Specular Amount setting I chose in the material. In Figure 5.12, you can see these settings.

FIG 5.8 A diffuse map can be used to add dirt to a surface.

The same workflow was used to add the Specular Color map, but instead of painting this map with a Brush, I just used the Fill tool to flood the map with the color I wanted to tint the highlight with. In Figure 5.13, you can see how I painted a specular map for the head model we've been discussing thus far. A specular map can greatly add to the realism of your model.

Reflection Maps

Reflection maps are very similar to specular maps in how they are created. They are grayscale maps as well, and the white areas translate to more reflection and the dark areas represent less reflection. The main point I want to stress with not only reflection maps but also with all maps is that by painting maps, you can choose specifically where the effect is going to be applied and by how much. Maps allow you to break up a surface. Many things can disrupt the reflection amount of a surface, such as fingerprints, dirt, and scratches. You need to always think about these types of subtle details and add them to you reflection maps. In Figure 5.14, you can see the reflection map that I painted for my head model. This map is very subtle, as I only wanted to introduce a small amount of reflection to the skin surface of the model. It is practically black, but if you look closely, you can see small amounts of variations of grey around the

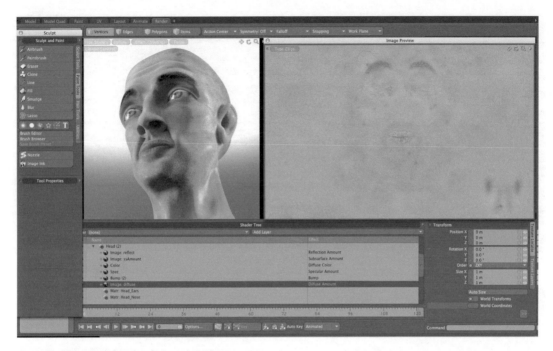

FIG 5.9 The diffuse map regulates the reflection and specular maps.

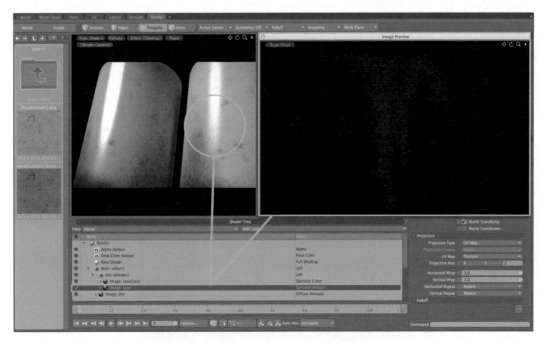

FIG 5.10 A specular map can be used to break up specular highlights on a surface.

FIG 5.11 A specular color map can be used to tint the highlight.

FIG 5.12 The Paint Brush tool with a Procedural Nozzle and a FG Color set to the 20 percent Specular Amount was used to break up the specular highlight.

FIG 5.13 The head model uses a specular map to add specular highlights. The map is used to control what areas of the mesh receive more or less specularity.

FIG 5.14 The head model uses a very subtle reflection map.

145

eyes. Although it might not be very apparent, most surfaces tend to have a small amount of reflective properties.

Bump Maps

Bump maps, along with specular and grime maps, are one of the most important maps to create when texturing your model. A bump map is used to describe the surface of your object. However, a bump map will not actually add detail to a mesh in the form of real polygons, as a displacement map will. A bump map is used for more subtle surface details such as pores, scratches, and small cracks. With a bump map, the bump details won't actually be visible when the mesh is viewed at an angle as shown in Figure 5.15.

Bump maps can go a long way to adding the texture of a surface. By this I mean that even without color, bump maps add a lot of realism and surface detail to the model as shown in Figure 5.16. It's for this reason that I will sometimes start with a bump map and then create the color map based off the bump map's detail. A bump is a grayscale image as well, and the white areas translate to areas that will protrude or produce a raised surface, and dark areas will have the effect of pushing into the surface. Again, as we've discussed, this is only an illusion as the bump map is not actually altering the mesh.

In Figure 5.17, you can see the bump map I created for the head model. Notice that I used small black dots to create tiny holes that represent pores in the skin.

FIG 5.15 The illusion of the bump map is revealed when the object is viewed at an angle.

FIG 5.16 A bump map creates the surface detail.

FIG 5.17 The bump map was used to create surface details such as hair stubble, pores, and veins.

For parts like forehead veins, I painted white to have them appear to rise up the surface of the skin. I also painted tiny white dots to represent facial hair stubble. This ended up being my favorite part of the bump map, since I really liked the affect it had on the model as you can see in the Preview Window also shown in Figure 5.17.

Adding Dirt and Grime

Adding Dirt and Grime is such an essential part of texturing. Nothing in this world is in pristine condition. You can always find some type of dirt, dust, moss, or everyday wear on any object. Images created on a computer have the reputation of looking too clean and perfect; by adding some wear or dirt to your texture, you can greatly increase realism and remove that "CG Look" from your scene.

I like to use modo's Paint tools to add dirt and grime to my textures. In Figure 5.18, you can see a color map that has dirt and rust added using modo's Paint Brush tool with a Procedural Brush Nozzle. This method works well to quickly add dirt, since you can rotate the model in the Paint View and quickly add a few strokes of dirt here and there, as shown in Figure 5.19.

The best workflow for adding grime using modo's Paint toolset is to add a new blank texture in modo and then paint the texture details on this new layer. This way you can have the dirt layer separate from the color map. This in turn gives you greater control since you can easily drop the opacity of the dirt layer to minimize its affect. For example, in Figure 5.20 you can see that I've added a

FIG 5.18 In this image, I've highlighted the areas where I have painted dirt and rust using modo's Paint Brush tool with a Procedural Brush Nozzle.
Source: Wes McDermott.

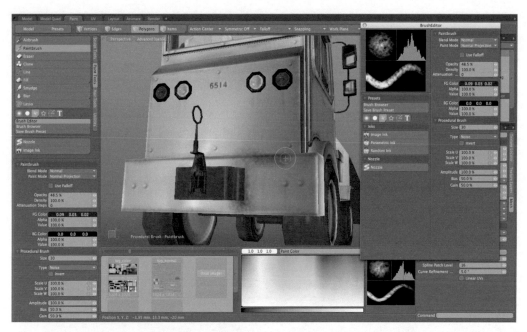

FIG 5.19 Using modo's Paint Brush Tool with a Procedural Brush Nozzle is a quick way to dirty up a model.

Source: Wes McDermott.

FIG 5.20 Using modo's Paint Brush tool with a Procedural Brush Nozzle and Image Ink, I painted some rust onto a new image texture layer.

Source: Wes McDermott.

new blank texture with its Effect set to Diffuse Color. From there I used a Paint Brush with a Procedural Nozzle and Image Ink activated to paint rust.

In the Image Ink properties, I picked a rusty metal image as also shown in Figure 5.20.

📖 **Tip:** When using Image Ink, make sure that the Brushes FG Color is set to white 1.0, 1.0, 1.0 so that you are using just the color from the texture map. If you get strange results while using Image Ink, check the FG Color.

When you have completed the texture, you can then bake the dirt and color into a new image map by right-clicking the dirt map and choosing Bake to Texture as shown in Figure 5.21. You can then use the baked image as the Diffuse Color and hide the dirt map and clean color map.

FIG 5.21 Baking the textures down into one image is similar to using Flatten Layers in Photoshop.
Source: Wes McDermott.

Subsurface Maps

I create a subsurface map when using Subsurface Scattering in modo. Subsurface Scattering is a rendering process for simulating the natural effect of how light rays that penetrate the surface of a translucent object are scattered by bouncing within the material and then exit the surface at a different point. The material will tint the light that is scattered. This effect is enabled in modo on the Material Trans Tab of a material.

I control the Subsurface Amount with a map. This map is also a grayscale map where white areas control the amount of scattering and dark areas translate to no scattering. The scattering distance is the distance that a light ray travels. The farther the light ray travels the more the RGB values used in the Subsurface Color will be attenuated. As the rays travel farther from the entry point and before they exit the surface, the color will appear to become darker, which gives the effect of the light traveling through a thicker surface. In Figure 5.22, you can see the head model with a subsurface map applied. I set the Scattering Distance to 20 mm. I then added a blank image texture and set its

FIG 5.22 Painting a subsurface map controlled the Subsurface Scattering. The white areas denote the parts of the face where I want to activate Subsurface Scattering.

Effect in the Shader Tree to Subsurface Amount. From there, I began to use modo's Paint tools to apply white color everywhere I wanted to increase the Subsurface Amount. The trick here is thinking about areas of the face where the skin is thin or where there is a lot of cartilage, such as the nose, ears, chin, and forehead. It's in these areas that you'll want to introduce Subsurface Scattering to the object.

As I said before, you don't have to be an incredible illustrator to paint your own maps. By studying your reference photos of the surface you want to create, you'll be able to break the surface down into a task of painting simple shapes such as dots and lines. From there, you can begin to build up the detail little by little until you have crafted the texture. For instance, let's say you need to create a texture of a weathered wooden door, with rusted kick plates and nails. Don't get overwhelmed by all of the texture, just take it a layer at a time. You have a wood texture with a dirt layer; you have metal with rust layers. Each layer by itself is rather simple to create. By working through each layer one step at a time, you'll eventually have a complex texture.

The Shader Tree

The Shader Tree in modo is a powerful way of setting up materials in your scene. The Shader Tree uses a layering system that processes materials and texture layers from the bottom of the tree to the top of the tree as upper layers always obscure lower layers. When I started learning modo, I had such a hard time grasping the concept of using Groups and Masks within the Shader Tree. In this section, I'd like to discuss the ways in which I organize the Shader Tree for my projects, and through this process I hope to dispel some confusion you may have about the tree. Let's start by looking at Groups.

Groups

Groups in the Shader Tree can act as containers or masks. Using Groups as containers for other Groups and materials can be a great way to organize your scene. For example, in Figure 5.23 you can see a model that was used for the book's cover. For this scene, I have created a Group for the plane, and inside that Group I have placed the Groups and image maps that make up the plane's parts, such as the fuselage and tail.

The master Plane Group has its Item set to all on the Groups Properties Panel, so that it's not masking anything and is purely used for organizational purposes. It now contains all of the other Groups that make up the plane's surfaces. I also added a material to this organizational Group. By doing this I only need to adjust settings on one material and these settings will be applied to all of the SubGroups contained in my main organizational Group. In a sense, the master Group tells all other SubGroups to use this material. I also like to

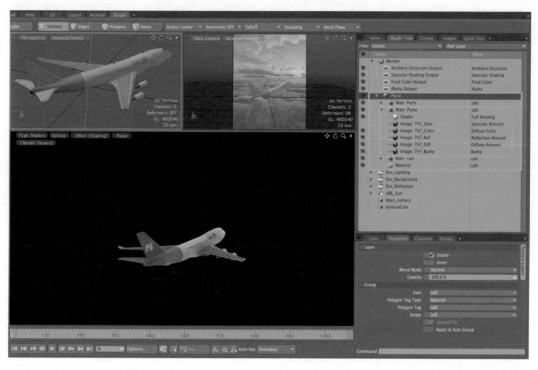

FIG 5.23 In the Shader Tree I created a master Group that holds all Groups that make up the plane's surfaces.
Source: Wes McDermott.

add a shader to the master Group. As with the material, the shader is used by all the SubGroups contained within the master Group. This allows me to globally set the Shading Rate for all the SubGroups. In this case of the Plane SubGroup, I added a shader because I wanted to control the Visible to Camera setting for the material this SubGroup was masking.

I mentioned that the Plane SubGroup was masking polygons. A Group can be masked by an Item, which is an object, by a polygon selection or by a material. In the case of the Plane SubGroup, it's masking by a material, as denoted by the Polygon Tag Type setting for the Group's Properties. When you select a set of polygons and hit the M key on the keyboard to create a material, you are creating a Group in the Shader Tree that has its Polygon Tag Type set to material, and the material chosen is the material you created in the Create New Material Dialog. There are other ways to set how a Group masks items such as using Selection Sets. I commonly use Selections Sets to control how a material is applied to a set of polygons. In Chapter 3, we discussed creating hair for a model. For that model, I used Selection Sets to create areas of the head through which I could create Hair Guides, as shown in **Figure 5.24**.

FIG 5.24 The Polygon Tag Type is set to the Selection Set that I want to link the Group to.

To illustrate the masking of the Groups using Selection Sets, I have disabled the h1 and h2 Groups. Notice that the Fur Material is no longer rendering hair for the Hair Guides that are associated with these Groups through Selection Sets as shown in Figure 5.25.

Group Masks

You can change any layer in the Shader Tree into a Group Mask by simply right-clicking its Effect and choosing Group Mask. A Group Mask will mask the Group in which it is located and will allow the Groups, materials, or image maps below it to blend through. It's a very effective way of blending materials. For example, in Figure 5.26 you can see that I am blending two texture maps by a third texture map that has its Effect set to Group Mask.

The metal color and bump maps are inside a group and the ground texture lives outside this group. To create the mask image, I used modo's paint tools to paint an image that would act as a mask to reveal the dirt texture below, as shown in Figure 5.27.

Once the mask image was created, I just needed to set its Effect to Group Mask. The layer then blended the texture in the Group with the texture sitting below the Group. I don't normally find myself using Group or Layer Masks in modo since, as I said before, I don't want to create a surface that is too

FIG 5.25 The Fur Material is no longer rendering the Groups that have been disabled.

FIG 5.26 A texture was painted in modo to be used as a Mask for blending two texture maps.

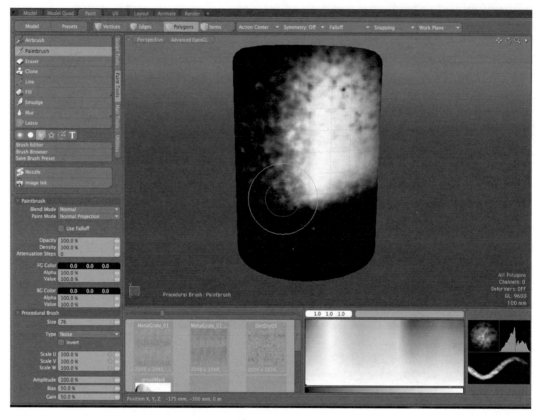

FIG 5.27 The mask texture was painted in modo. The black areas will reveal the texture below the Group.

complex to be exported correctly to other applications. However, if you plan on rendering your scene in modo, Group Masks are a powerful tool for setting up multilayered materials. Now let's take a look at texturing hair inside modo.

Texturing Hair

In Chapter 3, we discussed creating hair. In this section, I want to discuss texturing the hair that was created. We will look at the Fur Material as well as using Gradient texture layers and image maps to texture influence the color of the hair and fur.

Fur Material

In this section, I'd like to further discuss the Fur Material settings that were used to create the hair in Chapter 3. Let's first look at some key settings on the Fur Material Tab. To have the Fur Material behave more like hair, I've enabled the Use Hair Shader option. The Use Hair Shader function will create specular

highlights that run parallel to the fur direction, which in turn produces a more realistic highlight that mimics the characteristics of hair. The Dimension settings will control the length and spacing of the fur cylinders. The Width and Taper settings control the size of the cylinder at its base and tip. The Taper setting will taper the end of the cylinder. To create fine fibers such as hair, you will need to increase the Max Segments to a rather high value. This setting is effective by adding segments to the cylinders thereby letting the cylinder be able to bend more. Also, with hair you will need to increase the render density to make sure there are enough fibers to cover the head.

> 📖 **Tip:** Increasing the Max Segments can greatly increase the Geometry Cache. If you get an error that the Geometry Cache has been exceeded, you may need to increase your Geometry Cache Size in the System Preferences under the Render Tab.

Now let's check out the Fur Shape Tab settings. When using Hair Guides, I use Range for the Guide Settings. The Guide Range value sets the area around the root of the guide from where the fibers will "grow." The advantage is that when the guides overlap, the fibers will blend between the two guides based on the Blend Amount. With a Guide Length setting of 100 percent, the fibers will be generated to the length of the guide. Lower values will effectively shorten the hair fibers (such as getting a hair cut). The Blend Angle and Amount are very important settings when using the Range Guide Type. The Blend Amount controls the degree in which guides will blend between overlapping guide position, while the Blend Angle sets the maximum angle for blending to occur between the overlapping guides. In Figure 5.28, you can see the difference in the Blend Amount at 0 versus 80 percent blend.

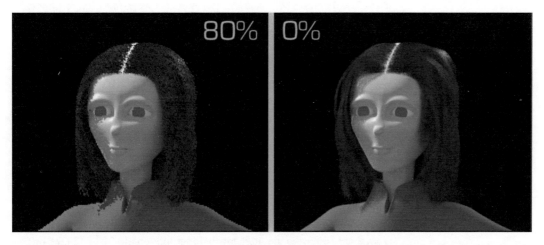

FIG 5.28 The Blending Amount and Angle are important settings when creating hair using the Range Guide Type. Notice that by adding a Blend Amount you can get the hair to lay straight as if it were combed, whereas with no blending it just looks like you are having a bad hair day.

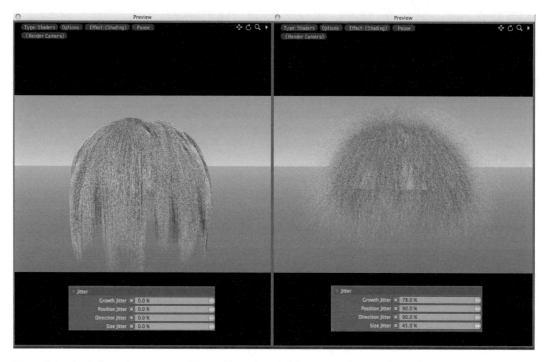

FIG 5.29 By lowering the Jitter settings you can cause hair to straighten, whereas high Jitter settings will cause it to become frizzier.

Finally, the Jitter and Bend properties control the direction and flexing of the hair fibers. The Jitter settings will apply a random look to the position, size, direction, and growth of the hair as shown in Figure 5.29. For creating hair, I set the Flex to 0 percent so I could get it lay more flat while low Jitter settings will help it to lay straight as shown in Figure 5.30.

Using the Strip Type

With the Fur Material, there are two types of geometry that you can create: cylinders and strips. We have already used cylinders, which are tiny tubes, to create hair, so now we'll take a quick sidestep from looking at hair to creating grass using the Strip Type. Strips are flat planes. You can map a texture onto these flat planes, and that is what I'll do to texture the grass. You can actually apply texture maps to the Cylinder Type as well, but for the purpose of creating grass, the Strip Type will work better. To create the grass, I created a plane and added a Fur Material to the Shader Tree. On the Fur Material's properties, I changed the Type to Strips and adjusted the Dimension properties using the Preview window until I reached some values that I liked. From there, I adjusted the Jitter and Bend settings on the Fur Shape Tab on the Fur Material properties. The Jitter settings control just what they say: size,

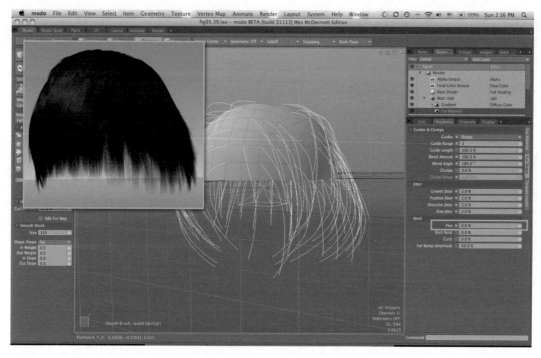

FIG 5.30 I find that changing the flex to 0 will help to get the hair lay flat.

position, and direction. Basically these settings help to randomize the grass blades. The Flex settings essentially "bend" the blades as shown in Figure 5.31.

Using the Preview Window makes this process very interactive and it's easy to find the settings you want visually. Once I had the Strips looking like grass, it was time to texture each Strip with texture map. I went outside and found a nice blade of grass and picked it from the ground. I then photographed the blade and created a color texture map as shown in Figure 5.32.

To apply the texture map to the Strips, change the Projection Type on the Texture Locator to Implicit UV. This will then apply the texture to each Strip or Cylinder in the Fur Material. In Figure 5.33, you can set the Projection Type to Implicit UV as well as the texture map is used to map the Strips.

Finally in Figure 5.34, you can see the rendered image of the grass.

Using Gradients

Let's once again look at the hair example. Now that we've looked at setting up the Fur Material, let's look at adding color to the hair by adding a Gradient layer. In the Shader Tree, above the Fur Material, I added a Gradient layer and set it to Effect to Diffuse Color. Next, I changed its Input Parameter to Fur

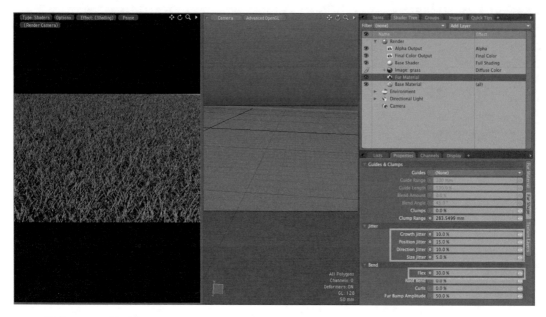

FIG 5.31 The Flex settings will bend the grass.

FIG 5.32 This is the color map used for the blades of grass.

Parametric Length. This Input Parameter maps values along the length of the individual fur fibers. On the Gradient, a key at 0 percent is mapped to the root of the fiber, while a key at 100 percent is mapped to the end of the fiber. In Figure 5.35, you can see the keys and color values that I have created on the

FIG 5.33 Using Implicit UV as the Projection Type, each individual Strip or Cylinder on the Fur Material will be mapped.

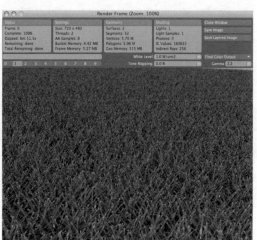

FIG 5.34 The grass was created using the Fur Material with the Type set to Strips.

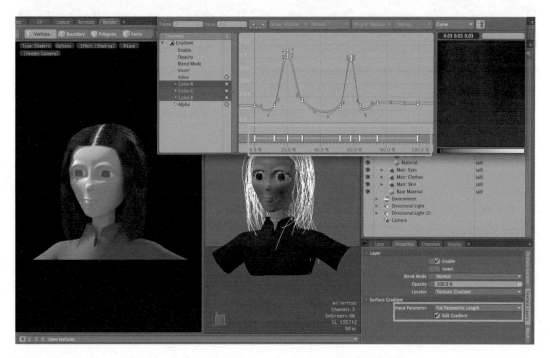

FIG 5.35 A Gradient with an Input Parameter of Fur Parametric Length was used to map colors to the individual hair fibers.

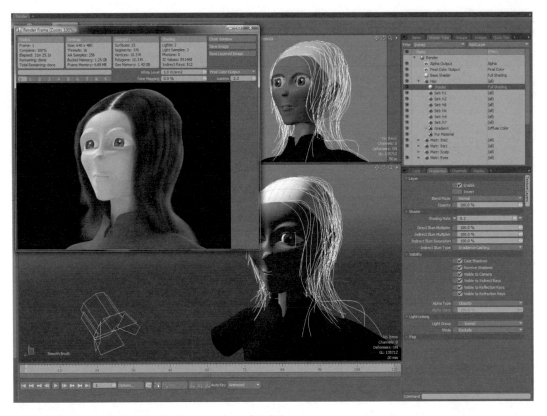

FIG 5.36 The hair was created using the Fur Material and several layers of Hair Guides.

Gradient and how these values translate to the hair fibers in the Preview Window.

In **Figure 5.36** you can see a render of the hair on the model.

Summary

In modo, texturing is quite a fun process. The integrated Painting toolset makes adding dirt and grime interactive while using the Preview Window to fine-tune textures and Material settings to greatly increase productivity. You can control the material properties organically by hand painting color, diffuse, specular, reflection, and bump maps. Also, using modo's Image Ink is a great way to quickly add dirt and grime to a map by sampling the subtleties found in a image. However, the true secret to creating texture is in studying the world around you and collecting reference images of surfaces you want to create.

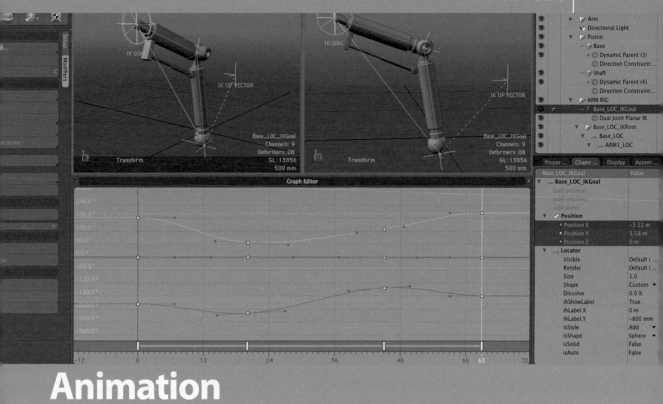

Animation

When modo was first launched, it was strictly a modeling tool. However, with each new release, modo is quickly becoming a full-featured 3D application. The animation toolset presented in modo 401 has undergone a major update. Great functionality has been added, such as Constraints and Dual Joint Planar IK. In this chapter, we'll discuss the use of Morph Maps and IK. In the process, we'll cover channel links, user channels, and constraints, which can be a valuable asset to everyday production.

📔 Animation is difficult to illustrate using still imagery. On the book's resource site, located at wesmcdermott.com, you'll find video walk-throughs that will clearly demonstrate the topics covered in the chapter, as well as demonstrate additional constraint types and animation tools found in modo.

Morph Maps

A Morph Map is a Vertex Map that contains offsets for vertices, which can be stored as either absolute or relative. A Morph Map is embedded into the object that it is added to, much like when creating a UV Map; and, as with a UV Map, any editing of the base mesh will transfer to the Morph Map. Morph Maps are most useful when creating blend targets for facial animation. The Morph Map is the "target" in which a user modifies the vertices on the Morph for the base mesh to blend to, such as a smile. In this section, I'll discuss how you can add the Morph Deformer to an object, and then set up a controller that uses User Channels to drive the blending between the Morph Deformers applied to the object. This example will demonstrate several tools that can be used in other projects and setups, such as Channel Links and Assembly Commands.

Working with Morph Maps

To begin, you'll need to have an object that has Morph Maps. In this example, I'll be using the OldManWithMorphMaps.lxo model that ships with modo. In Figure 6.1, you can see that the model has several Morph Maps applied. To create these maps, you can click the New Map text, which is found in the

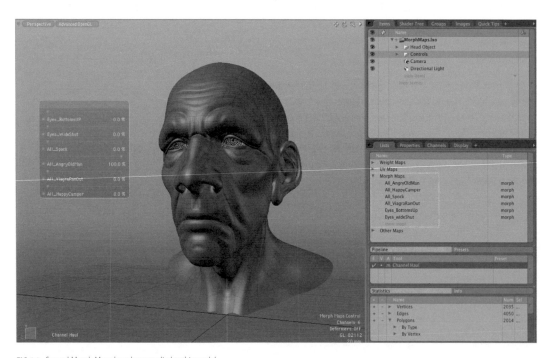

FIG 6.1 Several Morph Maps have been applied to this model.

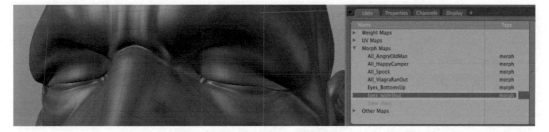

FIG 6.2 The vertices on the Morph Map have been offset from the vertices of the base mesh. This creates a "morph" target that the Morph Deformer can blend to and from.

Morph Map category in the Item List. A dialog box will appear asking you to enter a name for the map.

Relative Morph Map will be selected for the Vertex Map Type by default, which creates offset values for the vertices in the base mesh. Once the map is created, you just need to use modo's modeling tools to arrange the vertices on the base mesh to the desired target location, such as closing the eyes, as shown in Figure 6.2. The vertices of the base morph will not be affected.

Now that all of the morphs are in place, I will create a Morph Deformer and create a controller that I can use to interactively blend between the various morphs in the mesh.

Adding Morph Deformers

To animate the Morph Maps in the scene, we'll need to add some Morph Deformers to the head item. This is easily done in the Animate Viewport. With the head mesh selected in Item mode, I clicked the Morph button found in the Deformers category on the Modifiers tab. On the Properties Panel for the deformer, I chose the Morph Map that I wanted to associate the Deformer with. I then clicked the Add Morph Layer on the Properties Panel for the deformer to add a new Morph Deformer to the head mesh. Once the new deformer has been added, I can associate another Morph Map to the deformer; repeat this process until each Morph Map has been assigned a Morph Deformer, as shown in Figure 6.3.

Creating a Controller

The controller is simply a Locator item that has some user-defined channels attached to it. A User Channel is actually what it says. It's a user-defined channel that is added to the list of default channels, which can be used to assign custom animation properties for an Item. First, I created the Locator, adjusted its size, shape, and label. The locator was positioned around the head of the model, as shown in Figure 6.4.

FIG 6.3 A Morph Deformer has been associated with a Morph Map by adding a Morph Deformer, choosing a map, and then adding a new Morph Map Layer to repeat the process.

FIG 6.4 The locator has been positioned and given a custom shape.

FIG 6.5 A Dynamic Parent Constraint was added to the Locator to parent it to the head model so that the head model is moved, the morph control will follow.

Finally, I applied a Dynamic Parent Constraint from the Locator to the head model, so that wherever the head model is positioned, the morph control will follow. To do this, I simply selected the Locator, and then SHIFT selected the head and clicked the Add Parent button, which is found on the Modifiers Tab when working from the Animate Viewport, as shown in Figure 6.5. This added a Dynamic Parent Constraint to the Locator, that is also outlined in Figure 6.5.

Creating the User Channels

The next step is to create a relationship between the morph control and the Morph Deformers. First, I need to add some User Channels to the morph control Locator, by selecting the mesh control Locator and clicking the Add User Channel button on the Modifiers tab in the Animate Viewport. This will bring up the Create User Channel dialog box. In this dialog box, I named the Channel and changed the Type to Percentage, while setting a Min value of 0 and a Max value 100, because I want to control the Opacity Channel of the Morph Deformer, which has a range of 0-100%, as also shown in Figure 6.6.

This User Channel is being applied as a Channel on the morph control Locator. The User Channel will represent a link to the Opacity Channel of the Morph Deformer, which is used to animate the Morph Map. The reason for doing this is to create a controller, where I can easily get to and key frame the Morph Deformers. I repeated the process of adding a User Channel for each Morph

FIG 6.6 I am creating a User Channel to link to the Opacity Channel of the Morph Deformer.

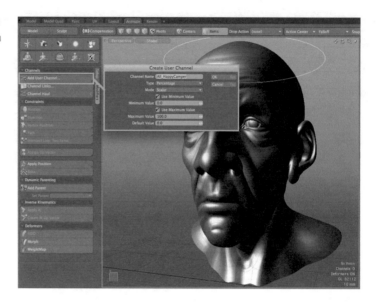

Map that I want to control, and these User Channels are located in the Channels for the morph control Locator.

The User Channels have been added to the morph control Locator; but since they haven't been linked to anything, they do nothing.

Creating a Link to the Morph Deformers

We will use Channel Links viewport to create a link between the User Channels and the Morph Deformers. With Channel Links, you can set up a direct link or relationship between channels to have one Item "drive" another. To establish the link, I open Channel Links by clicking the Channel Links button on the Modifiers tab in the Animate Viewport. The Channel Links window is split vertically where the left side holds the Channels for the "Driver" Item and the right side containing the "Driven" Item, as shown in Figure 6.7.

The Driver controls the Driven Item by establishing a link or relationship between the Item's Channels. To create a link between the morph control Locator and a Morph Deformer, I load the morph control Locator into the Driver side by selecting the morph control and clicking the Load Driver button at the top of the Channel Links window. Next, one of the Morph Deformers is loaded into the Driven side by selecting one of the Morph Deformers in the Item List and clicking the Load Driver button at the top of the Channel Links window, as also shown in Figure 6.7.

Now that the Driver and Driven items have been loaded into the Channel Links window, I need to select the Channels for the Driver and Driven items

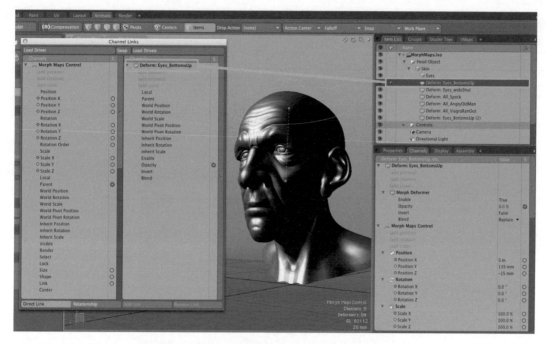

FIG 6.7 The Morph Deformer was added to the Driven side of the Channel Links window by selecting the Morph Deformer, and then clicking the Load Driven button in the Channel Links window.

that I want to link. For the Driver side, I need to scroll down through the list of the Channels for the Driver item until I find the User Channels that I added to the morph control Locator.

Direct Link

To establish a link, I need to select a Channel on the Driver side and a Channel on the Driven side of the Channel Links window, and then click the Link Button. To create a link that will control the Morph Deformer, I selected the All_HappyCamper User Channel on the Driver side, the Opacity Channel for the All_HappyCamper Morph Deformer on the Driven side, and then pressed the Link button with Direct Link selected, as shown in **Figure 6.8**.

By pressing the Link button, a direct link between the two Channels has been created. This means that the value set for the All_HappyCamper User Channel will translate linearly to the Opacity Channel for the Morph Deformer; i.e., setting All_HappyCamper to a value of 50 will translate to a 50% setting on the Opacity Channel. Establishing a Direct Link is exactly what I need to do. Remember that I set a Min and Max value of 0-100 for the User Channels. This range directly relates to the 0-100% opacity range for the Morph Deformer

FIG 6.8 The User Channel and the Opacity Channel have been linked.

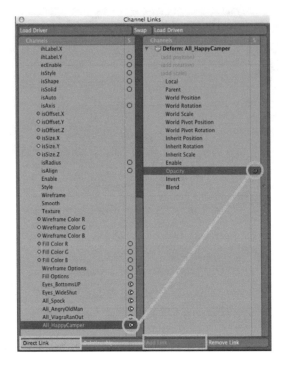

Opacity Channel. I then repeated this step for each User Channel/Morph Deformer that was created. You can also create a relational link to the Channels, which allows you to vary the way one Channel drives another. Although this method isn't used in the example, I'd like to discuss it for a moment so that you have a complete understanding of the linking process.

Relationship

Using Relationship as the link method allows you to vary nonlinearly how the link from the Driver to the Driven Item is applied. This is controlled through setting keys in the relationship interface window. Loading the Channels into the Channel Links window is the same process; however, before clicking the Add Link button, you'll need to change the link method to Relationship by clicking the Relationship button at the bottom of the Channel Links window.

This will link the Channels and bring up the Relationship Interface Window (Figure 6.9), which allows you to configure the relationship between the linked channels. The Driver and the Driven Channels appear in the dark gray areas of the window, and values can be set by Left Mouse Button (LMB) dragging the Driver or Driven Channel in the window. Using the white square button, you can set a key for the value; and, using the left- and right-pointing arrows, you

FIG 6.9 The controls for setting keys in the Relationship Interface Window.

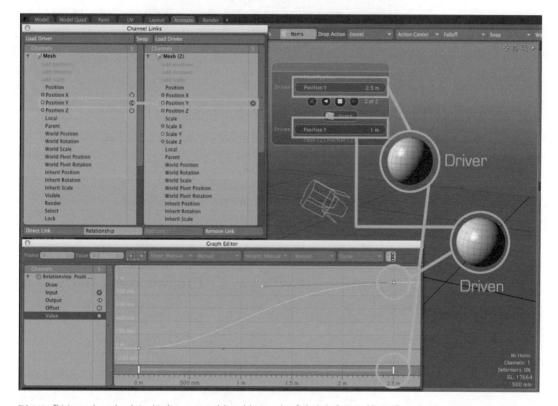

FIG 6.10 This image shows the relationship that was created through keying values for both the Driver and Driven Channels.

can navigate between key values. You can also click the Graph button to manually edit the values in the Graph Editor.

The way the relationship is configured is that you set a key for the Driver Channel, and then a key for the Driven Channel. What you are creating is a relationship that states when the Driver Channel reaches a certain value or keyframe, the Driven Channel will reach its value or keyframe that you set in the Relationship Interface Window. Let's look at an example. In Figure 6.10, sphere 1 has had its Y Position Channel set as the Driver, and sphere 2 has had

its Y Position Channel set as the Driven in a relational link. I have set a key for sphere 1 at 2.5m on the *Y*-axis. I then set a key for sphere 2 at 1m on the *Y*-axis. This means that when sphere 1 is at 0, sphere 2 will be at rest; but as sphere 1 begins to rise in the *Y*-axis, sphere 2 will also move. However, when sphere 1 reaches the 2.5m mark, sphere 2 will hit the 1m value that was set, as shown in **Figure 6.10.** The Graph Editor can be used to adjust keys and add easing to the values.

A relational link is different from a direct link in that it's not taking values linearly from one channel to the next. You can set when and where Channels will be linked by setting keys in the Relationship Interface Window and adjusting these keys in the Graph Editor. Let's now continue with the configuring the morph controller.

Configuring the Morph Controller

We left the morph controller at establishing a Direct Link between the User Channels and their corresponding Morph Deformers. As it stands now, you can select the morph controller, navigate to the User Channels found on the Channels Panel, select one of the Channels, and then hit the C key to activate Channel Haul. This will bring up a window that contains the Channel with a slider, as shown in **Figure 6.11.**

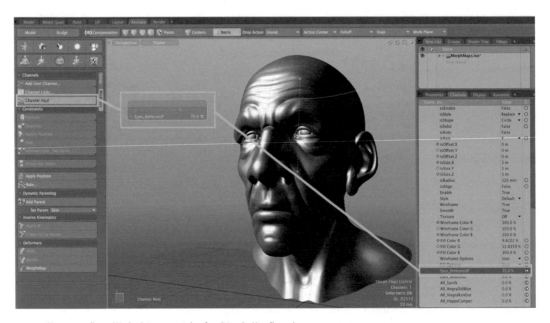

FIG 6.11 You can use Channel Haul to bring up a window for editing the User Channel.

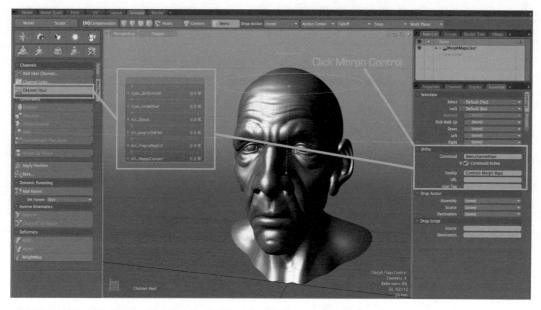

FIG 6.12 Using the item. ChannelHaul Command automatically activates the Channel Haul when the morph control Locator is clicked.

This is not the most ideal workflow, because we'll have to keep selecting the User Channels before using Channel Haul. We can further optimize the controller by adding an Assembly Command.

Adding an Assembly Command

Assemblies were briefly discussed in Chapter 2. In this case, we're not going to create a Rig, but we're going to take advantage of the ability to assign Commands in the Assembly Panel. By adding the item Channel Haul command to the Command input field in the Assembly Panel, the morph controller will automatically activate Channel Haul when the morph controller is left-clicked, as shown in **Figure 6.12**. This greatly streamlines workflow, because the User Channels will all be displayed without the need to select the Channels on the morph controller Locator. The morph controller has been parented to the head model, so at anytime I can simply click the morph control to bring up the User Channels that have been linked to the Morph Deformers, to quickly adjust the values.

Inverse Kinematics

In modo, you have the tools to create Dual Joint Planar Inverse Kinematics (IK) Chains. In this section, we'll discuss how to setup an IK chain in modo.

FIG 6.13 We'll be creating an IK rig for this robotic arm.

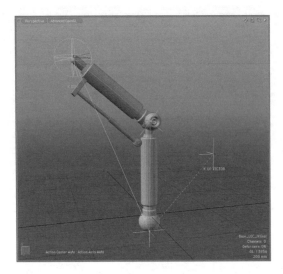

To illustrate this, I'll be using a simple example of a robotic arm, as shown in Figure 6.13. We will be covering how to set up up a hierarchy between Items for IK by utilizing Constraints; and we'll also cover using Constraints to set up the piston on the robot arm so that as the IK chain moves, the piston will expand and contract. Through exploring the robot arm, we'll cover most of the important aspects to setting up IK in modo. To begin, we'll first look at how IK works in modo.

Setting Up IK

To setup an IK chain in modo, you'll need to establish a hierarchy between three Items that you want to apply the chain to. This hierarchy is a simple parent/child relationship. For example, I will create three locators in an orthographic view, such as Right, and then establish a hierarchy by parenting each locator to the one before it, as shown in Figure 6.14.

When creating the Locators, I was careful not to place them in a straight line. Instead, I moved the second Locator out from the rest so that if you were to draw an imaginary line from one Locator to the next, there would be a bend (from Parent to Locator (2) to Locator (3)) instead of a straight line. This was done so that when IK is applied, the bend in the Locators will establish the preferred bending angle for the IK chain. Without this bend, modo won't be able to create the IK chain.

Once the hierarchy has been established, you need to select the hierarchy by double-clicking the top level Item in the Item List, and then select Apply IK

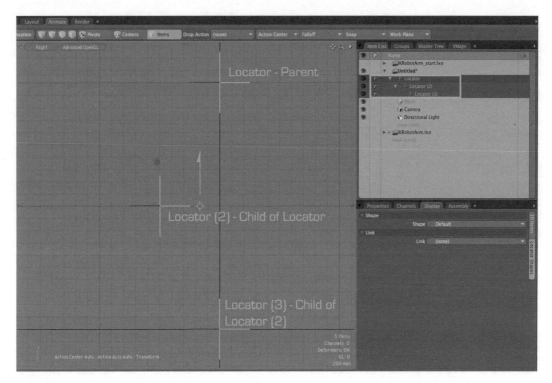

FIG 6.14 The Locators are parented to create a hierarchy.

on the Modifiers Tab in the Animate Viewport. From there, you will be prompted to automatically align the Item Axes, in which you just need to click OK. Now, you will have an IK chain applied to the locators, as shown in Figure 6.15.

Applying IK in modo is a basic process. Now let's take a look at applying IK to an actual mesh.

Rigging the Robot Arm

When rigging in modo, I always tend to use Locators and then parent the mesh to the Locators. You can create a hierarchy from mesh Items, and then apply an IK chain to it; but I prefer to work with Locators, as I feel it keeps the scene a bit cleaner and I'm used to working with Bones in other applications. Because modo doesn't have Bones, I use Locators as a substitute. The robot arm is separated into a base arm, upper arm, and piston, which have a base and a shaft, as shown in Figure 6.16.

FIG 6.15 The IK chain has been applied to the Locators. By moving the IK Goal, you can animate the chain.

Creating the Locators

To begin, I created three locators and carefully aligned them on the areas of the robot arm that will rotate and bend. For instance, the base Locator is placed at the base of the arm, and the elbow locator is placed at the elbow joint of the arm. Finally, the tip Locator is placed at the tip of the upper arm, where the wrist is located. This is done to ensure that the robot arm rotates and bends appropriately. I then created a hierarchy for the Locators as follows: the Locator at the base of the arm is the parent for the Locator at the elbow, and the elbow Locator is the parent for the locator at the tip of the arm. You can see this hierarchy in Figure 6.17.

Aligning Centers

The next step is to adjust the Centers for each part of the robot arm so that when the mesh Items that make up the arm are parented to the IK chain, the mesh will rotate and bend correctly. This is easily done in modo using the Center Position command. For example, I can align the Center for the base arm by selecting the base arm in Item selection mode, SHIFT selecting the base Locator, and then clicking Center Position, which is found as a suboption

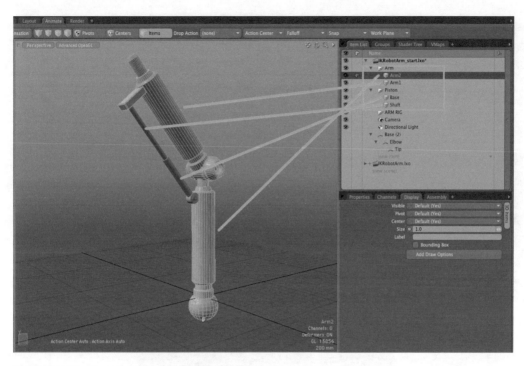

FIG 6.16 The robot arm is constructed from multiple mesh Items.

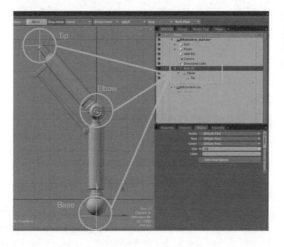

FIG 6.17 The locators have been parented in a hierarchy, and they have been positioned at key areas on the robot arm.

under Match Position in the Match and Align category on the Setup tab in the Animate Viewport, as shown in **Figure 6.18**. To get to the Center Position, you will need to click and hold Match Position until a Popup window reveals Center Position as a suboption.

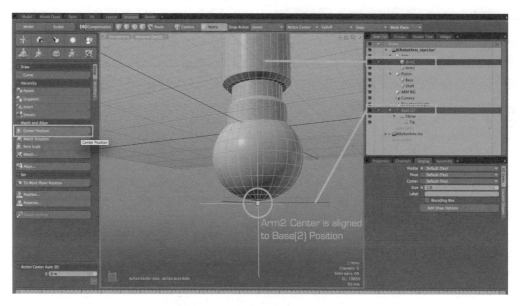

FIG 6.18 Center Position will align the Center of the first selected Item to the Position of the second.

FIG 6.19 The upper arm's Center is placed at the area where it will rotate around the base arm.

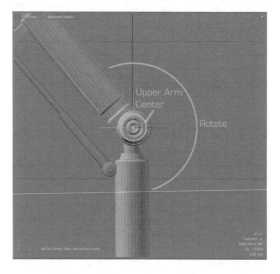

This procedure is then repeated for the upper arm. The upper arm's Center is placed where the upper arm will rotate around the base arm, as shown in **Figure 6.19**.

Now that the Centers for the upper and lower arm Items are set correctly and a hierarchy has been established for the Locators, we can now create the IK chain from the Locators.

Create the IK Chain

At this point, we can create the IK chain. To do this, I double-click the base Locator; and since it's at the root level, everything in the hierarchy will become selected. I will now be able to create the IK chain by selecting Apply IK on the Modifiers tab in the Animate Viewport and clicking OK to the prompt to Align Item Axes as shown in Figure 6.20.

The IK will be applied to the Locators. A line will be drawn from the Goal Locator, which is the Item that the IK chain will attempt to follow. The Goal Locator will appear in the Item List with the postfix tag IKGoal, and the Locator hierarchy will be grouped and given the postfix tag IKRoot, as shown in Figure 6.21.

The next step will be to associate the robot arm meshes to the Locator hierarchy, so that the mesh will follow along with the IK chain.

Parent Mesh to Locators

To parent the arm meshes to the Locators, I use the Dynamic Parent Constraint. The procedure is to select the mesh, SHIFT select the Locator, and then press Add Parent under Dynamic Parenting on the Modifiers tab in the Animate Viewport, as shown in Figure 6.22.

However, notice in Figure 6.22 that there is problem. The base arm has snapped to a new position because it inherits the transforms of the parent, which is the

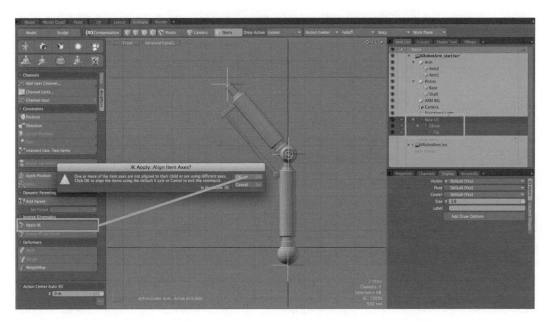

FIG 6.20 The IK chain is applied to the Locator hierarchy.

FIG 6.21 A Goal will be applied and will have a postfix of IKGoal.

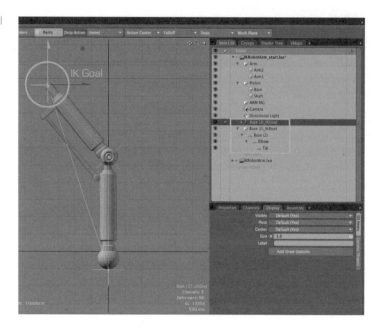

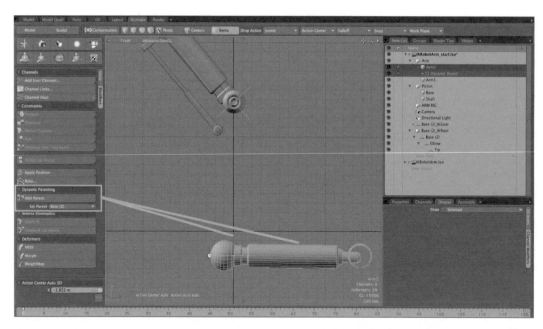

FIG 6.22 With Dynamic Parenting, the first Item selected will become the child of the second selected Item.

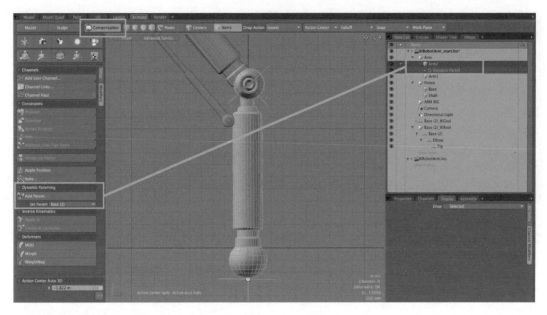

FIG 6.23 Compensation will retain an Item's Position when it is parented to another Item that has had transforms applied.

base Locator. To fix this, I just need to activate Compensation before parenting the Items. Compensation will retain the Item's original Position when parented, located at the top of the Animate Viewport. In Figure 6.23, I've parented the base arm to the base Locator with Compensation active. Notice that the base arm mesh retains its position. You can also see that a Dynamic Parent Constraint has been added to the base arm in the Item List.

The same process was used to parent the upper arm to the second Locator positioned at the arm joint. Once both mesh Items have been parented to the Locators, the meshes will now follow the IK chain, as shown in Figure 6.24.

Adding Up Vector

Now that we have the IK chain working, I'll want to create an Up Vector for the chain. The Up Vector simply tells the chain which way is up. This will help the chain not to get mixed up when it's trying to solve the direction, as shown in Figure 6.25.

To apply the Up Vector, you need to select the IK Modifier by clicking the plus sign next to the IK Goal in the Item List, and selecting the Dual Joint Planar IK Modifier. Next, you select Create IK Up Vector found under Apply IK on the Modifiers Tab in the Animate Viewport, as shown in Figure 6.26.

Now that we've corrected the Up Vector, we will set up the piston so that it expands as the arm extends and contracts as the arm shortens.

181

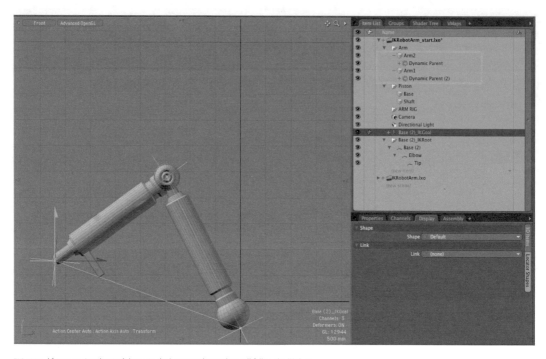

FIG 6.24 After parenting the mesh Items to the Locators, the meshes will follow the IK chain.

FIG 6.25 Without an Up Vector assigned, the IK chain flips when rotated on the *Y*-axis.

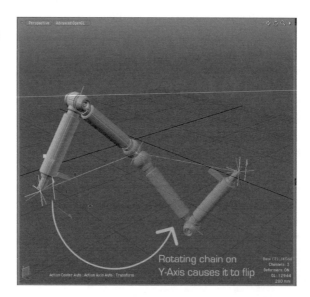

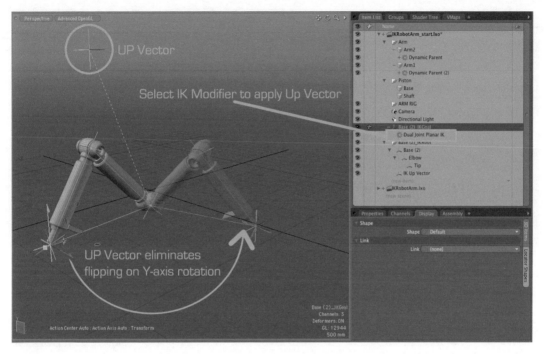

FIG 6.26 Creating an Up Vector eliminates the flipping.

Rigging the Piston

Before I begin discussing the piston setup, I would like to mention that on the Luxology Asset Sharing site, there is an Assembly that will quickly help you to setup a piston.

However, instead of showing the piston Assembly, I want to illustrate how to do this manually so that you can see the process. I'd like to thank Mark Brown and Rich Hurrey for helping me to understand this rigging process. The piston is created from two meshes, a base and a shaft. The idea is that as the robot arm extends out, the shaft will extend from the base of the piston; and as the robot arm contracts, the shaft is pushed back into the base of the piston, as shown in Figure 6.27.

Adjusting Centers

The first thing to do is to adjust the Centers for both the shaft and the base of the piston. To do this, I selected the base; and in Center select mode, selected the Center and positioned it so that the base of the piston would rotate from the end of the base where the piston is attached to the base arm mesh. Next, the Center for the shaft is positioned at the point where the end of the shaft is attached to the upper arm by selecting its Center and moving it

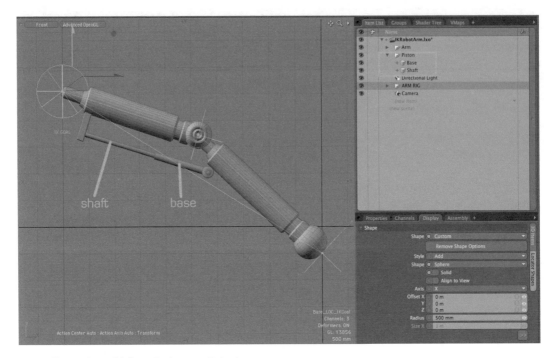

FIG 6.27 The piston base and shaft extend and contract with the robot arm.

into position with the Move Tool. In Figure 6.28, you can see the Centers placed in their appropriate positions. Positioning the Centers correctly is important because if they're set incorrectly, then the shaft will not line up with the base of the piston.

Parenting

Now the shaft and piston base need to be parented to the robot arm. I will use Dynamic Parenting again to accomplish this task. I will need to parent the piston base to the base of the robot arm, and the shaft to the upper robot arm. Again, this is done by first selecting the item I want to parent, the piston base, and then select the Item I want to parent it to, which in this case is the base of the robot arm. With the Items selected, I just need to click the Add Parent button on the Modifiers tab in the Animate Viewport, as we've previously discussed. Finally, I need to parent the shaft to the upper robot arm. Once the parenting has been set, the shaft and the piston base will now move with the robot arm; however, they will not be working correctly, as shown in Figure 6.29.

Adding Constraints

The idea is to have the shaft and the base of the piston always pointing at each other, so that they will align with each other. I can simply use a Directional

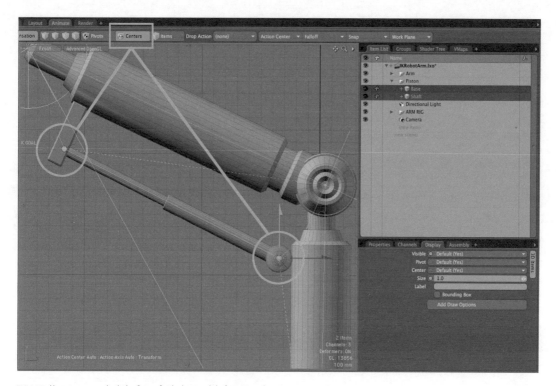

FIG 6.28 Here you can see both the Center for the base and shaft positioned.

FIG 6.29 The piston items are following the arm, but they're not aligning correctly.

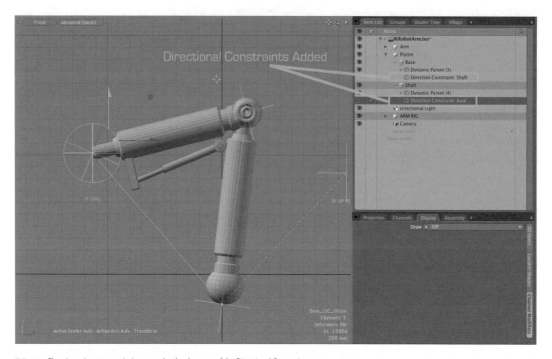

FIG 6.30 The piston items are pointing at each other because of the Directional Constraint.

Constraint, which will cause the Items to point or look at each other. To do this, I selected the base of the piston and then SHIFT selected the shaft, which is the item I want the base to point at, and clicked the Directional Constraint button found on the Modifiers tab under Constraints in the Animate Viewport to apply the constraint. Next, I selected the shaft and SHIFT selected the base of the piston, and added a Directional Constraint. In Figure 6.30, you can see the working robot arm and piston Items with Directional Constraints applied.

Summary

In this chapter, we discussed how to create a controller to streamline the workflow for working with Morph Maps. We discussed adding User Channels and establishing links and relationships via the Channel Links window. We also discussed how to apply IK to a robot arm with the use of Constraints, such as Directional and Parent. There are more Constraints and animation tools to cover; these aspects of modo will be explored through the bonus videos at wesmcdermott.com.

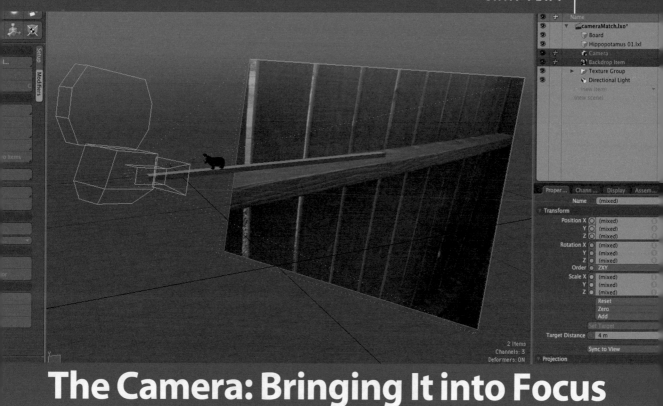

The Camera: Bringing It into Focus

Setting up the camera in a 3D scene can be broken down into two categories. The first category is purely an artistic perspective. It's your idea, story, or vision that dictates how the camera will be positioned. The second category deals with matching a real-world camera, which will provide the 3D camera's settings. Because your render will come from the camera's perspective, it plays a vital role in every 3D scene. This chapter covers several topics that will help you better understand how you can use the camera to improve your renders. Let's begin with looking at the 3D camera itself and how it relates to its real-life counterpart.

The Camera

As I mentioned earlier, the camera's perspective dictates what is rendered in the scene. Now, you don't have to know everything about real-world cameras to set up your 3D scene, but the more aspects you're familiar with, the more realistic your scenes will be. Most images that we see come from cameras. Think about TV shows, movies, or even the family pictures you take. We are so used to seeing life through the eyes of a camera. In fact, we are so used to it

FIG 7.1 The camera's Properties panel holds the controls for setting up our camera and mimics the settings on a real-world camera.

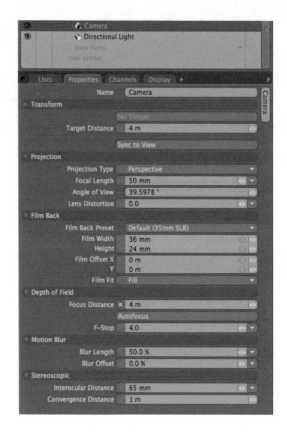

FIG 7.1 The camera's Properties panel holds the controls for setting up our camera and mimics the settings on a real-world camera.

that images without certain artifacts such as lens flare, distortion, and blooming tend to look fake. Even if it's only on a subconscious level, our brains will register that something looks wrong. In this section, we are going to look at these types of characteristics and how we can simulate them in a 3D environment. The camera controls that we'll be looking at are found on the camera's Properties panel as shown in Figure 7.1.

Focal Length

The Focal Length setting in the camera's Properties panel controls how much of the scene we can see and is tied to the Angle of View. Changing one will change the other. By increasing the Focal Length, you will be inadvertently lowering the Angle of View as you can see in Figure 7.2.

Although you can type in any number, it's best to work with millimeters because that is what the Focal Length of real lenses is measured in. It's much easier to think in terms of real-world lenses. A lens that is considered normal is a lens that best reproduces a perspective similar to how we see. For example, a

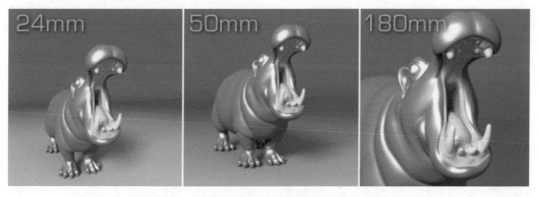

FIG 7.2 Lower focal length values will create a wide-angle lens, whereas higher values will have the effect of zooming in the lens.

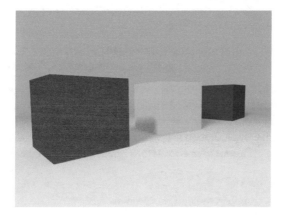

FIG 7.3 The camera's Focal Length was set to 24 mm. Notice that all the blocks are visible.

normal lens on a 35-mm camera is 50 mm, while a wide-angle lens could be thought of as anything below 28 mm. However, as we'll discuss in the next section, the Film Back setting has a major bearing on what lens is considered "normal" for the particular Film Back that is being used.

Perspective Compression

Although lens distortion is a characteristic of the Focal Length, we'll discuss this more later. For now, I want to discuss one other characteristic of Focal Length and that is perspective compression. When you increase the Focal Length, such as to 180 mm, you get the effect of compressing the perspective. Now, this is not accomplished by just changing the Focal Length; you have to move the camera as well. For example, look at Figure 7.3. In this scene, the camera's Focal Length was set to 24 mm and all the blocks are visible in the camera's view.

FIG 7.4 The camera's Focal Length was set to 180 mm. Notice that most of the blocks are out of view.

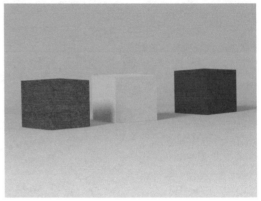

FIG 7.5 The camera's Focal Length was set to 180 mm, and the camera was pulled back. Notice how the perspective has been compressed.

When the Focal Length is changed to 180 mm, the lens zooms into the scene and most of the blocks fall out of the camera's view as shown in Figure 7.4.

Now in Figure 7.5, the camera's Focal Length was not only changed to 180 mm, but the camera was pulled back in the Z-axis to get all the blocks in the Angle of View. The side effect of this is that the perspective is now compressed and shallow. Although the blocks are positioned one after the other, the overall proportions of the boxes look similar due to the compressed perspective.

> 📖 **Tip:** Unless I am going for a unique angle, I typically will try and compress the perspective in my scenes. In order to avoid any distortion, a wide-angle lens will display on the objects, and I'll typically use a Focal Length of 105–135 mm. I find this works particularly well when rendering head models because I don't want to exaggerate any proportions on the face such as the nose.

Film Back

In a real camera, a film negative is positioned between two plates, which are called the Film Back and the Film Gate. The negative rests on the Film Back and is held in place by the Film Gate as shown in Figure 7.6.

The Film Gate is a metal plate that rests in front of the negative and only exposes a portion of the film to light. The region that the Film Gate is exposing is what modo is simulating to match a real camera and is expressed by the Film Width and Height parameters that are located in the camera's Properties panel. The Film Width and Height represent our virtual film that is loaded in our 3D camera within modo and is measured in real-world units.

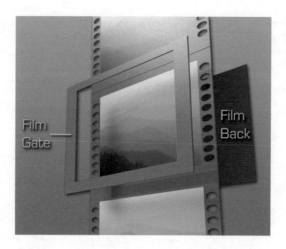

The Film Back Preset parameter holds a list of different types of cameras. These values represent the size of the film negative in a camera. By changing the preset, modo will set the Film Width and Height appropriately. Earlier I mentioned that changing the Film Back would have an effect on the Focal Length as well. In Figure 7.7, you can see two cameras that have the same Focal Length of 50 mm but have different Film Backs. The camera on the left has a Film Back Preset of a 35-mm single lens reflex (SLR), and the one on the right has a 35-mm 2 K 1.85 projection preset. As you can see from the dotted lines that represent the Angle of View, the 50-mm Focal Length works out to be a normal lens on the 35-mm SLR Film Back, but on the 35-mm 2k back, it appears to be more of a telephoto lens.

The Film Back Preset in modo plays a vital role when matching to a real-world camera. However, to correctly match the camera, we need to understand how these settings, which represent real-world measurements in millimeters, relate to the render resolution, which is output in pixels.

The Resolution Gate and Film Aspect Ratio

When talking about the Resolution Gate, I am actually referring to the Frame Width and Height settings that are found in the Frame settings under the Render Properties panel. The Frame Width and Height are measured in pixels and can be represented as a ratio. For instance, by taking the width and dividing it by the height, you will get an aspect ratio.

The Resolution Gate is measured in pixels and is the size that is output when the scene is rendered. When matching a real-world camera, it is vital that the Resolution Gate's aspect ratio matches the Film Gate's ratio. The good news is that modo will handle the matching for you. For instance, when you choose a

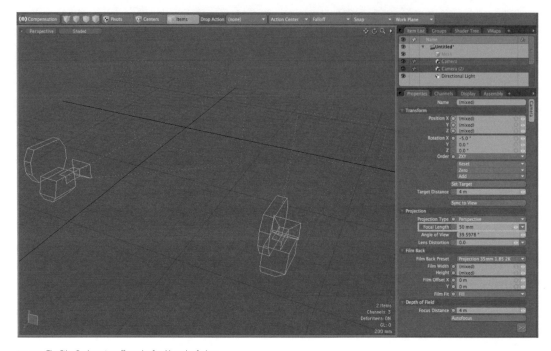

FIG 7.7 The Film Back setting affects the focal length of a lens.

Film Back Preset, the Film Gate is expressed in Film Width and Height, and the Resolution Gate is set accordingly. This means that with the camera's Film Back being set at the 35-mm default, the Resolution Gate and the Film Width and Height aspect ratios will match. However, this only works with the presets. If you are going to be matching a specific Film Back, you will need to also properly set the Resolution Gate.

If you find that your Film Gate and Resolution Gate aspect ratios are not matching, you can use the Film Offset and Film Fit parameters to control how the Film Gate relates to the Resolution Gate. However, I find this difficult in modo because there isn't a way to visualize the Film Gate and Resolution Gate when looking through the camera as in other apps such as Maya.

Depth of Field

Depth of field (DOF) in photography relates to how much of a scene is in focus. With a real camera, DOF is affected by the range set on the focus ring and also by the lens's aperture. An aperture in a camera is like the pupils in your eyes. When the pupil dilates, more light is let into the eye. When it becomes too bright, the pupil will become smaller to let in less light and protect your eye from damage. The camera's aperture is much like a pupil in that opening it lets

FIG 7.8 The F-Stop setting controls DOF in the scene.

in light and closing it lets in less light. In photography, an aperture setting is called an F-Stop, and closing down an aperture is referred to as stopping down. As mentioned above, the F-Stop setting will affect the DOF in that a larger F-Stop will decrease the DOF and stopping down the lens will increase the DOF. It's kind of similar to the effect of squinting your eyes to make things look sharper. In modo, DOF is controlled on the camera's Properties panel.

Adjusting the F-Stop setting controls the DOF in the scene. By lowering the F-Stop value, you will decrease the DOF and increase the out-focus blurring in the scene. Although there are presets for setting a DOF that matches real-world lenses, I find that to increase the blur I need to lower the settings much more. In Figure 7.8, you can see how the F-Stop was set to 0.08 to get the extreme DOF effect. You can also see that the Ruler tool shows the distance that was set in the Focus Distance setting. Adding DOF not only adds style to your renders, but it also increases realism. However, I find that rendering DOF is not always the best solution. It's usually better to handle DOF in post where you can have full control over the effect in real time without having to constantly rerender. In Chapter 9, we'll discuss how this can be done using Render Outputs to create a Depth pass.

Lens Artifacts

Although professional lenses are made from very expensive glass and much is done to reduce the elements inside to cut down on light reflecting, the fact is that lenses will always produce certain artifacts. It's our job as 3D artist to recreate these types of artifacts in our renders to increase realism and style.

Lens Distortion

As I mentioned earlier, wide-angle lenses will produce distortion in the form of a curvature of the scene. Light passes through a curved lens that bends the light toward the aperture, producing the distortions we are so familiar with. Rendering in 3D has no lens, so all the rays travel in perfectly straight lines, eliminating the effects we see as pincushion and barrel distortions. Modo offers the ability to simulate the bending of the light rays with the lens distortion settings. By adjusting the value for this setting, you can introduce a barrel or pincushion distortion depending on the setting you choose. For example, Figure 7.9 shows a barrel distortion applied to the scene.

This effect can be valuable to matching a real-world lens, but I typically wouldn't render this effect from modo. I prefer to apply this effect in post as well. A good workflow for compositing CG elements into a real-world scene would be to remove the lens distortion from the background plate in a compositing application, render CG without distortion, composite all elements without distortion, and when the composite is complete, reapply the lens distortion to the entire composite. Again, it is better to be able to adjust effects in real time within a compositing app and not have to worry about rerendering. I found a great Shake macro by Eddie Offermann for removing

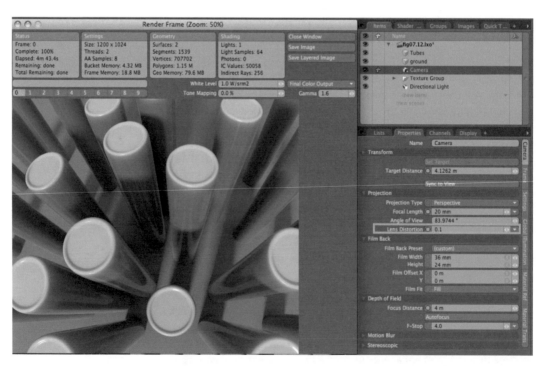

FIG 7.9 This image was rendered with a distortion value of 0.1, which will produce a barrel distortion.

FIG 7.10 This image was rendered without distortion. It was applied in Shake to match modo's rendered distortion of 0.1.

and applying lens distortion, and it can be found at www.shakeartist.com. In Figure 7.10, you can see how I rendered the modo scene without lens distortion and applied it in post using the same values from Figure 7.9.

Specular Bloom

Specular bloom is where bright areas in a scene appear to glow. It is actually an artifact of the film in the camera. When very bright light hits the film emulsion, the energy bleeds toward the surrounding areas, producing the bloom artifact. This effect can come from an actual light source or a light source that is reflected off a reflective surface. In Figure 7.11, you can see a specular hit and how it appears to glow and bleed into the background.

Specular bloom is going to be noticeable at glancing angles or the angle of incidence. The bloom is going to become more or less pronounced as your perspective on the object changes. I find that the secret to creating convincing bloom is to render and composite in 32-bit linear floating point. Working in linear space will be covered in-depth in Chapter 9. For now, just understand that with linear floating point, we are working in 32 bits, which allows us to work with pixel values that can extend beyond 1.0, which is a high dynamic range image. This lets us create highlight values that can become very intense just as they would exist in reality. The linear part just creates an environment that allows us to composite light realistically. Having said that, you can also

FIG 7.11 The specular bloom on the stop sign.

create bloom with 8-bit renders. I happen to prefer the 32-bit route, and for the next few examples, I'll be covering that approach.

To create specular blooming in modo, I never use the Bloom controls that are found in the Final Color Render Output. Instead, I render a specular shading pass and use that pass in a compositing application to create the bloom. For example, in a compositing application that supports 32 bits such as Shake, I will blur the specular shading pass and then add this over top of the final color pass.

The key here is that I can use an Add node to layer the images because I am working in a linear space. In the real world, light is added linearly, so by adding the bloom in linear space, I am creating the composite as it would work in real life. Again, this is covered in Chapter 9, but it is important to mention it here because it is a part of the workflow I use for creating lighting effects such as bloom. If I were doing this composite in 8 bits, I could use a Screen blending mode much like the Screen Layer Blend mode that is found in Photoshop.

In Figure 7.12, you can see the effects of creating a post-bloom effect in Shake.

To illustrate the difference between creating bloom in 32 bits versus 8 bits, check out Figure 7.13. By creating the composite in linear space, I get a lot of realism for free such as the nice halo and light blooming. Once the blur is

FIG 7.12 In this image, you can see the blooming and how the final color and specular shading passes were added together.
Source: Wes McDermott.

FIG 7.13 Notice how much more realistic the 32-bit composite is over the 8 bits.
Source: Wes McDermott.

applied to the spec pass, the light blooming looks realistic in linear space, where as in 8 bit or video space, I'd have to work to get the same effect.

In this image, you can clearly see that the 32-bit linear composite is much more realistic. In the circle highlight, notice that the 32-bit bloom has a halo-like effect as it bleeds over the top edge to the bottom of the wing. This

FIG 7.14 Notice how the bloom is much brighter in the 32-bit version. Also, the edges bleed into the background much nicer.
Source: Wes McDermott.

effect is nonexistent in the 8-bit version. Also, the bloom is not nearly as bright in the 8-bit version as in the 32-bit version. That has to do with the fact that with 32 bits, I had access to pixel values much greater than 1.0. When trying to create the 8-bit example, I had a lot of trouble even getting the bloom to show. I had to layer the specular shading pass over itself several times to build up enough density. I couldn't simply add a levels adjustment and crank the highlights up because with 8 bits the values can never exceed 1.0, and this makes it very difficult to get a realistic effect. One final point to stress with this sample is that with 8 bits, you get banding in the bloom areas, where as in the 32-bit version it's very smooth as shown in Figure 7.14.

Lightwrap
I also associate bloom with lightwrap. Lightwrap is when an extremely bright background object "blooms" on film. The glowing edge is obscuring the edge of a foreground element, which is what causes the light to "wrap" from the background over the foreground.

The Bokeh Effect
I've heard this effect pronounced in so many different ways that; I wonder if anyone knows how to actually pronounce it correctly. Personally, I go with boke-uh, as that's the pronunciation I've heard the most. Bokeh is a Japanese term that means blurred or fuzzy, and the Bokeh effect refers to the geometric shapes that can appear when highlights are defocused by using a shallow DOF. These shapes, as shown in Figure 7.15, are typically circular and differ from lens to lens.

In photography, this effect can be used to draw attention to a subject such as when shooting a portrait. It's a very stylistic and pleasing effect and can help to dramatize your render.

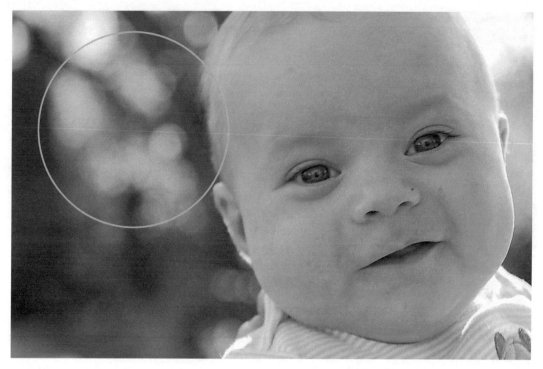

FIG 7.15 You can see the circular patterns that appear as highlights are defocused due to the shallow DOF. (Thanks to my son Logan for smiling for this image.)

In modo, there isn't a Bokeh filter or shader such as in mental ray. Although modo does support Bokeh, there's no setting for it. It is simply part of the renderer. The main limitation is that it's fixed at a circular aperture and one typically needs to max out the Anti-Aliasing passes to produce acceptable results. This is why I'd rather produce this effect in post. This effect will work best when using a shallow DOF and a "long-lens" or a large focal length. However, I find that as with specular blooming, rendering in 32-bit float and using the high-dynamic range in the scene, the effect will be much more pronounced and visually appealing.

In Figure 7.16, you can see a render from modo that has had the highlights blurred to create the Bokeh effect. In this scene, the lighting was cranked up beyond 1.0, creating super-white values and was composited in linear space. Again, this is detailed in-depth in Chapter 9. For now, just know that these intense lighting values are stored when the render is saved in high dynamic range format. Now, when this file is then blurred in a compositing application that supports 32-bit float, the intense values in the file will smear and blend as they would in the real world.

FIG 7.16 The post blur was added in Fusion 5.3. The effect on the right was rendered in 32 bits, and the image on the left was 8 bits.

Take another look at Figure 7.16. This effect was composited in Fusion. The image on the right was rendered in 32 bits and composited in 32-bit linear FP, whereas the image on the left was rendered in 8 bits. Notice the bright values in the image on the right and how nicely the edge blur is bleeding into the background, whereas the blurred edges on the left-side image feather off into gray.

As I said earlier, the Bokeh effect can produce a shape on the blurred highlights because the effect is being created by the curvature of the iris in the lens. For example, in Photoshop you can use the Lens Blur filter to add these shapes as shown in Figure 7.17. This effect doesn't support 32-bit values, so I tend to render 16-bit files from modo if I know I will be adding the Bokeh effect.

Another thing to keep in mind is that when you're not working in a linear environment such as in Figure 7.17, the blur around the edge can appear dark if you apply the Lens Blur on a layer with transparency. In Photoshop, you can use the Defringe option in the Layer menu to remove the black matting. In Figure 7.18, you can see how applying a Defringe to the layer will affect the overall image.

FIG 7.17 You can use the Lens Blur effect in Photoshop to apply a Bokeh effect to your render.

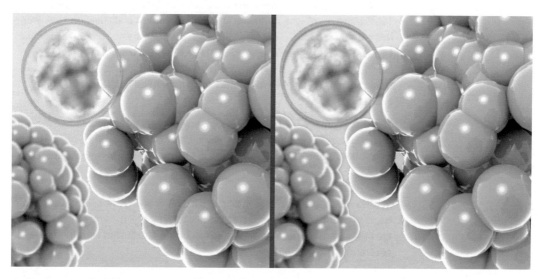

FIG 7.18 You may need to Defringe the layer as shown on the left, to remove the black matting.

FIG 7.19 In this image, you can see blue and reddish color wrapping around the edges of the branches.

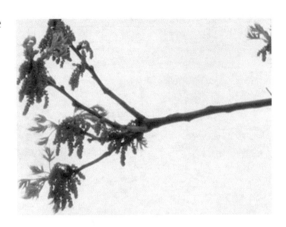

FIG 7.19 In this image, you can see blue and reddish color wrapping around the edges of the branches.

Chromatic Aberration

Chromatic Aberration is another lens artifact, and it occurs because a lens will have a different refractive index for each wavelength of light. Similar to how a prism will separate a light into a rainbow of colors, a lens will disperse light wavelengths unequally, and as a result you will see a color fringing in the high-contrast areas of an image. The light dispersion occurring on the lens is called Material Dispersion. In Figure 7.19, you can see the effect in this enlarged photograph of tree branches.

Modo doesn't have a setting for Chromatic Aberration. You can fake it by putting an actual "lens" mesh in front of the rendering camera and set it to be 100% transparent with refraction and a small amount of dispersion. However, this is another effect that is best created at the compositing stage. I use Shake to add Chromatic Aberration because I found a great free macro created by David Wahlberg, which can be found at www.pixelmania.se. In Figure 7.20, you can see the effect applied to a render from modo. Notice the color fringing along the edges.

Adding Chromatic Aberration to your renders is a major step to adding realism. It's a subtle effect but it goes a long way. It's an effect that can be noticed in most photographic images, especially in images taken with digital cameras.

Lens Flares and Glints

In this section, I'll discuss the importance of flares and glints and how they can be used to enhance your rendered elements. Typically, these are elements that are best created in post because they can be easily adjusted without the need to rerender the scene.

Flares

Lens flares occur as light scatters across the surface of the lens and are reflected off the lens's internal mechanisms. In Figure 7.21, you can see an image

FIG 7.20 In this close-up view, you can see the color fringing along the edges of the rendered tree.

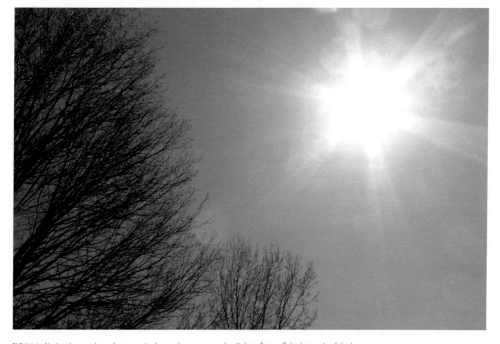

FIG 7.21 Notice the streaks and geometric shapes that are created as light reflects off the internals of the lens.

that shows a lens flare. The key to using lens flares is to make them subtle. Lens flares have been extremely over used in 3D, and nothing looks cheesier than an obvious computer-generated lens flare streaking across your image.

I increased the levels to make the geometric shapes and streaking more apparent. When creating lens flares, it's good to have several references of real lens flares that you can study. Different lenses and focal lengths are going to produce different flares. For example, as light reflects off a lens iris with five blades, it will create a pentagon shape. This is the Bokeh effect at work, as the reflections on the lens elements are severely out of focus but very bright. When the reflections bounce off the lens element and through the aperture, it takes the shape of the aperture itself, which in this case is a pentagon shape.

There is also not an option to create lens flares within modo, so you'll need to go into another application to create the effect. There are several options depending on what application you plan on compositing the flare. Probably the best option would be to use Knoll's Light Factory plug-in. This plug-in is available for Photoshop, After Effects and, other applications. It's been used in Hollywood FX shots and provides an amazing toolset for creating all types of light reflections and flare effects. However, it's a bit on the expensive side for the After Effects plug-in. It's much more reasonable for the Photoshop plug-in, so it's definitely worth checking into.

I use Shake, which you can purchase for the cost of Knoll Light Factory Pro, to apply lens flares. I've found yet another free macro called Pro Flares that works very well, and if you happen to use Shake, you can find the macro on highend3d.com. In Figure 7.22, I used Pro Flares to create a lens flare to represent light coming from outside the left of the frame. I also used a small amount of bloom in the highlights to further accentuate the effect.

Glints

Glints are intense bright areas that occur when light strikes reflective surfaces and are focused in one spot. Glints will usually have a star like appearance and will become apparent in the specular bloom of the render. In Figure 7.23, you can see several glints as the sun reflecting off the surfaces of the cars. If you look at the enlarged area in the image, you can see the star pattern as the light streaks outward from the bloom.

To create glints, I will use a program like Photoshop or Shake to create streaks similar to the glints found in Figure 7.23. As with specular blooming, this effect will work best in 32 bits. In Figure 7.24, you can see a glint that was created in Shake. The trick was to create a simple circular gradient shape and then push the color values beyond 1.0 to create an intense light reflection. This shape was then squeezed horizontally to create a beam of light. The shape was then duplicated, blurred, and rotated to form a star pattern that was then added overtop the background image.

FIG 7.22 This lens flare was created in Shake using Pro Flares.

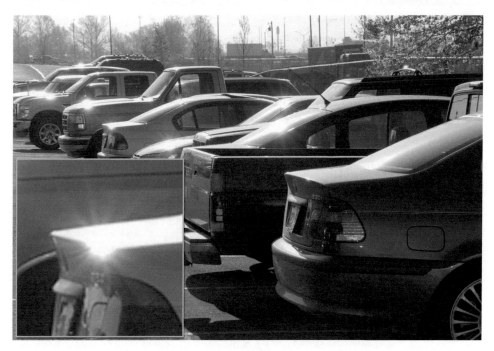

FIG 7.23 Glints appear in the intense areas of specular blooming and will have a star like appearance.

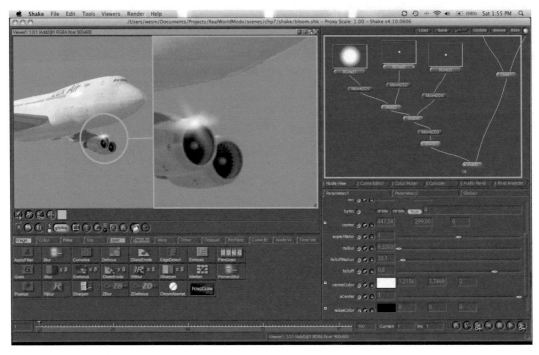

FIG 7.24 This glint was created in Shake by manipulating a series of radial shapes that had their color values pushed above 1.0.
Source: Wes McDermott.

> 📖 **Tip:** You can actually get better results by using a pen and tablet to use gradual pen pressure to paint fine streaks that can then be blurred. Just be sure to paint with color values greater than 1.0 to create intense highlights.

Motion Blur

In a still camera, there is a shutter that opens to expose light to the negative or charge-coupled device (CCD) sensor. The shutter speed controls how long this shutter stays open. The shutter works with the lens aperture to create the exposure. If the light coming in through the lens is too low, then the shutter will need to stay open longer to correctly expose the film or CCD. It's when the shutter is open for a long period of time that an object in motion will tend to smear or blur. Motion-picture cameras use what is called a rotary disc shutter. This disc has an opening that equates to an angle and sits in front of the Film Gate. When the shutter's opening is over the film, it exposes the film to light, and when the closed portion of the disc is in front of the film, a mechanism

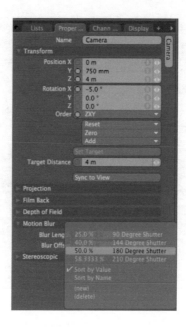

FIG 7.25 In modo, the simulated shutter works like a rotary disc shutter.

pulls the next frame of film into position. The larger the opening or shutter angle, the more blur will occur. An opening of 180 degrees is considered to be a normal amount of motion blur. In modo, the Blur Length that is found on the camera's Properties panel, as shown in Figure 7.25, controls the simulated shutter, which works like the rotary disc shutter.

If you want to increase the blur in your render, you just need to increase the Blur Length, which in turn increases the shutter angle. In Figure 7.26, a shutter angle of 210 degrees was used to get the desired amount of motion blur.

Blur Offset

Because the shutter is spinning, you can get an effect of the motion blur beginning on a frame, centered on the frame, or ending on the frame by adjusting the Blur Offset in the Motion Blur properties of the camera. There are three settings to choose from, which will position the blur at the beginning, center, or end of the frame. By changing where in the frame the motion blur will take place, you will get the motion blur happening at different times. For example, in Figure 7.27 you can see a ball with motion blur and how, by changing the Blur Offset, you change where the blur is taking place on the ball, which equates to the blur appearing behind, centered on, and after the ball's motion. The usage of this offset really comes into play when compositing CG elements into a live background. You will need to be able to match the motion blur of the CG elements to the real scene. Depending on how the

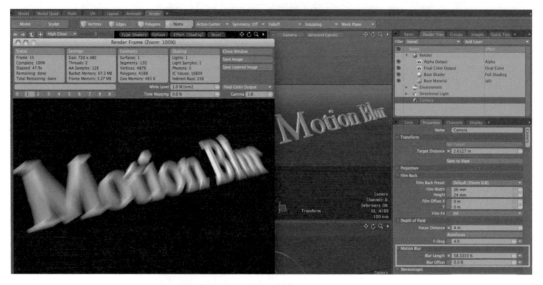

FIG 7.26 In this image, the shutter was set to an angle of 210 degrees, which is a blur length of 58.33%.

FIG 7.27 The different Blur Offset settings.

scene was shot, you may need to apply an offset to the CG motion blur to match when in the frame the exposure had taken place. For the most part, this is a matter of studying the blur in the live background footage and applying the CG motion blur accordingly.

Matching Real-World Cameras

In this section, we'll be taking a look at matching a CG camera to a real camera for the purpose of compositing CG elements within a background plate. To begin, we're going to have a look at aspect ratios and frame rates and then

we'll move on to an example where I'll discuss how to match an actual camera within a modo scene.

> 📖 Typically in a visual effects pipeline, a live-action background that is later composited with CG or actors is called a background plate.

Aspect Ratio

Before I get into actually matching a camera, I'd like to discuss the importance of understanding aspect ratio and frame rate.

Render Aspect Ratio

The render aspect ratio is the Frame Width divided by the Frame Height, and as mentioned earlier, it is also referenced as the Resolution Gate as shown in Figure 7.28. This value describes the size of the output device. The output device can be your monitor, TV screen, print size, or projection size in a movie theater. The point is that every format has a ratio that defines the relationship to its width and height. Also, as mentioned earlier, the Film Back is a ratio as well; this ratio defines the width and height of the film being used in the camera.

FIG 7.28 The render output size expressed as a ratio of 1.5.

It is very important when matching a real-world camera that the Resolution Gate and the Film Back aspect ratios match.

Pixel Aspect Ratio

Pixels have an aspect ratio as well, and this ratio or Pixel Aspect Ratio (PAR) will have a bearing on camera matching. For the most part, you will use a PAR of 1.0, which means that the pixel's width and height are the same and produce an equally square pixel as shown in Figure 7.29. This is called a square PAR, which can be written as a ratio of 1:1.

Video formats deal with a different type of PAR called nonsquare. As the name suggests, with a nonsquare PAR the width and height are not proportional. They are rectangular and can be expressed as a ratio of 2:1. The video world of standards is extremely complicated and confusing. Basically, the PAR term wasn't coined until the standard definition television standard called Rec.601 was created. To convert analog video to digital, a sampling rate is used to determine how the luma values in the video are converted into pixels. The sampling rate for the 480i video format is 12+3/11. In the Rec.601 standard, the video picture lines contain 720 nonsquare pixels. The standard also states the standard for luma sampling will be 13.5 MHz.

If you take the information from the sampling rate of 480i and the Rec.601 standard, you can derive a PAR for video by taking 12+3/11 divided by 13.5 to get 10/11 or 0.9. This value is for NTSC 4:3 video. Different formats are going to have a different PAR. If rendering to video, you will need to determine what PAR you need to set in modo. You can set the PAR in modo by going to the Render Properties and changing the PAR found on the Frame tab as shown in Figure 7.30. Because a computer monitor uses square pixels, your render will look distorted, but when the render is displayed on the television, it will look correct.

FIG 7.29 A square PAR is when a pixel's width and height are equal.

FIG 7.30 Here you can see that the PAR was set to 0.9 for working with NTSC 4:3 video.

> 📖 **Tip:** Some commonly used PAR values are 0.9 for NTSC 4:3 video, 1.21 for NTSC 16:9 widescreen, 1.09 for PAL 4:3 video, and 1.45 for PAL 16:9 widescreen.

Matching the Camera

As I mentioned earlier, I will need to match a real-world camera in modo when I need to produce a print render, or an image for use in a multimedia application such as a Flash presentation. Let's take a look at the techniques that are required to create a successful match.

Camera Data

The key to a successful match is found in the information collected about the scene and camera. The more information you can record about the scene, the easier the match will go. It's vital to record measurements such as camera focal length, height of camera, and distance to subject to name a few. However, sometimes you'll just be given a photograph and asked to add the 3D elements such as a set extension. For example, in Figure 7.31 you can see an architectural visualization where I needed to replace the current building with a Tiki bar.

I was given the background plate and some rough sketches of what the client wanted the bar to look like. In this case, I wasn't given any information about the camera lens or its position, and unfortunately the jpegs of the background didn't contain any EXIF data. In this case, I needed to study the photograph for clues about how to setup the camera in modo. I looked at how the verticals in the shot tended to bend as they moved toward the top of the frame, which

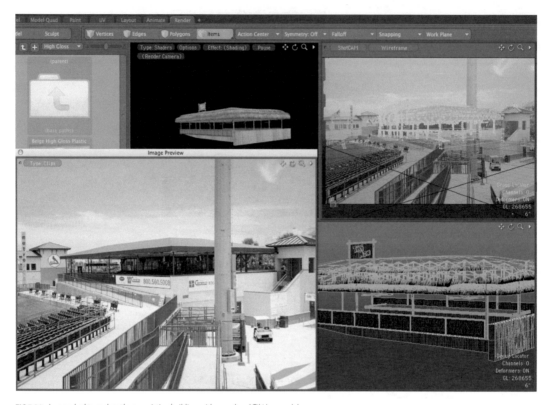

FIG 7.31 I was asked to replace the preexisting building with a rendered Tiki bar model.

indicated that a wide-angle lens of at least 28 mm was used. This gave me a starting point. Next, I created a cube that later became the foundation for the bar, and I began to adjust the focal length and z position of the camera until the cube lined up with the base of the building as shown in Figure 7.32. This method is really just trial and error, and because the camera isn't moving, you won't have to worry about the perspective changing.

The best scenario is when you have adequate scene data that you can use to properly set up the camera in modo. Let's look at an example. For this example, I took a photo of the deck in my backyard. The goal is to add a small CG hippo that can be found in the modo content to this background plate. I used an everyday digital point-and-shoot camera to take the shot. I did this because you definitely won't find this camera in modo's Film Back Presets. I used a Canon A540 and a tripod that can be seen in Figure 7.33.

The first step is to determine the Film Back for the camera, which is the CCD sensor size. After a quick Google search, I found a site that posted the

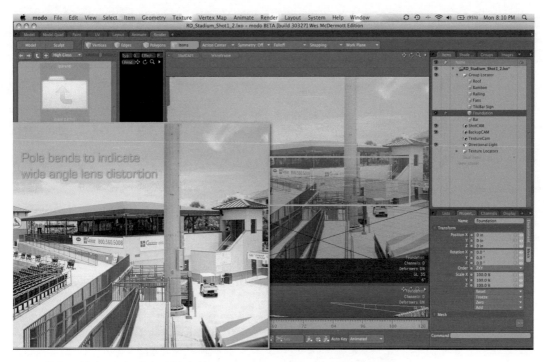

FIG 7.32 The base of the bar matches the base of the building.

information I needed about the digital camera I was using. The sensor size for my camera is 5.75 mm by 4.31 mm, and this information is input into the Frame Width and Height fields in the modo camera's properties. Now that I have the Film Back setting for my camera, I can find more information by accessing the EXIF data that was saved with the image. I used Preview on OS X to view the data and was able to get the Resolution Gate and Focal Length information as shown in Figure 7.34.

The resolution of the image is 1600 by 1200 and this is the Resolution Gate, which is input into the Frame Width and Height in the Render Settings. The important aspect of setting up the Resolution Gate and Film Back is that they have a matching aspect ratio. For example, by dividing the Frame Width and Height, you get 1.333, and if you divide the Film Width and Height you get 1.334. As you can see, these ratios when rounded both equal 1.33 and match perfectly. The modo camera is now set to match my Canon A540.

> 📖 **Tip:** If you are using the same camera for each shot, you can create a Film Back Preset to quickly set up the camera for future projects.

FIG 7.33 I used this basic setup to discuss how to find the correct camera information.

Scene Data

Now that the camera settings are correct, it's now time to place the camera in the scene. This is where the scene data comes in. For this scene, I took measurements of the board I was placing the CG model on, the distance from the ground to the camera, the distance from the camera to the board, and rough angles of the camera tilt and rotation. In modo, I switched my Units to English and typed the measurements in the camera's position and rotation. For instance, in Figure 7.35, you can see that the camera is 3 feet 5 inches from the ground, which matches the measurement I took on set.

Now, even though I took precise measurements of the set, the camera still won't match perfectly. This can be due to the fact that there is lens distortion to the image. The measurements will get you about 95 percent of the way, but to complete the match you're going to have simply eyeball it. That's exactly what I did. I slightly tweaked the rotation and position of the camera, which took me out of the bounds of my measurements slightly, but it looked right in the render. As I said, the discrepancy in the match is probably due to the lens distortion. Although modo offers lens distortion in the render, I always add it in post. I could have removed the lens distortion from the background plate before bringing it into modo, but for this example, I wanted to show a

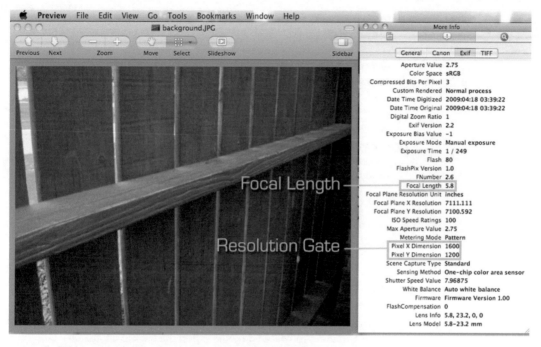

FIG 7.34 The EXIF data contain information about the camera that can be used to set up the camera in modo.

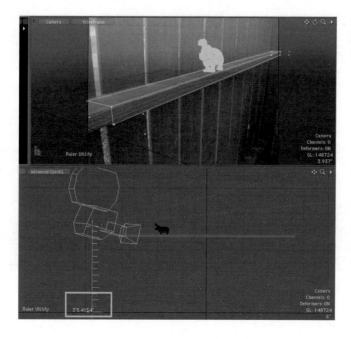

FIG 7.35 The camera is 3 feet 5 inches from the ground, which matches the measurement I took on set.

real-world reality when working with 3D and that is sometimes, you just have to eye-ball it!

Compositing

To composite the CG element over the background plate, I used Shake. From modo, I rendered a linear EXR file of the hippo and set Alpha Type for the 2 × 4 stand in mesh to Shadow Catcher to have the shadows appear in the Alpha Channel of the render. The composite in Shake was done in a linear floating-point environment as is detailed in Chapter 9. I removed the lens distortion in the background plate and then reintroduced it later in the composite to the background plate and the CG hippo as shown in Figure 7.36.

> 📖 **Tip:** I find that it's always easier to remove lens distortion and camera movement before doing any actual compositing. This makes it easier to align layers, and you can then apply the data at the end of the composite not only to the source footage but also to any comped layers.

That's the workflow that I use for camera-matching stills in modo. If you have a need to do a matchmove on an image sequence, you can use SynthEyes, www.ssontech.com, to export camera tracking to modo. If you already have camera-tracking software, you could export the track to another 3D application such as Maya and then export the camera to modo via FBX.

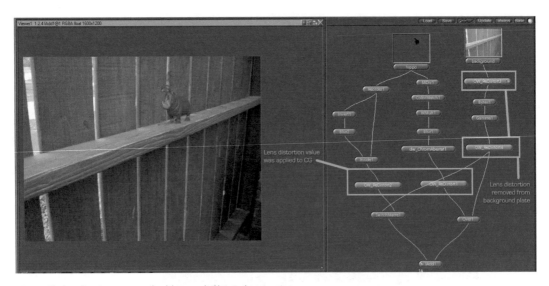

FIG 7.36 The lens distortion was removed and then reapplied later in the composite.

Summary

In this chapter, we discussed the important aspects of matching the modo camera to a real camera's settings through adjusting the Film Back, Resolution Gate, and aspect ratio. We also discussed adding lens artifacts such as distortion and Chromatic Aberration. Finally, we took a look at a real example of matching a camera. The more you understand about how a real camera operates, the more equipped you will be to simulate the camera in modo. We are so used to seeing images created by cameras, and by reproducing effects such as lens distortion, Chromatic Aberration, and lens flares, the more realistic your renders will be.

Lighting and Rendering

Lighting is an extremely important aspect of 3D and rendering is at this time a necessary evil. Perhaps, someday there won't be a need to have to render a scene, as everything will just be processed in real time. Until that glorious day arrives, we'll have to continue to discover techniques to reduce render times while finding amusing ways to entertain ourselves as we patiently wait for our renders to complete. However, lighting will never be a one-click solution. Sure, we have global illumination and image-based lighting that can produce fantastic results with little effort, but good lighting is an art. In this chapter, we'll be discussing different aspects of lighting and rendering to dispel some of the technical hurtles and allow you to focus on the art of your project.

Characteristics of Light and Shadow

In this section, I'll be discussing the characteristics of light and shadow as it pertains to lighting a 3D scene. Before you can begin adding lights to your scene, it's important to understand how the light should interact with your objects. It's also important to have an understanding of characteristics of light

such as intensity and diffusion to name a few. To begin, let's take a closer look at the characteristics of light.

Light

Lighting is just as important to your scene as the models that make it up. Without light, we wouldn't be able to see anything. In this section, we'll discuss some aspects of light and shadow that describe their characteristics as it relates to the quality of the lighting design in your projects. First, we'll look at the characteristics of light:

- Intensity
- Diffusion
- Temperature
- Form

Intensity

When speaking of a light's intensity, we are simply referencing how bright it is. When it comes to light intensity, we really only have to be concerned with two aspects: brightness and decay rate. In modo changing, the Radiant Exitance parameter on the light's properties panel controls a light's brightness. It's pretty simple: increase the value and the light gets brighter, decrease the value and the light gets darker. A light's brightness will be dictated by the source it represents. For instance, light that represents the sun will be very bright.

In the real world, a light's energy will diminish as its rays travel away from the source. This is represented in 3D as a light's decay rate. It allows you to create a light that will emit rays as they are in reality. In modo, lights other than directional use physically-based falloff. This means that the lights illumination is proportional to the inverse square of the distance from the light source. Currently, this is the only type of light falloff available in modo, but it's based off how light behaves in the real world. You can see in Figure 8.1 that as the light rays spread further from the source, the brightness diminishes.

> 📖 **Tip:** Clicking the downward facing arrow next the Radiant Exitance input field on the light's property panel will bring up a pop-up menu that will allow you to create your own light brightness preset. These types of UI presets are used throughout modo 401.

Diffusion

A good example for diffusion is to compare a sunny day to an overcast day. On a sunny day, light shines directly on everything, "directly" being the keyword. Not counting the earth's atmosphere, at mid-day nothing is coming between the light rays from the sun and the objects they hit. The result of this is bright light that leaves dark contrasting shadows. Because of the sheer brightness,

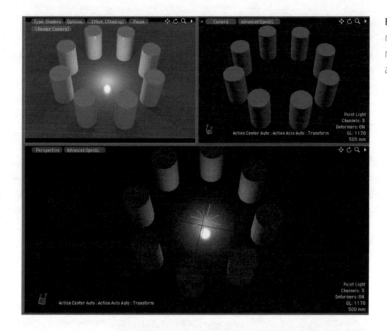

FIG 8.1 The Radiant Exitance is measured in Watts per volumetric meter, which produces physically accurate light.

FIG 8.2 The diffused light lowers the contrast and reveals detail in the shadow areas.

colors will tend to be suppressed when photographed and detail is lost due to the huge dynamic range of light. With an overcast day, there is a thick layer of cloud between the sun's rays and the objects the rays hit. The clouds diffuse the light, which means they scatter the light rays. The result of this diffusion is an even light distribution that lowers the dynamic range of the light. When I

was heavy into photography, overcast days were the best days to shoot because of the even lighting and detail that could be photographed due to the lower dynamic range. The diffused light would also allow colors to look more vibrant.

In Figures 8.2 and 8.3, you can see a simple example of diffused versus direct light. Things to note are the difference between the two scenes' contrast and the level of detail in the shadows.

Temperature

A light's color temperature can be simply expressed as the color of the light. A light's color temperature is measured in kelvin, and without getting into the science of color temperature, higher color temperatures are considered to be cool (blues–greens) and lower temperatures are warm (oranges–reds). For example, when designing a light scheme for a scene, you can use warm light color to represent early morning or late evening daylight, as shown in Figure 8.4 or cool colors to simulate night, as in Figure 8.5.

> 📖 **Tip:** Besides just being used to simulate the time of day, light color can also be used to stylize your scene. We subconsciously relate color to emotion, such as the color red conveying anger. Always be aware of how color can play into your scene to invoke emotion.

FIG 8.3 The direct light increases contrast and reduces detail in the shadow areas.

FIG 8.4 Warm colors can be used to simulate early morning or late evening light.

FIG 8.5 Cool colors can be used to simulate nighttime scenes.

> 📖 **Tip:** Light is never pure white and can be a dead giveaway that a scene is computer generated. Never leave your lights set to pure white, instead give them a small tint in order to more realistically simulate light.

Form

Light has physical form. The shape of a light and its size can have impact on how it illuminates objects. However, in this case, I'm not referring to a light's size or shape, but instead I am talking about how a light "models" the object. You could have a great-looking model, but without setting up the lighting in a way that will properly illuminate the contours, it will just look dull or flat, as shown in Figure 8.6. In Figure 8.7, you can see the same scene with a three-point lighting scheme applied. Notice that the lighting helps to define the object's shape. The light is "modeling" the object to reveal its form and design.

Another usage of form besides "modeling" is modifying the light's throw pattern to break up the light and add style to your scene. *Gobo* is a photography term. It's an object that you place in front of a light to cast a pattern across a scene and is an excellent tool to use in 3D as well. To add a Gobo to your light in modo, just add an image layer to the light's material in the Shader Tree. The image can be any type of pattern. In Figure 8.9, you can see a gray-scale image that I painted in Photoshop and was used in the previous scene to break up the light as shown in Figure 8.8.

You don't have to be a lighting expert to light good scenes. By studying nature as well as art, you can learn how to use light to improve your scenes. When designing a lighting scheme, think about the characteristics discussed above

FIG 8.6 Without the proper light rig, your objects will appear flat and dull.

FIG 8.7 By using a three-point lighting scheme, the model's shape is more defined.

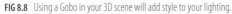

FIG 8.8 Using a Gobo in your 3D scene will add style to your lighting.

FIG 8.9 Gobos can be created from anything. You can use color images or hand-painted maps.

and how you can use these characteristics to improve the quality of light in your renders.

Shadow

Now that we've discussed some key principles to lights, let's now look at their inverse effect: shadows. The characteristics we'll be discussing are

- Softness
- Occlusion

Softness

Shadows in the real world are not perfectly sharp. In fact, they have a bit of softness as the shadow falls away from the object. Directional light shadows in 3D are sharp, as shown in Figure 8.10.

This is due to the fact that unlike reality, these lights do not have any volume. A light source's volume causes the shadows casted by the light to soften on the edges and as the shadow falls away from the object. However, by adjusting the spread angle of the light, you can create nice, soft edges, as shown in Figure 8.11.

The key to soft, realistic shadows is to have the light source appear to have volume. An area light's shadows will already be soft because they have volume, as shown in Figure 8.12.

FIG 8.10 Raytraced shadows can have sharp edges, which lend to the "CG look."

FIG 8.11 The same render as **Figure 8.10**, but with the spread angle increased. Notice the soft edges and how the shadow suggests that the light has volume as it wraps around the object.

FIG 8.12 Area lights have volume, which is why they produce such nice, soft shadows.

Occlusion

Occlusion is usually referred to as ambient occlusion and is basically the areas of your scene where light is being blocked. These areas are the small nooks and crannies within your objects that are occluding light. It's a very important aspect of shading objects, and although it's usually a subtle effect, it goes a long way to adding realism to your scene.

FIG 8.13 The Ambient Occlusion pass brings a subtle but vital realness to the render. Ambient Occlusion is added as a Render Output.

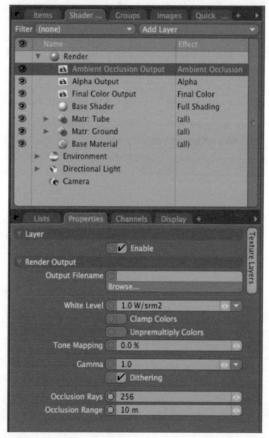

In Figure 8.11, you can notice that although the scene has a nice, soft shadow, the object seems not to be anchored, especially around the bottom of the cylinder where it meets the ground plane. In Figure 8.13, you can see the same scene with an ambient occlusion pass multiplied over the render. Again, the effect is

subtle, but you can now see how the occlusion around the bottom of the cylinder helps to better anchor the object.

An occlusion pass is easily created in modo by adding a Render Output set to Ambient Occlusion. In Figure 8.14, you can see the occlusion pass is rendered in a gray-scale image that can be multiplied over your render in an application like Photoshop.

Now that we've discussed some of the characteristics of light and shadow, let's take a look at a specific light type used for physically-based lighting called Photometric lights.

Photometric Lights

Photometric lights are derived from accurate measurements of real-world illumination from a specific light type. This data is commonly referred to as Illuminating Engineering Society (IES) data. IES is a standard file format for storing photometric data. Basically, it's a digital profile of a real-world light and can be used in modo to create a physically accurate light, as shown in Figure 8.15.

Notice in Figure 8.15 the realistic look of the light's throw pattern on the wall. You can create a Photometric light through the New Item pop-up menu in the Item List or even by converting a current light by right-clicking on the light and choosing Photometric light in the Change Type pop-up menu.

FIG 8.14 An occlusion pass can be multiplied over the beauty or color pass in the compositing stage.

FIG 8.15 IES data is a lighting profile that can be used to create real-world lights.

Deep Shadows

Deep Shadows are a new feature in modo 401. They are very similar to the Deep Shadow feature that is found in Renderman for Maya.

Deep Shadows are shadow maps with the additional capability to render transparent and volumetric shadows. They work best on complex scenes with lots of transparent geometry, since using Raytraced shadows on simple scenes may still render faster. In Figure 8.16, you can see a render with transparent shadows thanks to Deep Shadows being activated on the spotlight. As with regular shadow maps, you can set the shadow map resolution to increase the quality of the shadow in the render.

In Figure 8.17, you can see that Deep Shadows will allow you to render volumetric shadows using shadow maps rather than using Raytraced shadows.

Global Illumination

Global illumination is the process of adding indirect lighting to your scene. In this section, I'd like to discuss some key principles using GI within modo 401.

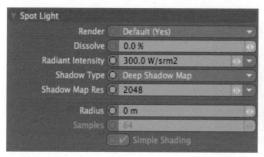

FIG 8.16 By using Deep Shadows, you can now render transparent and volumetric shadows using a shadow map.

FIG 8.17 Deep Shadows allow you to render volumetric shadows using shadow maps.

Let's begin by looking at the two methods of sampling that modo uses when evaluating rays used to calculate indirect lighting: Irradiance Caching and Monte Carlo. If you are unfamiliar with GI in modo and how it is calculated, please refer to the help docs for the technical explanation. For our purposes, we just need to know that rays are cast out from a surface and are evaluated when they strike another surface. Irradiance Caching and Monte Carlo are the two methods that modo can use to evaluate these samples.

Irradiance Caching

Irradiance Caching is the default method of global lighting and is designed to accelerate GI by blending between samples without having to sample every pixel in the image. It uses a higher number of rays, but doesn't use every pixel in the sampling. The side effect to this method can sometimes produce splotchy artifacts to the render. It samples the scene at different locations, precomputes the data, and then calls up the data to be used when needed. In Figure 8.18, you can see the Global Illumination panel and the Irradiance Caching settings.

Let's look at a few of the most important settings for controlling the quality. The Irradiance Rays are the same as Indirect Rays that are fired out from a surface when calculating indirect illumination. Irradiance Rate and Irradiance Ratio set the range in which pixels are sampled. The Irradiance Rate is the minimum distance in pixels between the samples. For example, the default is 2.5, which translates to 2.5 pixels in the render. This means that modo can sample a pixel and skip 2.5 pixels before a new sample is taken. The pixels in between the new samples have values taken from the neighboring pixels. The irradiance ratio is a multiplier of the irradiance rate. For example, with a rate of 2.5 and a ratio of 6, no Irradiance Cache values would be closer together than 2.5 pixels and no further apart that 15 (6 × 2.5). The Interpolation Value will blend between the samples and increase the quality of the samples at the cost of render time. Learning to use Irradiance Caching is very important since it's

FIG 8.18 The Irradiance Caching settings are found on the Global Illumination panel.

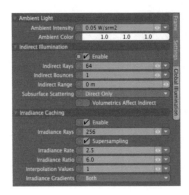

the method that you'll use the most. Later in this chapter, I'll show you how modifying the Irradiance Caching rate can speed up large renders.

Monte Carlo

Now, let's take a quick look at Monte Carlo sampling. Monte Carlo can be set on a per-shader basis. The main difference is that Monte Carlo uses fewer rays to sample, but uses every pixel with a low number of samples. The side effect can sometimes be a grainy appearance in your render. Increasing the number of ray samples will reduce the grain, but also exponentially increase the render time.

Environment

Global Illumination doesn't work so well without an environment. The environment is the background area of the scene that isn't geometry. It's the space that sounds your 3D world. For example, the environment could be the sky. It is also used to give your reflective objects something to reflect. The environment in modo is accessed through the Shader Tree and is, basically, a material just like you would use for any other item in modo. The Environment defaults to a four-color gradient that simulates daylight. Earlier I mentioned that Irradiance Caching sends out rays to sample a scene. In simple terms, the environment that surrounds the scene is used in the Irradiance Caching samples to produce the indirect lighting when using Global Illumination. By using different environments, you'll get different light, as shown in Figure 8.19.

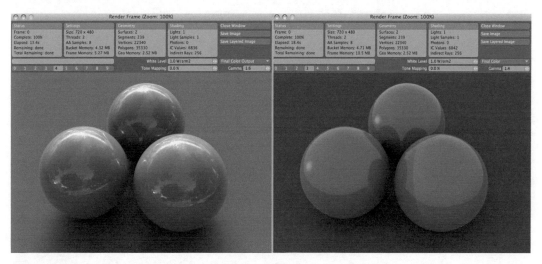

FIG 8.19 Different environments can affect the lighting and reflections in your scene.

Image-Based Lighting

In my projects, I usually use an image as my environment. This is called Image-Based Lighting (IBL). Although you can use any image, the best results will come from using a High Dynamic Range Image (HDRI). An HDRI is a special image format that is capable of storing the full dynamic range of a scene. By taking a series of photographs at varying exposures, you are able to capture the illumination of the scene. Faster exposures will capture only the brightest lights, whereas longer exposures will capture dimmer lights as well as ambient (bounced) light, producing accurate brightness levels. By manipulating the tonality of the HDRI, you can reveal detail in the bright and dark areas of the image.

The benefit is that since this HDRI captures the real-world luminance values of the scene, when used as an environment in modo with GI enabled, the HDRI can produce extremely realistic lighting results. Using HDRI essentially allows

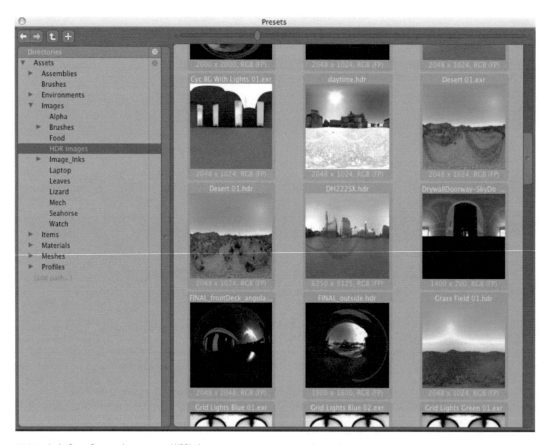

FIG 8.20 In the Preset Browser, there are several HDRIs that you can use as an environment in your scenes.

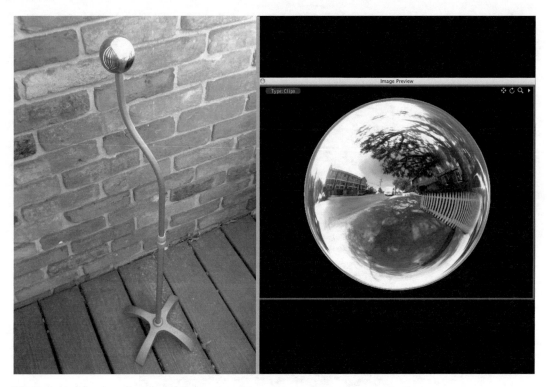

FIG 8.21 A mirror ball can be used to create a Light Probe.

you to bring the real-world luminance values from the photographed scene and use that data to light your scene in modo. If you don't want to worry about having to create your own HDRI, the Preset Browser has several HDRIs, which can be found under the Images category, as shown in Figure 8.20.

There are different formats of HDRIs as well as different ways to create them. It's beyond the scope of this book to go into HDRI creation, but I'd like to discuss the two most common formats and how to apply them to the environment within modo. Since the HDRI needs to represent the entire scene, one method for creating an HDRI is to use a mirror ball that reflects the entire scene. The image that is produced by using the mirror ball is referred to as a Light Probe as shown in Figure 8.21.

To use a Light Probe in modo, you need to add the image layer to the Environment and in the image's Texture Locator, change the Projection Type to Light Probe as shown in Figure 8.22.

The second HDRI format is called Latitude/Longitude. It can be created by photographing a mirror ball as well. However, you will need to do some manipulation to convert the HDRI from the Light Probe to Latitude/Longitude or Spherical format. To use the spherical HDRI in modo, you will need to add

FIG 8.22 If you're using a Light Probe, you need to set the Projection Type in the Texture Locator to Light Probe.

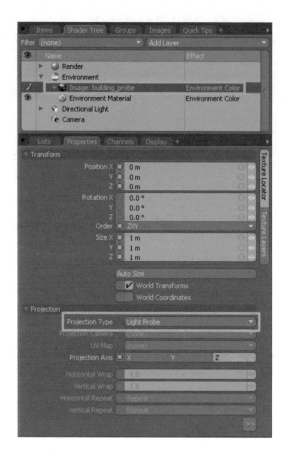

the image to the Environment in modo as with the Light Probe, except you will need to change the Projection Type to Spherical as shown in Figure 8.23.

To add the High Dynamic Range (HDR) to the Environment, you just need to add an image map layer to the Environment. Then, you can change the image's projection type to match the format of the HDR in the properties panel, as shown in Figure 8.24.

Using HDR in your scenes is a very effective way to gaining realism to your render. In the next section, we'll be discussing a way to streamline the process of using HDR as well as perfect the results.

Creating HDRI
📖 The process of creating your own HDRIs is beyond the scope of this book. This process could fill the book on its own and, in fact, already has. I would highly recommend reading The HDRI Handbook by Christian Bloch. This book covers in detail how to create your own HDRI.

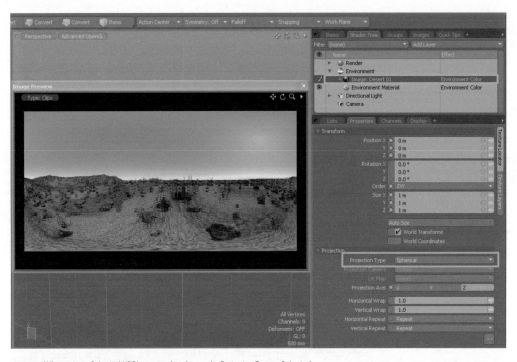

FIG 8.23 When using a Spherical HDRI, you need to change the Projection Type to Spherical.

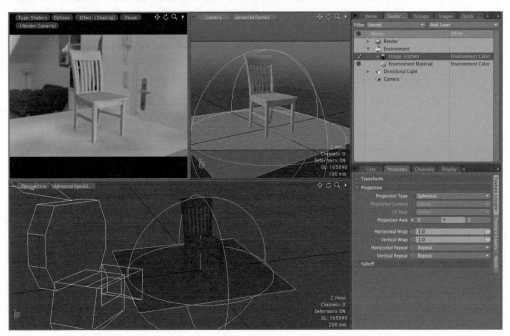

FIG 8.24 A spherical HDR map was used to light the chair. Notice that the Projection Type was set to Spherical and that the lighting matches the HDRI.

Using sIBL in 401

The word sIBL stands for Smart Image-Based Lighting and was developed by Christian Bloch. It was designed to remove some of the issues that arise when using HDRIs for IBL. The process involves breaking an IBL setup into a set of HDRIs and simplifying the steps to adding IBL to your scene down to the push of a button. By using the sIBL loader script, you can choose from an IBL set and easily apply the set to your 3D scene.

> 📖 **Tip:** You can read more about using sIBL as well as other information on HDRI, including downloading the free sIBL Edit program, at http://www.hdrlabs.com.

As Christian Bloch states, it takes a long time to render high-resolution HDRI files and it can take a very high antialiasing setting to get rid of the sampling noise and flickering. In practical applications, it's much better to use a blurred low-resolution HDRI for diffuse lighting and a high-resolution image for reflections only. This principle is the heart of sIBL as it uses a set of three images to define the lighting: one for diffuse lighting, one for reflections and specular components, and one for the camera background. These images are linked together by a description file, which also includes information on where the main source lighting is located and from which a light will be created in your scene that matches the intensity, direction, and color of the HDR imagery. All these come together to create a sIBL set, which can be added to your scene through the loader script. The real power of sIBL is the collection library. It is a library of HDR sIBL sets that you can use in any of your scenes and allows you to quickly set up an HDR lighting rig. You can also add to the library with your own HDR sets by using the sIBL Edit program.

I commonly use sIBL in all of my projects since it greatly simplifies the process of using HDRI in 3D. Also, with sIBL I have access to numerous sIBL sets that I can use when I quickly need to get quality lighting in my scene. Gwynne Reddick of modonize.com developed the sIBL loader script for modo and did a fantastic job of bringing sIBL to modo. For 401, he developed a great script called mm_sIBLToModoEnvironment for using sIBL sets through the Preset Browser. The script can be downloaded from the book's resource site as well as on hdrlabs.com.

The script is an sIBL set to Environment preset converter. It can be run on a single sIBL set or an entire sIBL collection to create Environment presets that can be accessed through the Preset Browser. The presets are pointers to the actual sIBL HDR files, so you don't want to delete the original collection. Once the script is installed, you just drag the preset onto your scene and you're ready to render, as shown in Figure 8.25.

You can replace the sIBL set by simply dragging a new set into the viewport. The script will also automatically add a ground plane grouped with a shader

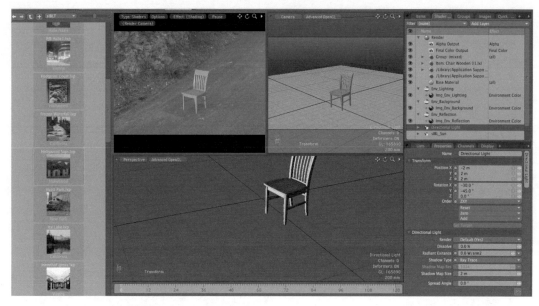

FIG 8.25 Drag a sIBL Environment preset onto your screen to load the sIBL set.

that has its Alpha Type set to Shadow Catcher for easy compositing against the high-resolution sIBL background image. This is how the chair from Figure 8.25 is casting a shadow on the ground. If you don't need this functionality since you'll be compositing the render later, you can simply delete the ground plane item without affecting the rest of the setup.

Lighting Phenomena: Volumetrics and Caustics

Volumetric effects and caustics are new features in modo 401. In this section, I'll be talking about how you can use volumetric and caustic effects to enhance the lighting in your scene. Although both caustics and volumetric effects are characteristics of light, volumetric lighting can add a sense of style to your scene. Let's begin by taking a closer look at volumetric effects in modo 401.

📖 Volumetric and caustic effects are new features in modo 401.

Volumetrics

Volumetrics exhibit the effect of light scattering through the particles in the air, such as beams of light through a row of columns, as shown in Figure 8.26. Volumetrics are enabled on lights and contain just a few controls, such as

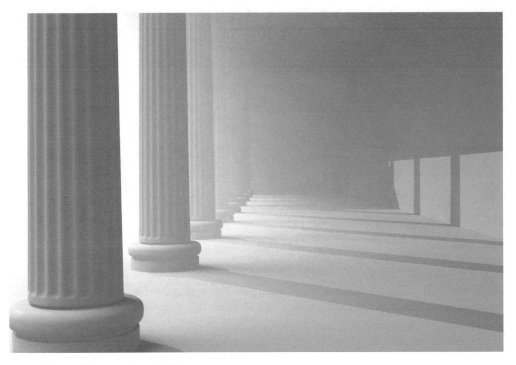

FIG 8.26 Volumetric effects are seen in everyday life.

FIG 8.27 You can use a Gradient set to Volumetric Density to change the color of a volumetric effect.

Height, Radius, and samples. They are pretty simple to set up and provide a nice effect to your renders. To color the effect, I like to add a Gradient into the light's Material Group and set its Input Parameter to Volumetric Density as shown in **Figure 8.27**. This will color the volumetric effect based on the density.

FIG 8.28 Caustics are the effect of a light being focused through refractive or off reflective surfaces. Caustics are enabled on the Global Illumination tab.

Caustics

A caustic is a bright pattern of light that appears when light rays are bent from reflecting or refracting off a surface, as shown in Figure 8.28. Caustics are enabled on the Global Illumination tab of the Render Settings.

The key to getting caustics to work is to leverage the number of photons that get stored in the photon map versus the Total Photons setting in the Global Illumination tab. You can view the number of photons that are stored in the map in the Render Statistics window, as shown in Figure 8.29. Luxology's Chief Scientist Allen Hastings states that the number of photons used in the render is often less than the number of photons emitted because many of the photons either escape or hit a diffuse surface before a reflective or refractive surface. By

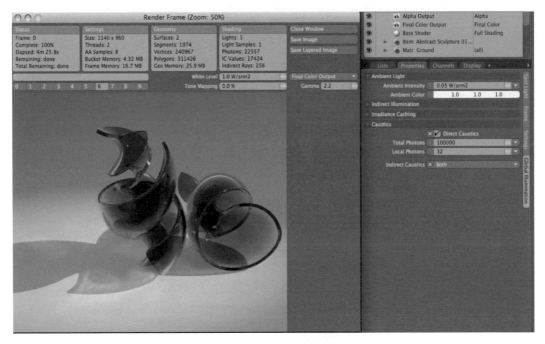

FIG 8.29 The Render Statistics photon number is often less then the Total Photon setting in the Global Illumination tab.

using a spotlight that is tightly focused on your object, you will be able to increase the number of photos that are hitting the reflective or refractive object as shown in Figure 8.30. You can also control the number of photos on a directional light by defining an appropriate shadow map size, which can be visualized in the viewport as a dotted square around the light. For example, if you render your scene and notice that the photon number in the Render Statistics window is very low, abort the render, adjust the Directional light Shadow Map Size value, render and check the photon number again. If the photon number is still low, keep adjusting the Shadow Map Size value until you get the highest number you can.

📖 **Tip:** With caustics, you can't preview the effect in the Preview Window. You'll need to do a full render to see the effect.

Light Linking

Light Linking is the process of grouping lights or attaching lights to only affect certain items. Light Linking is set on a shader and is used in conjunction with Groups. Both Light Linking and Groups are new to 401.

Perspective Advanced OpenGL

Spot Light
Channels: 3
Deformers: ON
GL: 311426
500 mm

Transform

FIG 8.30 Focusing the light on the object will increase the number of photons used in the render.

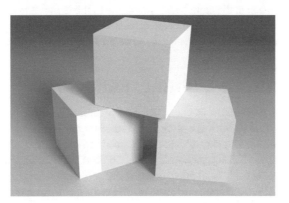

FIG 8.31 Without Light Linking, the fill light spills onto every object in the scene.

Light Linking can have many uses. I use it often to introduce a rim or fill light to my objects in my scene. With Light Linking, you have full control over what objects will be illuminated by a Light Linking group. For example, in Figure 8.31, I have a fill light coming in from the right, and it is affecting all the objects in the scene. To have only the top cube affected by the fill light, I'll need to create a group and add the fill light to the group by right-clicking the group and choosing Add Items.

FIG 8.32 This image shows the fill light only illuminating the top cube thanks to Group Masks and Light Linking.

Since Light Linking is controlled on the shader, it's best to create a Material Group by selecting Group from the Add Layer drop-down menu in the Shader Tree. Then, place the materials that you want to exclude from the light into the Material Group. Finally, add a shader to the Material Group and set the Light Group in the Light Linking category to the Group that contains the light or lights you want to include or exclude. In Figure 8.32, you can see the same render with only the top cube being illuminated by the fill light.

Studio Lighting: Reflectors

In this section, I'd like to discuss a technique to enhance reflective objects. I used to work as a photography assistant in a commercial photography studio. One day we had a job come in where we had to photograph a series of Louisville Slugger baseball bats. Some of the bats were metal and somewhat reflective. To cut down on what the bats were reflecting, we had to build a cylinder-shaped enclosure made from white foam boards. We then built a stand to hold the bat and cut a hole in the foam board so that the camera lens would fit through. This setup allowed us to photograph the metal bats with a nice, white highlight running down one side. You can use these types of studio setups in modo to give your renders that product-shot feel.

For example, compare Figures 8.33 and 8.34. In Figure 8.33, I created two polygon objects and positioned them on both sides of the glass. These polygons have been given a luminous material that contains its own shader with only the visible to reflection and refraction rays enabled. You can see this setup in Figure 8.35. The purpose of these objects is to act like reflectors or fill cards in a

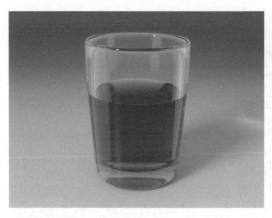

FIG 8.33 In this image, the glass is reflecting the reflectors that were set up in the scene.

FIG 8.34 In this image, the glass isn't reflecting the reflectors that were set up in the scene.

photography studio, much like the white foam enclosure that was used to photograph the baseball bats mentioned above. Having reflectors in the scene enhances the reflective quality of the glass, producing more realistic results.

This is the way glasses or reflective objects are sometimes photographed, and we are used to seeing reflections of fill cards and reflectors in studio photographs even if they are only on a subconscious level. The point is that in order to create renders that look like photographs, you'll have to think like a photographer and "shoot" your scenes like you would if you were setting it up in a studio.

Render Settings

Knowing how to properly adjust the Render Settings is a key to leverage the image quality to render time. In this section, we'll look at the global settings of the renderer that you'll use to control the quality of pixel shading, as well as subdivision.

Antialiasing

Antialiasing can be explained roughly as the process of "smoothing out" the rough edges in the scene. It affects geometric surfaces and is broken down into three settings that control the quality of the pixels in the rendered image, which are Antialiasing, Refinement Shading Rate, and Refinement Threshold. For example, setting the Antialiasing to eight samples per pixel would divide the pixel into eight fragments that are all evaluated and averaged. This happens to every pixel in the scene. Next, modo looks at the Refinement

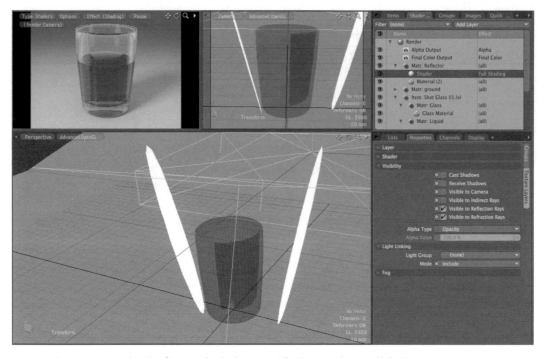

FIG 8.35 In this image, you can see how the reflectors are placed in the scene as well as the options that are enabled in the shader.

Threshold and calculates the Antialiased pixel from the direct left, right, up, and down neighboring pixels to see if it needs further refinement. If yes, then the Refinement Shading Rate kicks in, and based on its value, additional samples are evaluated and processed. A setting of 0.5 divides the pixel into four evaluations, while a setting of 0.1 divides it into 100 evaluations. The Refinement Shading Rate affects mostly the shading edges, such as shadows, reflections, refractions, image-based and procedural textures.

The Refinement Shading Rate is expressed as distance in pixels, and it controls how fine or dense the shading samples are. For example, a value of 1.0 means those shading samples that are next to each other are approximately one pixel apart, which results to one sample per pixel. With the default rate of 0.25, the shading samples would be spaced approximately one quarter of a pixel apart and this would result in 16 samples per pixel as shown in Figure 8.36. Note that the actual number of samples used will never be higher than the Antialiasing setting. Higher quality antialiasing can be achieved by lowering the Shading Rate, which is limited to 0.1. At a Shading Rate setting of 0.1, you can effectively get the shading samples equal to your Antialiasing setting. The Refinement Threshold dictates how much contrast between adjoining pixels is

FIG 8.36 This figure shows how a rate of 0.25 divides the Antialiasing into 16 samples per pixel.

acceptable. By leveraging the Antialiasing, Shading Rate, and Threshold settings, you can effectively control the quality shading in the render.

> 📖 **Tip:** In modo, when setting a rate, whether it is Shading, Subdivision, or Displacement, the lower the values the better the quality at the expense of increased render time.

Geometry

Under the Geometry category of the Render Settings pane, you'll find the controls for fine-tuning Adaptive Subdivision and Micropoly Displacement. These controls are responsible for the refinement of geometric edges at render time. Let's start by looking at Adaptive Subdivision.

Adaptive Subdivision

Before we get into Adaptive Subdivision, I want to bring your attention to the Mesh's Subdivision Level on the Mesh Properties panel. In Figure 8.37, you can see that the mesh's Subdivision Level is set to 1 and that there are 352 polygons visible in the OpenGL viewport. Now, when you render while the Adaptive Subdivision is turned off, the mesh will only be subdivided by its Subdivision Level, as shown in Figure 8.38.

This might work fine for some renders, especially if the mesh is not close to the camera. In fact, it's a great way to speed up a render since a mesh will not be continually refined with Adaptive Subdivision. However, if you're rendering an

FIG 8.37 The Subdivision Level controls how much the mesh is subdivided.

animation, you need to be careful with just using a mesh's Subdivision Level, since over the course of the animation the camera could get close enough to the mesh to reveal faceting in the geometry.

As you can see in Figure 8.38, just using the mesh's Subdivision Level is not subdividing the geometry enough as you can actually see well-defined edges. This is where Adaptive Subdivision comes in. In Figure 8.39, I have enabled Adaptive Subdivision and as you can see the edges are now nice and smooth; however, the polygon count has increased tremendously from 352. By changing the Subdivision Rate, you can set a threshold on how much the geometry should be subdivided. This rate is also expressed as a distance in pixels and states that if a geometric edge is greater than the rate value, then the edge should be further subdivided. For example, the default Subdivision Rate of 10.0, which means that if an edge is longer than 10 pixels, will be further subdivided until it is no longer greater than the rate. Because it is adaptive, only edges that are greater than the rate are being divided such as the edges closest to the camera, whereas edges farther away are not further refined.

Since the Subdivision Rate is comparing edge length to distance in pixels, we run into an interesting notion that increasing polygons in the mesh will ultimately reduce the overall polygon count when Adaptive Subdivision is on. Take a look at Figure 8.40 and make a note of the polygon count of 55, 296.

There are a lot of polygons for two wood boards. The reason for the polygon count being so high is the length of edges of the mesh, as shown in Figure 8.41.

FIG 8.38 With Adaptive Subdivision turned off, the mesh will be subdivided according to its Subdivision Level.

FIG 8.39 With Adaptive Subdivision turned on, the mesh's edges are nice and smooth.

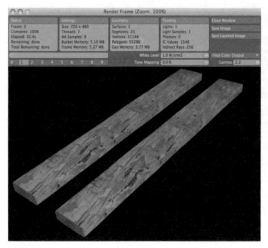

FIG 8.40 The polygon count is too high for two wood boards.

FIG 8.41 The edges in the mesh are long and are greater than the Subdivision Rate, which is requiring the geometry to be subdivided more than it needs to be.

The selected edges are extremely long and are much greater than the Subdivision Rate of 10.0 pixels in length, so the renderer is unnecessarily subdividing the edges until they are not greater than the Subdivision Rate. This mesh is not properly optimized for using Adaptive Subdivision. If I were to subdivide the long edges into much smaller edge lengths, the renderer wouldn't have to subdivide those long edges as much during the render, which in turn will result in a smaller polygon count. In Figure 8.42, you can see how the board was divided using Loop Slice to bring down the polygon count during the Adaptive Subdivision at render time, as shown in Figure 8.43. This type of geometry optimization can be done for each Mesh Item in the Item List and is a good way to reduce polygon count and render times.

Micropoly Displacement

As with the Subdivision Rate, the Displacement Rate is adaptive and is also expressed in distance in pixels; however, it only applies to surfaces with displacements maps. If a geometric edge is longer than this distance but no smaller than the Minimum Edge Length, it is subdivided. By increasing the Displacement Rate, you'll decrease the render time, but at the expense of quality and fine detail in the displacement.

The Displacement Ratio is used to control the polygons that may fall outside the camera's view. A setting of 1.0 will subdivide all geometry the same, but by

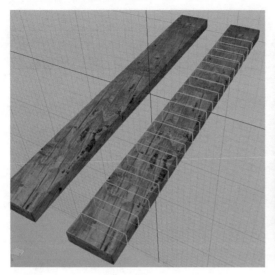

FIG 8.42 The mesh was divided using Loop Slice to bring down the polygon count during the render.

FIG 8.43 After optimizing the mesh for Adaptive Subdivision, the polygon count is reduced.

increasing this value you will reduce the amount of subdivision outside the view of the camera.

📖 Mesh items that are outside the camera's view will still show up in reflections and refractions, so you'll need to be careful about how changing the Displacement Ratio will affect these polygons.

Ray Tracing

The main point to discuss with Ray Tracing is the Reflection and Refraction Depth settings. These settings simply dictate how many times a ray is going to bounce in the scene. If your depth is set too low, the reflection quality will suffer and some objects may not even be calculated in the reflection. This really becomes apparent in refraction, with dark areas showing up in the glass, as shown in Figure 8.44. One trick that I use often for eliminating these dark spots is to set the Exit Color in the Ray Tracing category in the Material Trans settings. By changing this color, you can get rid of the dark areas that show up when rendering glass, as shown in Figure 8.45. You can also increase the Reflection Depth in the Render Settings to eliminate this issue as well. Adjusting the Exit Color is useful when you have the depth set low and need to render a lot of transparent surfaces in an animation.

FIG 8.44 Dark spots can occur from having the Trace Depth set too low.

FIG 8.45 Changing the Exit Color has reduced the dark areas in the glass.

Rendering for Print

In my job, I am often asked to render models at print resolution. I mainly work at video resolution, so when rendering at higher resolutions, I usually need to modify my render settings. Let's begin with the obvious. Rendering at high resolution is going to increase the pixel count in the image. The final output, or the medium you're rendering for, will determine the resolution. Depending on your project, this information will usually come from the graphic artist who is designing the print piece. In my case, I work hand-in-hand with the designers to supply them with the image. They will give me the size in inches and a DPI that the image should be. To get the resolution, I multiply the width and the height of the dimensions by the DPI. For example, if I need to render an image at 7×7 inches at 300 DPI, I would multiply the 7×300 to get 2100 and place this number in the Frame Width and Frame Height.

Earlier I mentioned that the Irradiance Rate was the distance in pixels between samples and that its purpose was to speed up the Global Illumination calculation. However, by increasing the render resolution, the default Irradiance Rate will not be too small, which could cause the render time to increase. For example, check out Figure 8.46 and notice the highlighted render time as well as the Irradiance Cache value. This render was done with a resolution to create a 6×4-inch image at 300 DPI.

FIG 8.46 This image was rendered with increased resolution, but the Irradiance Rate was not adjusted.
Source: Wes McDermott.

Now, take a look at **Figure 8.47** and notice that the render time has decreased by about 7.5 s and that the Irradiance Cache value is much lower as well. The Irradiance Rate was set to 5.0. Increasing the rate spreads out the sampling, decreases the overall Irradiance Cache, and essentially lowers the render time. You can also see that there isn't any noticeable difference in the quality.

> 📖 **Tip:** If you ever get an error that the Geometry Cache is full, you can increase the Geometry Cache Size found in the preferences under the Display/Rendering category.

Something else to consider when rendering at large resolutions is the render buckets. By default, modo stores the full floating point render in the frame buffer, which can be seen in the Frame Memory value of the Render Window. The Frame Memory can become very large, especially when rendering for print; however, you can save on the Frame Memory by selecting Write Buckets to Disk and possibly lower render time.

By selecting Skip Existing Buckets, modo will use the Frame Memory that was written to disk by enabling Write Buckets to Disk. If, for some reason, you had a crash, the next time you rendered, modo wouldn't have to calculate the buckets that were written to disk.

FIG 8.47 By increasing the Irradiance Rate, the render time was decreased. *Source*: Wes McDermott.

Summary

In this chapter, I've discussed several topics that hopefully "shed some light" on the various aspects of modo's rendering engine. We discussed several import topics such as using sIBL in modo and creating volumetric lights. We also discussed how Antialiasing works in modo and how to best use Adaptive Subdivision to optimize your renders. Rendering is a part of the 3D process, and it's important to understand how to squeeze every second out of a render through adjusting the modo Render Settings to maximize your time and meet project deadlines.

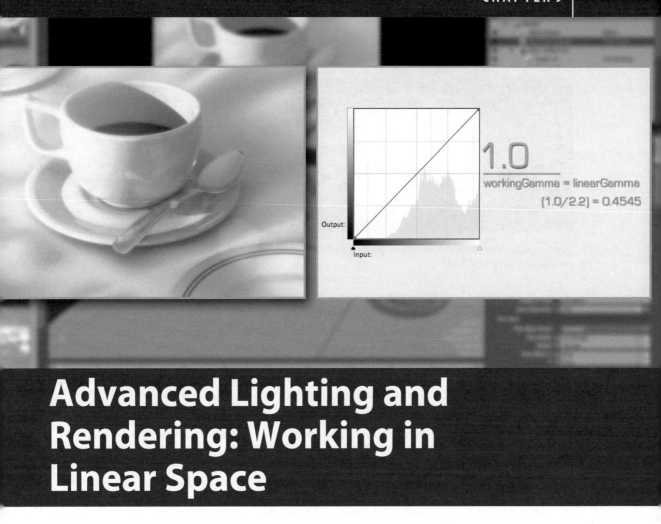

CHAPTER 9

Advanced Lighting and Rendering: Working in Linear Space

The topic of linear workflow has been a hot topic over the past few years. In a nutshell, a linear workflow is about creating an environment that allows light to behave as it does in the real world. A linear image is a 32-bit floating point image that has been stored in linear space, which means that it has gamma-encoded values removed and is set in a gamma of 1.0. Working in linear space is used in the compositing environment. It has several benefits, such as being able to realistically composite elements. For example, in Figure 9.1, you can see how realistically a 3D-rendered element with motion blur is composited in the scene. Nothing special has been done to get the motion blur to look so realistic. In a linear workflow, this type of result comes with the territory.

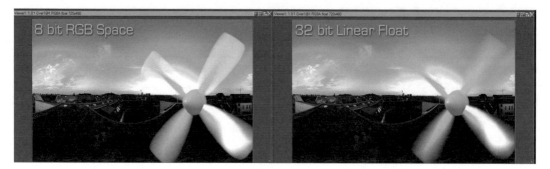

FIG 9.1 In the linear composition, the motion blur on the propeller blades accurately bleeds into the bright background. Notice the subtle background color that gets soaked up in the blur of the blades.

This is due to the fact that you are working in a gamma of 1 and in floating point, which we'll discuss later. It also allows the compositor to work in photographic terms, such as being able to adjust levels by 1 stop. For instance, when you multiply a linear floating point image by 2, the result will be a new value that is twice as bright, which would be 1 stop. Also, you can think of the value 0.5 as being half as bright as 1.0, which would be the same as closing the aperture of a camera by 1 stop. With the term linear, I am referring to the linear measurement of light.

Discussing compositing in linear space is beyond the scope of this chapter. Instead, the focus is going to be on creating renders that are in linear space for compositing in a linear project within a compositing application, such as Shake or Fusion. However, the advantage of working in linear space within modo is to optimize your final renders so that the rendered scene's dynamic range will be displayed properly on a monitor. Before we get into setting up a linear workflow in modo, I'd like to discuss a few important aspects of the process. I'd also like to note that linear space and gamma correction is very dense topic entrenched with technical pitfalls. In this chapter, I will get down to the nuts and bolts of setting up modo to work in a linear environment without getting caught up in exhausting technical babble.

Dynamic Range

To explain dynamic range, we are going to refer to basic photography. In the real world, the light intensity range of a scene is extremely diverse. In a given scene, we can have a combination of light sources such as from the sun, indirect light bounce, or even light from an everyday light bulb, as shown in Figure 9.2.

A given scene will have a range in the intensity values that are present. This intensity range covers the area in shadow all the way to the brightest source

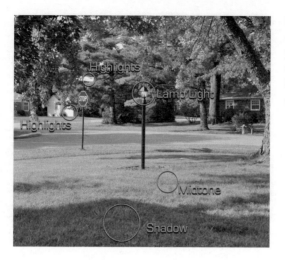

FIG 9.2 I took this shot with a digital camera right outside my front door. Here you can see a wide dynamic range: from the shadows in the foreground, to the lamppost light in the middle, and to the direct sunlight in the back.

light in the scene, such as the sun, and is referred to as a scene's dynamic range. Every image-capturing device (such as a film, a digital camera, or even our own eyes) will have a limit to that range of light intensity that can be captured or perceived. This would be referred to as the dynamic range of that device. For example, with film, a photographer will need to choose which portion of the intensity range of the scene he/she will need to expose for—that is, the shadows or the highlights. Without using special techniques, the photographer will not be able to capture the entire range of light intensity in the scene because the film has only a certain dynamic range in which it can capture. The same is true for our eyes, and computer monitors as well. A computer monitor is not capable of displaying the entire dynamic range that is present in a high dynamic range (HDR) image. Dynamic range is important with a linear workflow, because in modo we'll be working with HDR data. This HDR data exists with a gamma of 1.0 and can be described as scene-referred values, which are pixel values that reference light intensities.

Floating Point

We can't really discuss HDR and dynamic range without including the topic floating point. Floating point is essentially talking about using 32 bits per channel to describe color, and can be referenced as a 32-bit FP. Floating point and 32 bits are related only in that a 32-bit file format is necessary to store the increased amount of information inherent to HDR images. Normally, we manipulate images in 8 bits per channel, in which we get 24-bit color. This gives us a range of 16,777,216 color variations, or what is commonly referred to as Truecolor.

Channel Bit Depth and Color Bit Depth

📖 Channel bit depth and color bit depth are essentially two different things, and it can get confusing. If you're talking about channel bit depth, then you're talking about how many bits make up a channel. A bit is the smallest unit of data, and represents either 0 or 1—that is, it represents on or off in the computer world. For instance, with 8 bits per channel you get 8 bytes red, 8 bytes green, and 8 bytes blue, which make the channel bit depth 24 (8 × 3). If you're talking about channel depth, then this is an 8-bit image; but if you're referring to color depth, then it's a 24-bit image. That is because 8 bits per channel × three channels of RGB = 24-bit color. If you were to add an alpha channel, which is an 8-bit channel, you would get a 32-bit image. This means an RGB image plus an alpha channel. However, this is not the same as 32-bit FP—because with 32-bit FP, you have 32 bits per channel, which equals 96-bit color.

Now this may sound like a lot of color, but it's very inadequate when it comes to reproducing the full dynamic range of a scene. A 24-bit image only stores color information; HDRI images store color *and* intensity. A single "bit" in a 24-bit image represents a specific fixed value that is evenly distributed along the luminance range, where 32-bit FP images have the highest accuracy in the shadow areas (much like our eyes are most sensitive in shadow areas). In regard to floating point, you could increase the accuracy of a so-called 24-bit image; but because the values are whole numbers (0–255), they always need to be transposed (and likely rounded, reducing accuracy). Floating-point values never need to be rounded, and increasing the accuracy of the image just means adding additional decimal places. HDRI images aren't of higher quality because they are floating point; the floating point is the means to make them more accurate. This is the key with floating point; the pixel values are unlimited, so we now have a way to represent a scene's full dynamic range. In a 32-bit FP, we can now store pixel values beyond white 1.0, or 255 in 24-bit. This is called super-white. For instance, imagine you have a scene in modo where you'd like to be able to distinguish between two light sources with vastly different intensities. Using floating point pixel values, you can do that.

Imagine a modo scene with two spheres that appear to be completely white because the materials have had the Luminous Intensity set above 0.0. One sphere has a value of 2.0, and the other sphere has a value of 4.0. Both of the luminosity values for the spheres are extending into super-white. The sphere with a Luminous Intensity setting of 4.0 is twice as bright as the sphere with a value of 2.0. Being able to utilize super-whites in a render or HDR image provides you with the valuable scene data to realistically simulate the full dynamic range. A linear workflow benefits from the additional dynamic range information inherent in 32-bit FP images, as they realistically simulate real world light intensities, which in turn produce realistic results.

Gamma

Adjusting gamma is the vehicle in which a linear workflow is established in modo. When you render a scene in modo, the renderer is working in a linear space, which means a gamma of 1.0. Gamma can be a very deep and tricky subject. For our discussion, I'll start with taking a look at the way we perceive light. Our eyes work nonlinearly, meaning that they work at a gamma that is greater than 1.0. Photometry is the science of measuring the light in terms of how its brightness is perceived by the human eye. Our eyes aren't equally sensitive to all wavelengths, so photometry tries to balance the measurement by factoring in how sensitive our eyes are to a given wavelength. For our purposes, we are going to focus on the human eye's sensitivity to changes in the darker tonal ranges; and the fact that because our eyes are more sensitive to darker tones than brighter tones, objects such as computer monitors and digital cameras factor in this sensitivity to display images so that we can perceive them correctly. However, it's not all about displaying images correctly. Computers also take the human eye's sensitivity bias to darker tones into account when storing data in brighter tones. If we can't really distinguish the difference between a super-white floating point value of 1.0 and a value of 1.1, why save that extra data by default?

That fact that our eyes and digital cameras are capturing images with a gamma greater than 1.0, they can be said to be gamma-encoded. These gamma-encoded values will cause the math for determining light intensity to go haywire. On mymentalray.com, there is an interesting post showcasing the effect in an example, which can be found at http://mymentalray.com/wiki/index.php/Gamma_example. This example illustrates the point that with gamma-encoded values, when you think you are adjusting the lighting to be twice as bright, you are in fact making it almost five times as bright. They used a photographic spot meter measuring cd/m^2 to measure the screen values displayed on the computer monitor. According to the example, this is because of the assumption that raw 8-bit pixel values on a computer monitor are linear to actual pixel luminance. This assumption is not correct, which means that if the software doesn't take the gamma-encoded values into account when rendering the scene, the gamma will be wrong. It states that a linear workflow is about accuracy, which I agree with.

To fix these issues with the gamma-encoded values that are found in digital image files, we will have to remove the gamma that has been applied, so that when rendering in modo, everything is being processed with a linear gamma value of 1.0. We will discuss the process in the next section. In its most basic form, "gamma" represents the relationship between an input and an output. In 3D, the input is what the software rendered, and the output is what is displayed on the screen. In a linear workflow, no gamma is applied to the resulting images that are texture maps and color picker values until the final output is rendered.

Setting Up a Linear Workflow in Modo

Setting up a linear workflow in modo 401 is actually very simple. In fact, it's already enabled by default. There are just a couple of settings we need to check. In this section, I'll discuss two methods for setting up a linear workflow in modo. The first method will be for rendering and saving images in linear space, as is needed for compositing in linear floating point. Compositing in linear floating point is beyond the scope of this book, as the goal of this chapter is to show a linear workflow as it pertains to 3D rendering. The second method will involve gamma correcting our renders to match your working gamma.

I've setup a quick scene in modo that uses the coffee cup from the Preset Browser, as shown in Figure 9.3.

I've also used an sIBL environment preset that we have discussed in the earlier chapter. By lighting the scene with a HDR image, I was able to use lighting information with bright values above 1.0. You can download the scene files from the books website.

Rendering and Saving in Linear Space

To begin, fire up modo, open the preferences, and go to the Rendering category. We are interested in the Default Output Gamma and the Display

FIG 9.3 This is the coffee cup scene that is used in the examples.

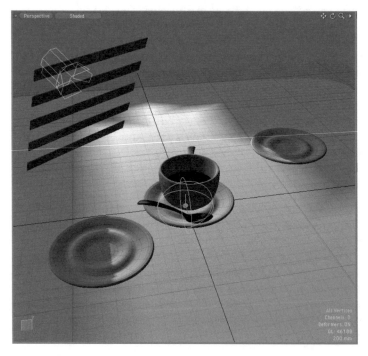

Gamma. By default, these values are set to 1.6. The gamma is already adjusted to the value of 1.6 by a small amount to compensate for the dark appearance of a linear gamma. When defining linear space, I mentioned that modo was rendering in linear space, and we also talked about how a computer monitor operates in a nonlinear gamma. When you view a render with a linear gamma on a computer monitor, it looks dark. That's because a gamma correction is not being applied to the render to compensate for the fact that the monitor is working in nonlinear fashion.

The first thing we want to do is to change the Default Output Gamma to 1.0. This will change the gamma of our renders to a linear gamma, but it is just a preference that sets the default gamma setting to this value for any new Render Outputs you add to the Shader Tree. The actual gamma for our render is actually controlled through the Render Output. In the shader tree, select the Final Color Render Output, and check out its properties. Under the Gamma setting, you'll want to change this to 1.0, if it's not already. You can also choose the linear preset by clicking the downward facing arrow next to the input field. Also in the properties for the Render Output, we'll want to uncheck Dithering. Dithering is used on images that are rendered in 24-bit color. Its purpose is to help blend the colors in tonal ranges that may otherwise produce a banding effect due to the inadequate color representation in 24-bit color. However, since we are rendering in 32-bit floating-point color, there is no need for dithering, since we have more than enough color information to accurately reproduce the tonality in the render. We have set the Render Output to a linear gamma, but the image still won't be in linear space. Also, if I were to do a render at this point, the render would look very dark, as shown in Figure 9.4. Remember, this is because the monitor is displaying the render in a nonlinear gamma, which in my case is a gamma of 2.2. So, to correct this, we need to create what is called a view lookup table (LUT). This essentially will remap the tonal values in our render to allow it to be displayed on the monitor. This is easily done in modo by changing the Display Gamma in the preference panel to your monitor's working gamma, and make sure that Independent Display Gamma is on. If you change this preference with a project that has already been created, you'll need to change the Gamma setting in the Final Color Render Output found in the Shader Tree before the gamma change will take affect. This preference setting will act as our view LUT and allow us to view the render correctly on the monitor, while maintaining a linear gamma of 1.0 when saving the file.

Render Window Gamma
On a sidenote, you can also change the gamma setting on the Render Window in the Gamma input field.

In Figure 9.8, you can see a render of the same scene, except the display gamma has been changed to my monitor working gamma. You'll notice that the

FIG 9.4 By setting the Render Output gamma to a linear value of 1.0, the render looks too dark. This is because the monitor displays the render in a nonlinear fashion.

FIG 9.5 The blue ring design texture map now looks washed out, since the display gamma was changed to 2.2.

image is much brighter, and the tonal ranges are evenly distributed across the image. You can also see a difference in the details that are now available in the shadows. Although we can now correctly view the render on the screen, thanks to the change in the display gamma, we still have an issue that needs addressing. Take a look at the blue ring design on the foreground plate in Figure 9.5. This blue ring is a color texture map, and because we changed the Display Gamma it now looks a bit washed out.

What's happening is that color map is essentially having a gamma correction applied twice. As I mentioned earlier, the color map already contained a gamma-encoded value. When we applied the Display Gamma to the render, it was added to the gamma already present in the file. The color map was created in Photoshop by just filling a selection with a blue color, and it was there the gamma was introduced. Color values that are chosen with the color pickers will have a gamma applied in order for them to be displayed correctly on the monitor. In modo 401, the compensation for the gamma-encoded values that are chosen with color pickers are handled automatically by activating it in the preferences. By choosing these options, you don't have to worry about removing the gamma from these color values.

In Figure 9.6, you'll see a simple scene that has two cubes with the same colors applied. The cube on the left had Affect Color Swatches/Picker and Affect System Color Dialog activated before the color was chosen, and the cube on the right didn't. When the Display Gamma was changed to 2.2, you'll notice that the cube on the right appears washed out.

The same holds true for image files as well. We need to linearize the image files we use as texture maps by applying the opposite gamma of the gamma that was used to create the file. Typically, this will be your working gamma, since the images are created on your system. Just take 1 and divide it by your

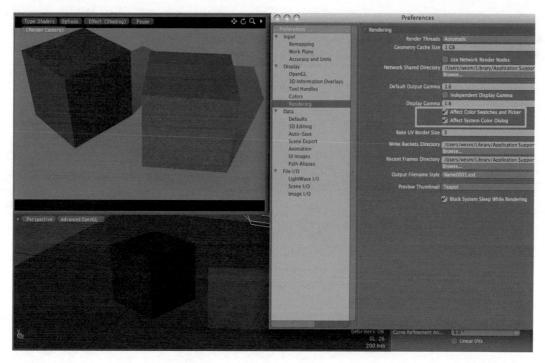

FIG 9.6 You don't need to worry about gamma-encoded values in the color values chosen with the color picker, as long as Affect Color Swatches/Picker and Affect System Color Dialog is activated.

working gamma. For example, my working gamma is 2.2, so 1 would be divided by 2.2 to give me the value of 0.4545. The same holds true for textures that are created from images from a digital camera since a gamma is being applied to the image in-camera. This is unless you are using a raw format since it has a linear gamma curve by default. Before we move on, I'd also like to point out that HDR images do not need to be linearized as well, since they are in linear space by default.

Once I have this inverse gamma value, I just need to enter it into the Gamma input, which is located in the texture maps Texture Layers properties. In Figure 9.7, you will see that after removing the gamma-encoded values from the texture map, the blue line design on the plate is no longer washed out. This image was rendered in linear space and gamma corrected to be displayed correctly on a non-linear monitor.

To Linearize or Not to Linearize
From all of my testing, I have come to the conclusion that there is no need to remove the gamma-encoded values for grayscale images

FIG 9.7 After removing the gamma-encoded values from the texture map, the blue line design on the plate is no longer washed out.

that are used to describe the reflectance or physical attributes of a surface, such as Diffuse, Reflection, Specular, and Bump. The reason for this is that these grayscale values represent numerical data for a surface attribute, such as Specular Amount, and should be interpreted by the render as such. (For example, if you choose to paint a specular value in Photoshop that should represent 20 percent of the specular amount, and then linearize this map). The 20 percent value will become darker than 20 percent, which would then throw off your specular setting.

Now that we finally are rendering in linear space, we need to be able to save a file in linear space. This is where the Gamma setting in the Render Output becomes vital. By changing this setting to 1.0, we will output a file with a linear gamma; and because our color values and texture maps have been linearized, the file will be in linear space for compositing in a linear environment and the effect will be that the image will now look dark when viewed on a non-linear monitor. Be sure to save the file in a floating-point format, such as OpenEXR.

📖 **Tip:** HDR files should always be saved in linear space. OpenEXR was a file format created by Industrial Light and Magic. It is currently the most versatile and widely accepted HDR format.

You will notice that since our image has been saved in linear space, it will now look dark when viewed in an application such as Shake, as shown in Figure 9.8. You will need to apply a view LUT to work with the linear image on your monitor, as shown in Figure 9.9.

When you open the file in Photoshop CS4, it should display correctly if color management is turned on. If you would like to view the file in linear space, you just need to go to Proof Setup under the View menu and choose Monitor RGB. Then, turn on Proof Colors to view the file in linear space.

FIG 9.8 In Shake, the linear image will look dark before a view LUT is added to the viewer.

Gamma Correcting Renders

You can still use gamma correction, even if you're not going to be saving your file to a linear format. All you need to do is set the gamma in the Gamma settings of the Final Color Render Output to your working gamma, and then save the file in a low-dynamic range file format. You'll still get all of the benefits to the linear workflow, such as detail in the shadow areas; but since you won't be saving to a HDR format, you may want to tone map the image in the Render Window to make sure that you are optimizing the tonal range—because once the file is saved, you'll be throwing out all of the floating-point goodness. We'll discuss this process later in the chapter.

Render Outputs

Render Outputs are items that can be added to the Shader Tree, and dictate which "slice" of the render to output to the Render Output Window. For example, you can set a Render Output to display outputs, such as Reflection and Specular Shading.

FIG 9.9 After applying a view LUT, the image now looks as it did in modo's Render Window.

Render Passes

Earlier we've been discussing Render Outputs as it pertains to setting Gamma, but you can also use individual Render Outputs to create different render passes for compositing. Just as with the final color Render Output, you can turn off Dithering and change the gamma setting to save out passes in linear space for compositing in linear floating point. Some Render Outputs may have additional information that you can set to control the output—for example, a Depth Render Output allows you to set the maximum depth of the scene that the Output is to consider when rendering. In my opinion, modo makes it extremely easy to break your scene up into render passes. All you need to do is go to the Shader Tree; and under Add Layer, choose Render Output. Once the Render Output is in the Shader Tree, you just need to right-click on the Effect and choose the pass from the popup menu that you want this Render Output to render.

For example, in the coffee cup scene, I added a Render Output to render the depth of my scene. In the properties of the Render Output for Depth, you'll need to set the maximum depth for the scene by selecting the Depth Render Output and entering a value in the Maximum Depth field on the properties

FIG 9.10 A depth pass was rendered using a Render Output set to Depth, and a post-blur effect was done in Photoshop using the Lens Blur Filter.

panel for the Depth Render Output. In Figure 9.10, you can see the depth pass that was rendered using the Depth Render Output, along with the post-depth of field that was applied in Photoshop using the Lens Blur Filter.

> **Depth Pass and Bit Depth**
> 📖 You'll want to save your depth pass in a bit depth greater than 8-bit. The grayscale values in the depth pass reference distance—and if you're using an 8-bit, the scale can only go to 256 shades of grey. This will ultimately give poor results. I usually save my depth pass in a floating-point format, such as EXR or a 16-bit tiff for Photoshop.

Material Masks

Using Material Masks in conjunction with Render Outputs, you can break up your scene into render layers based on Item Masks. For example, let's say that with the coffee table scene, I would like to create a reflection pass for just the coffee cup and spoon. All I'd need to do is add a Shader and Render Output to the cup's Material Mask, as shown in Figure 9.11. As you can see in this figure, the reflection pass is just for the coffee cup, dish, and spoon.

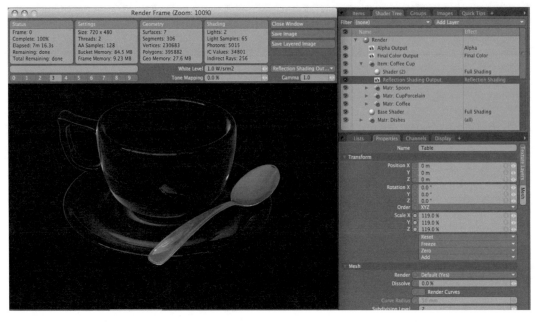

FIG 9.11 Using Material Masks in conjunction with Render Outputs, you can break up your scene into render layers based on materials.

Tone Mapping

Tone mapping is the process through which you can adjust the tonal values in a floating-point image so that it can be displayed on a computer monitor by compressing the extended tonal range in the HDR image, and condensing it to fit within the smaller tonal range of monitors and printed output.

I mentioned earlier that a computer monitor isn't capable of displaying the super bright floating-point values that are present in HDRI. Tone mapping allows us to choose what portion of the tonal range we would like to display in our image. Tone mapping is not a new concept. In fact, I used to do this when printing black and white photos in my darkroom. The tonal range that was in the negative was far greater than what could be displayed on the photographic paper, so I had to make decisions on how best to represent the negative's tonal range when it was printed on paper. I'd often have to revert to techniques called dodging and burning, much like the tools found in Photoshop—but the difference was that I had to use my hands, or shapes cut out of cardboard. With tone mapping, you're doing the same thing. In modo 401, tone mapping can be applied on the Render Output Window after a render has completed, or by entering a value in the Tone Mapping Setting found in the Render Output's properties panel.

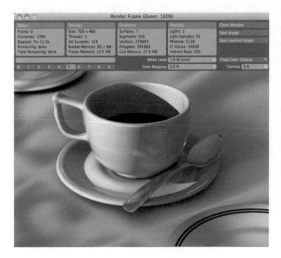

FIG 9.12 The detail in the shadow areas is not apparent on an 8-bit monitor.

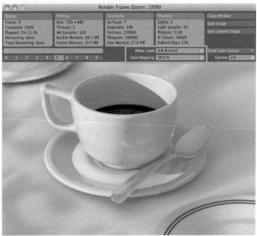

FIG 9.13 Because the render was going to be saved in 8-bit, tone mapping was applied to the final render to reveal the optimum tonal range before the data was thrown out.

I use the Tone Mapping settings in the Render Output window so that I can see the effects in real time. The White level allows us to set what pixels are pure white in a scene. You can use this setting to raise the white level and possibly bring out details that could be hiding in the super whites. The Gamma setting will adjust the distribution of tones over the image, and the Tone Mapping setting will compress the dynamic range of the render, to something that's visible on our monitors. In **Figure 9.12**, you can see the final render of the coffee cup scene without tone mapping applied. Notice that the detail in the coffee is lost to the linear nature of the render, and the monitor not being able to display the full dynamic range. To reveal the optimum tonal range before saving to 8-bit, the image was tone mapped to bring out the detail in the shadows, as shown in **Figure 9.13**.

Tone mapping can be a very subjective topic, and ultimately it comes down to what looks good to you. I will tone map a render if I know that the image needs to be saved to an 8-bit format. It's a real benefit that modo allows you to tone map the image after the render, because you will be able to have access to the entire tonal range before the data is thrown out by saving to an 8-bit format.

Summary

In this chapter, we've taken a look at a very advanced topic. We've discussed the issues with gamma-encoded values and how this affects the internal math

behind the rendering. We've also looked at how to set up a linear workflow in modo to not only improve renders, but also to create linear files that can be given to a compositor who is working in linear floating point. Advanced rendering is much more involved than just hitting the F9 button to render the scene. It's important to specify which portions of the dynamic range present in your scene you want to expose the "digital film" of the render to. By utilizing a linear workflow and tone mapping, you can have even more creative control over your renders.

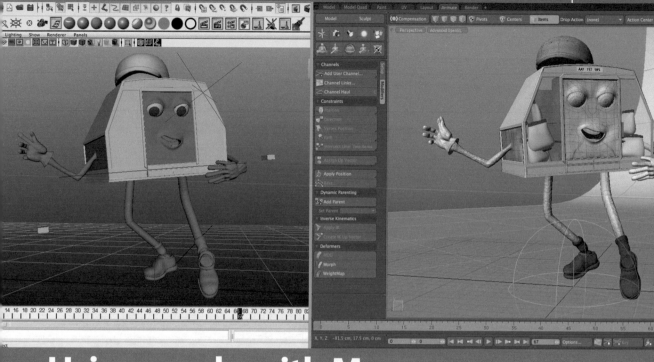

Using modo with Maya

F rom our discussions in the previous chapters, we can comfortably state that modo is an extremely versatile application. The new animation tools in modo 401 have broadened modo's animation capabilities. However, I find that there are times when you might need to export data from modo to another application such as Autodesk's Maya. Perhaps you work in a facility where you must adhere to a specific pipeline. You might be working only on a specific portion of an asset, and it may need to be passed through another application down the pipe. In this chapter, I will be discussing the workflow that I use when I export models created in modo for animation in Maya. We will also look how to get the animation keyframes back into modo for rendering.

Why Use Maya?

Maya has a very extensive animation toolset. Although there are several full-featured animation packages on the market such as LightWave 3D, 3ds Max, and Cinema 4D, I feel that Maya has the best animation tools and it fits my workflow. This chapter isn't about why I prefer Maya for animation. After all, this is a modo book. Instead this chapter is about playing to the strengths

of the tools that you use. Although I use Maya in conjunction with modo in this chapter, these principles can be applied to other 3D programs as well. As we've seen in Chapter 6, modo can handle complex animation. However, rigging and animating a character in Maya is easier and more efficient than it is in modo. If you can accomplish a task in application A faster than application B, then you're effectively increasing your productivity, which in turn could allow you to focus more of your time on the creative aspects of your project rather than the technical. As I said, it's important to play with the strengths of the tools that you use to maximize your time.

My Workflow

I am constantly examining and refining my 3D workflow. I always keep my eye out for new software or techniques that may help me to increase productivity. I've already mentioned that I use Maya for animation, but I'd like to take a brief moment to talk a bit more about my current workflow. I use modo for most of the creation process, which includes processes such as modeling, UV layout, and painting textures. To begin my project, I will start to model any assets I need within modo. As we discussed in Chapter 5, I then make some discussions on how this model will be textured. This means that I try and stick with using texture maps to control material attributes such as reflection, specular, and diffuse. As I use other 3D applications, I need to make sure that I retain compatibility between programs. Most of the time, my plan is to always do the final render in modo. In my opinion, it's just so much easier to set up and tweak a render in modo versus using Mental Ray in Maya. Once the model has been UV mapped and textured, I then export the model to Maya via FBX. Once in Maya, I then animate the model. For example, for doing character animation, which we'll see later, I rig and weight the model and then export the animation out of Maya in the form of MDD files. Finally, back in modo, I apply the animation created in Maya via modo's MDD Deformers, as shown in Figure 10.1.

FBX

Before we get into animation, we will first discuss transferring meshes from modo to Maya. FBX is a file format that can be used to transfer models for modo to Maya and vice versa. It is an extremely versatile format in that not only does it export mesh data, but camera and animation data as well. Exporting your modo scene to FBX is straightforward. All you need to do is either go to File>Save As or Export As to bring up a save file requester, and choose Autodesk FBX for the file type.

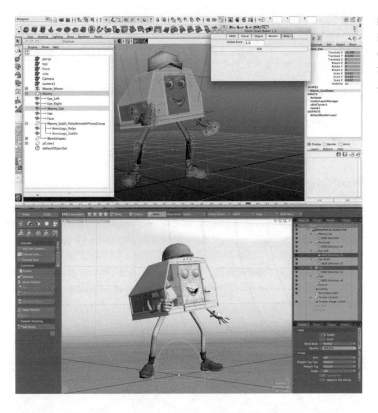

FIG 10.1 This character was animated in Maya, and the animation was exported to modo for rendering via MDD files.

Source: Wes McDermott

The difference between "Save As" and "Export" is: with "Save As," subsequent saves will continue to save the scene in the selected format, while overwriting previous saves; whereas "Export" just saves an alternate file, the open file and its associated saved file stay intact (and associated).

Using Save As will continue to save in the selected format, overwriting previous saves, while Export As just saves an alternate file. Once you have chosen a directory to save the file to, you will get Confirmation Request dialog that complex texturing can't be exported from modo with complete accuracy in the FBX format. Don't worry, nothing is wrong with your scene. This dialog is warning you that a complex shader network may not translate into the FBX format correctly. All that is left is to do is click the save button in the Confirmation Request dialog, and the FBX file will be saved.

The material that is assigned to your model in modo will be set as a Phong shader when the FBX file is loaded into Maya. Complex layers such as Gradients and Procedural textures will not carry over into the FBX file.

> 📖 **Tip:** Because I rely more on FBX and other 3D applications such as Maya and Mudbox, I try to stay away from using Procedural textures and Masking in the Shader Tree within modo. Instead, I use texture maps to define all of my shader attributes such as reflection, specular, and diffuse. This way, I can maintain compatibility between the applications I use.

That's all there is to actually exporting the scene. Now let's take a look at making sure that the sizing is properly set.

Working Units

When I first started exporting MDD files from Maya to modo, I had a tough time understanding the size discrepancies I was experiencing in the MDD file because of the working units of different 3D applications. I'll talk more about this size discrepancy in the MDD section. For now, let's look at the sizes of a model in modo and Maya. In Figure 10.2, you can see a model that I'd like to export to Maya. I have the Dimensions tool active so that I can see that the model is 1.48 m tall.

FIG 10.2 The model stands 1.48 m tall in modo.

FIG 10.3 The model stands 148.18 cm tall in Maya.

New to 401

📖 The Dimensions tool is new to modo 401. It quickly allows you to find the dimension of an object, as it aligns itself to the bounding box of the selected model. It can be found under the View menu.

In Figure 10.3, you can see this same model imported into Maya via FBX. I used the Distance tool in Maya to view the size of the mesh. Notice that the Distance tool is measuring 148.18.

The deal is that modo had its default units set to meter, while Maya was set to centimeter. By changing Maya's Working Units in the Preferences to meter, the size will display correctly as shown in Figure 10.4.

I said that, "the size will display correctly." Display is the key word in that statement. By setting the Working Unit in Maya to meter, all I did was set how the units will be displayed in the viewport. Internally, Maya is still thinking in centimeters. Although the Distance tool is displaying 1.48 m in the perspective view, in the Attribute Editor the units are actually being calculated in centimeters, as shown in Figure 10.5.

FIG 10.4 The Distance tool in Maya now displays the model at 1.48 m, as it does in modo.

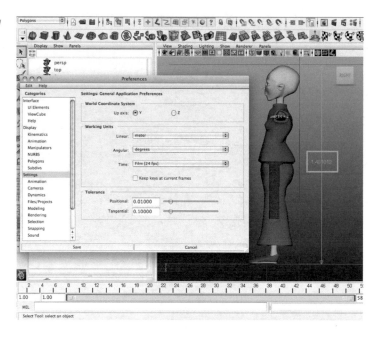

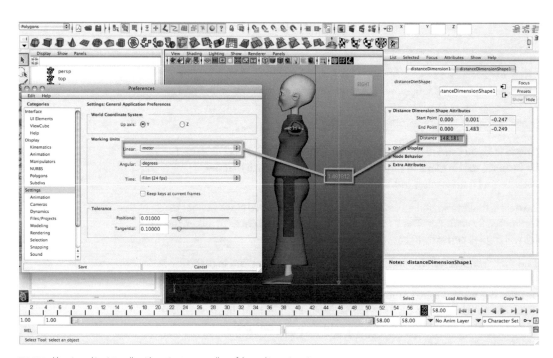

FIG 10.5 Maya is working internally with centimeters, regardless of the working unit setting.

Because Maya is internally calculating in centimeters, we will run into a sizing issue when not only exporting MDD files from Maya, but camera animation in an FBX file as well. The reason for this is that internally, modo is working in meters; and even if the working units for both programs are set to be the same, there will still be a discrepancy, because each app is internally calculating size differently. This will become apparent during the animation section of this chapter. The point I want to illustrate now is that there is a size discrepancy when exporting MDD files and camera animation via FBX from Maya, and we'll need to correct for this in modo.

Animation

So far we've discussed using the FBX format to transfer mesh data from modo to Maya. For the rest of this chapter, I'll be discussing how to get animation data from Maya to modo. We'll take a look at exporting camera data and using the MDD Deformer in modo to use MDD files exported from Maya. Let's begin by looking at exporting camera data via the FBX file format.

Camera

If I am exporting an animation from Maya to modo, I will usually only concentrate on the animation for the mesh objects. I tend to do the final camera work in modo once the animation has been imported. However, there are times in which you may want to do the camera animation in Maya. You might even have tracking data for a 3D tracking program that you'd like to get into modo. You can use the FBX file format to transfer the camera animation to modo.

Exporting Camera Only
Let's first look at exporting a camera from Maya without expressions or constraints. Once your camera is animated, select the camera and go to File>Export Selection from the main menu in Maya. In the FBX export options, you'll need to have Animation and Cameras checked.

Adjusting Camera Size
Once you've opened the file in modo, you'll notice a huge camera in middle of your scene, as shown in Figure 10.6. This is where the sizing issue comes into play.

The scene in Maya was internally being calculated in centimeters. The camera size in modo needs to be adjusted to match the Maya camera's dimensions. In modo, the camera size needs to be changed from 1.0 to 0.01, as shown in Figure 10.7.

FIG 10.6 We need to adjust modo's camera size to compensate for the size discrepancy.

FIG 10.7 You can correct the camera size by adjusting the size attribute in the camera's channels.

The Size value for the camera defaults to 1.0. Because Maya is working internally with centimeters and modo in meters, when the animated camera from the FBX file is imported into modo, the modo camera is too large. This is because the value for the camera size in the FBX file is being imported into modo in meters. To match the modo camera to the dimensions of the Maya camera, which are in centimeters, we'll need to resize the modo camera. To do this, we'll convert the modo camera's size to centimeters as well. There are 100 cm in 1 m, so if we divide 1 by 100 (1/100) we will get 0.01. This is how I determined the 0.01 value. This conversion is based off modo's default unit being set to meters.

Adjusting Curves

Now that the camera is appropriately sized, we'll need to look at the curves in modo's graph editor. By default, the interpolation for the curves will not match, as shown in Figure 10.8.

This means that the incoming and outgoing value of the curve is interpolating differently in Maya than in modo. This will cause the camera in modo to not animate exactly, as is in Maya. Luckily, there is an easy fix to this situation. Before exporting the FBX file from Maya, I always bake the animation curves of

FIG 10.8 Here you can see that in modo, an easing is applied to the keyframes in the graph editor; while in Maya, no easing is applied.

the camera. Baking the curves means that a keyframe will be placed for each frame, which will remove the interpolation from keyframe to keyframe. By baking the animation curves, you ensure that the curves will match exactly, as shown in Figure 10.9.

Now, even though the keyframes have been baked, you could still run into an interpolation issue. In the example from Figure 10.9, I noticed that the last keyframe was still having an interpolation issue, as shown in Figure 10.10.

To fix this issue, I just need to select the last keyframe and change id's interpolation to Linear In, as shown in Figure 10.11.

Camera with Constraints

If the camera in the Maya scene is using constraints or expressions to drive the animation, then the baking of the keyframes will need to be done differently. For instance, let's say that the Maya camera has an aim constraint applied so that it will always point to the locator. By keyframing the locator, you will be animating the camera. The problem is that no actual keyframes are being set for the camera itself. To bake the keyframes set on the locator to the camera, you need to use the Bake Simulation command found in the Edit>Keys menu. This will bake the keys from the locator to the camera, so that you can now

FIG 10.9 A keyframe has been placed for each frame, and no interpolation is taking place.

FIG 10.10 The keyframe on frame 24 needs to have its interpolation changed to linear.

export the camera animation to modo via FBX. Alternatively, to use the Bake Simulation command, you can use the Bake Animations option in the FBX export options dialog, as shown in **Figure 10.12**. This will effectively bake the animation from the constraint, and doesn't require the additional step of using the Bake Simulation command.

That just about covers it for exporting camera animation. Now let's take a look at exporting animation via the MDD format.

MDD

MDD files are a point cache that stores the positional information of each vertex for every frame in an animation. The MDD file allows you to, in a sense, freeze complex deformation on a mesh such as IK, skin deformers, and dynamic simulations. The major benefit to this file format is that it allows you to easily transfer animation from one application to another, as long as both apps support MDD. It can also be used to simplify playback or increase responsiveness in a complex scene by taking the calculations from deformers, and in a sense baking them into the MDD file. It can be like merging layers to save RAM in a Photoshop document with many layers.

FIG 10.11 The keyframe on frame 24 has been changed to Linear In, which fixes the interpolation issue.

The good news is that modo supports MDD natively as a deformer item type. MDD exporters are supported in most every major 3D package. However, we'll be taking a look at how you can use MDD to animate in Maya, and then apply this animation to your mesh in modo for rendering. Let's begin with looking at two methods for exporting MDD files from Maya.

Maya MDD Plug-Ins

Earlier, I talked about Maya being a robust animation package, but ironically it doesn't support MDD natively. This could be due to the fact that Maya supports its own Geometry Cache that can be exported via FBX. However, this route doesn't help us with getting animation into modo. So, we will have to revert using a third-party plug-in to export the MDD data. Point Oven and Maya2LW[2] are two great plug-ins that are extremely reliable in production.

Point Oven

Mark Wilson, who is a senior Technical Director at Framestore-CFC in London, UK, developed Point Oven. It is a widely used commercial suite of plug-ins that allows you to bake complex animation and transfer animation between

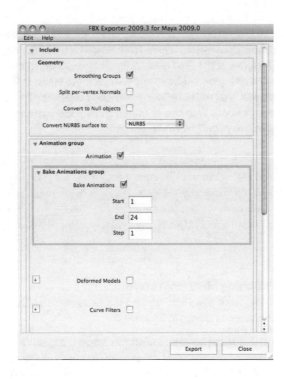

FIG 10.12 Using the Bake Animations option in the FBX, export dialog is the same as using the Bake Simulations command.

various 3D applications. It is relatively inexpensive, with a cost of $99.00 dollars, and supports Maya, LightWave, and 3ds Max. Point Oven can be purchased at http://ef9.com. At the time of this writing, Point Oven only supports modo 301 through a beta version. However, this won't affect us because modo supports MDD files natively. We just won't be able to bake animation from modo to another application.

Both Windows and OS X platforms are supported. However, only LightWave 3D and Maya are supported for OS X. Point Oven is my exporter of choice when using Maya on OS X. It is extremely easy to use, and I've never had any issues while using it in production. If price isn't an issue, I'd highly recommend picking up this plug-in if you plan on using Maya, 3ds max, or LightWave with modo.

Maya2LW[2]
Maya2LW is an open source set of scripts that were originally developed by Markus Weiland. Maya2LW[2] is developed by Lernie Ang, and is the version that is used in this text. Maya2LW[2] is a set of Maya MEL scripts and Windows executables that are used to generate an MDD file from Maya. Its original purpose is to set up a pipeline between Maya and LightWave. However, modo's MDD Deformer can use the MDD file that is output from Maya2LW[2].

This plug-in is only available for Windows, and I have used it many times in production without issues. The best part is that this plug-in is offered under the terms of the GNU General Public License, which means it's free. If you are working on Windows and don't want to invest in Point Oven, then Maya2LW[2] will definitely get the job done. It can be downloaded from this book's bonus Web site, or from the developer's site, which is www.maya2lw2.faulknermano.com.

> 📖 **Tip:** ModoMotion 2.0 is another MDD exporter, and can be found at www.modomotion.com. If you're a Cinema4D user, there is an MDD exporter for a C4D to modo workflow, which can be found at www.lovecraftforest.com/blog/2007/06/13/mdd-for-c4d-to-modo301/. Exporting MDD files from LightWave is supported natively, so no scripts or plug-ins are required.

Exporting MDD from Maya

In this section, we'll be taking a look at exporting MDD files for an animated character, as shown in Figure 10.13.

To give a little background on this scene, the character was created for an online training project I did at work. The body of the character is what we call at UPS a "can." The can is used to load packages on an aircraft. The character was modeled, UV'd, and textured in modo before it was exported to Maya via FBX. Once in Maya, the character was rigged and animated. I then exported the character's motion via MDD files, and applied this data in modo using the MDD Deformer. The character was then lit and rendered to an image sequence that was then used in Adobe Flash to create an interactive presentation. The final delivery for this project was over the intranet at UPS Airlines.

Scene Setup

Before getting into the actual export, I want to illustrate how this model was constructed. The model was broken into several different mesh items such as body, hat, and face, as shown in Figure 10.14. Each one of these mesh items will have an associated MDD file that will be applied in modo. I did this because the body itself is a polygon object, while the face, arms, legs, and hat are subdivision surfaces. I didn't want to have a mixture of the two in one object.

Let's now take a look at this scene in Maya, and see how to export the scene to an MDD file using Point Oven and Maya2LW[2].

Point Oven

First off, installing Point Oven is a simple process. The plug-in files are placed in the Maya plug-ins folder. The Point Oven MEL scripts go into your Maya

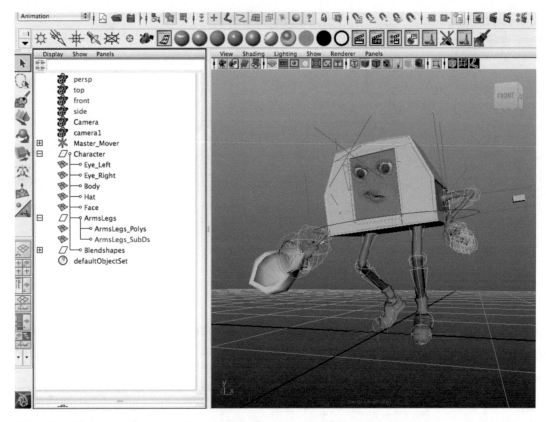

FIG 10.13 I used MDD data to transfer the animated character's motions that were created in Maya to modo for rendering.
Source: Wes McDermott.

scripts folder. From there, you'll want to go to the Plug-in Manager in the Maya Preferences and make sure that the plug-ins are set to load.

> 📖 **Tip:** You can type "getenv 'MAYA_SCRIPT_PATH';" in Maya's script editor to display all of the script paths in which Maya will look for using MEL scripts.

Now that Point Oven is installed, you just need to select mesh in Maya and choose the Point Oven Baker from the Point Oven menu at the top of Maya's UI, as shown in Figure 10.15.

From the Point Oven Baker window, you just need to set the output directory for the MDD files on the MDD tab, and then click the go button on the Misc Tab. The motion for the character will be baked into the MDD file. It's as easy as that. All that's left is to repeat the process for each mesh item that makes up the character.

FIG 10.14 The character was broken into separate mesh items, with each item having its own MDD file.

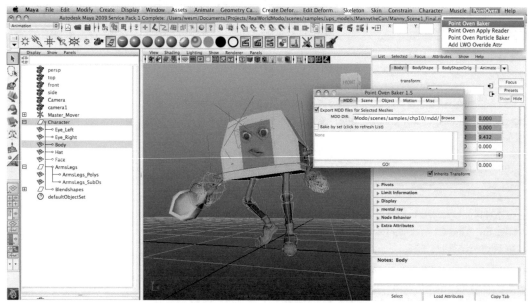

FIG 10.15 The Point Oven Baker can be found in the Point Oven menu located at the top of the Maya UI.

Source: Wes McDermott.

Maya2LW[2]

Now, let's take a look at exporting the same scene with Maya2LW[2]. Once you've downloaded Maya2LW[2], you need to place all of the .exe files into the bin folder found in the Maya's program directory, and then place the MEL scripts in your scripts folder. The process of exporting the MDD file using Maya2LW[2] is a little more complicated than with Point Oven. The nodes in Maya act as containers for information. Maya2LW[2] is exporting this information, but you have to be careful about what you have selected. For instance, when you select an item in Maya, you are actually selecting the Transform node of that mesh. You actually want to select the Shape node for the mesh to export its deformations with Maya2LW[2].

For example, if you're using PolySmooth or another node that can change the components of a node such as using PolyReduce, you can get errors when exporting the MDD file. By selecting the Shape node, you are selecting the low-resolution cage mesh and ensuring that the data will be received correctly when importing into modo. I don't use any smoothing nodes such as PolySmooth. Instead, I just use the 1, 2, or 3 key in Maya to apply subdivision to my model. This is a new feature that was introduced in Maya 2008, and it greatly simplifies the process of exporting MDD files with Maya2LW[2]. To select the correct node for export, I simply select the mesh and press the down arrow key to select the Shape node. Alternatively, you can use the Maya2LW[2] interface to select the desired Shape node.

Once you have selected the correct node for export, you just need to set the directory for where the file will be saved. The MDD file will have the same name as the Shape node that was selected for export, so it helps to have Short Names checked. Finally, you just need to select Export Animation [xform] from the File menu at the top of the Maya2LW[2] interface. The animation will be saved to an MDD file that can be used in modo.

Using modo's MDD Deformer

To apply the MDD files exported from Maya, you just need to add an MDD Deformer to the mesh item. This can be done by either right-clicking on the mesh item in the Item List and choosing Deformers>Add MDD from the Popup menu, or by selecting MDD from the Deformers category on the Animate tab, as shown in Figure 10.16. Finally, you could also add the deformer by choosing it from the Item menu found at the top of the modo interface. A file requester will open asking for the MDD file. Once the MDD file created from Maya has been selected, the MDD Deformer will be applied to the mesh; you can simply scrub the timeline to see the animation that was created in Maya, as shown in Figure 10.17.

This example seemed to work out very nice when the MDD file was applied in modo. However, I had already corrected this scene to compensate for the size

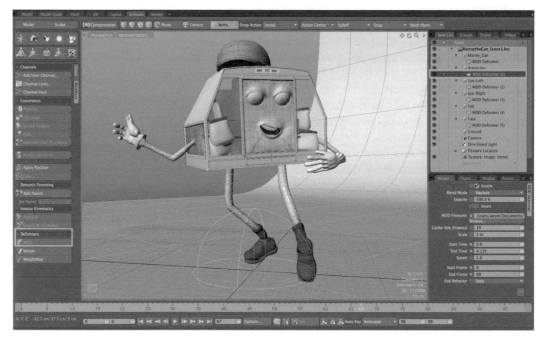

FIG 10.16 The MDD Deformer can be applied in the Item List, the Animate Tab, or through the Item menu at the top of the modo interface.
Source: Wes McDermott.

differences in the working units within Maya and modo. Let's take a closer look at this size issue.

Sizing Issues

Earlier when talking about exporting camera data, I mentioned the sizing issue that happens due to the difference in working units. This sizing issue will cause an issue when applying the MDD file in modo. Let's take a look at the sizing issue that happens while applying an MDD file from Maya, without taking into consideration the different working units between the two programs. In Figure 10.18, you can see the model that was shown earlier. Remember that this model stands 1.48 m in height. In Figure 10.19, you can see the same model in Maya; and remember that it stands 148 m, in height.

If I were to export an MDD file from Maya and apply it in modo with the MDD Deformer, the model would be resized to 148 m, as shown in Figure 10.20.

The model itself is not being resized. If I were to disable the MDD file, the model would return to its original size of 1.48 m. What's happening is that the 148 cm in the Maya file is being translated into meters in the MDD file. This is due again to the discrepancy between modo and Maya working internally at

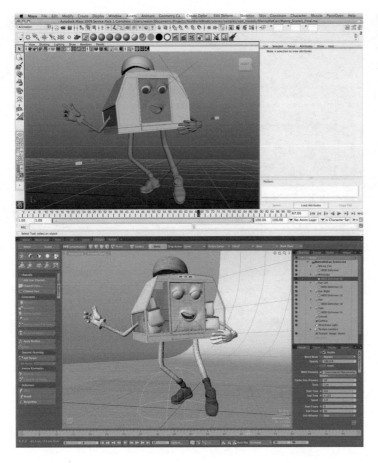

FIG 10.17 The animation created in Maya has been imported into modo via the MDD Deformer.
Source: Wes McDermott.

different working units. If you didn't know to expect this, it would be very strange to see your model suddenly disappear, only to be found when you zoom out in the viewport. Luckily, there is a simple fix. I can change the size of the MDD file by going to the Properties Panel for the MDD Deformer and changing the scale. Just as with the camera size example discussed earlier, the MDD Deformer scale needs to be adjusted. There are 100 cm in 1 m; so if we divide 1 by 100 (1/100), we will get 0.01. By entering 0.01, which is a 100th of a meter, in the Scale input field for the MDD Deformer, the model will retain its proper size, as shown in Figure 10.21. Again, this is based on the modo's Default Unit being set to Meter.

Changing the Scale parameter on the MDD Deformer is an easy way to correctly size the model. I could have resized the model in Maya to 1.48 cm; and upon export of the MDD file, the model would retain its correct size when the MDD Deformer is applied in modo. In fact, this is what I did for the UPS

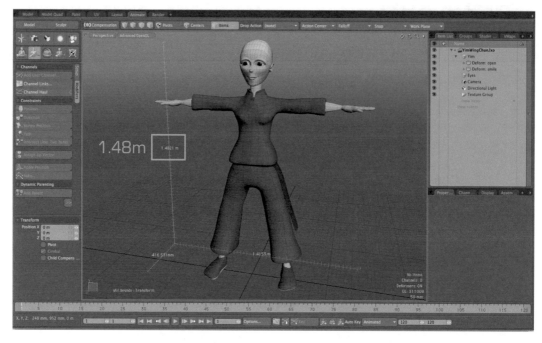

FIG 10.18 In modo, the model is 1.48 m tall.

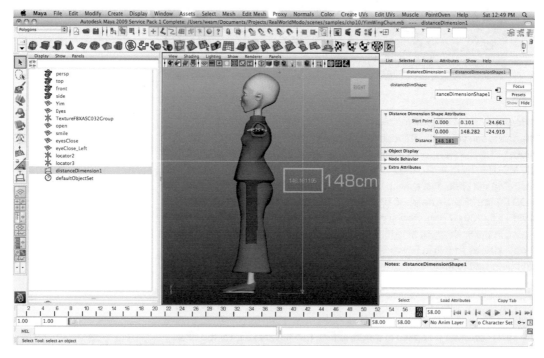

FIG 10.19 In Maya, the model is 148 cm tall.

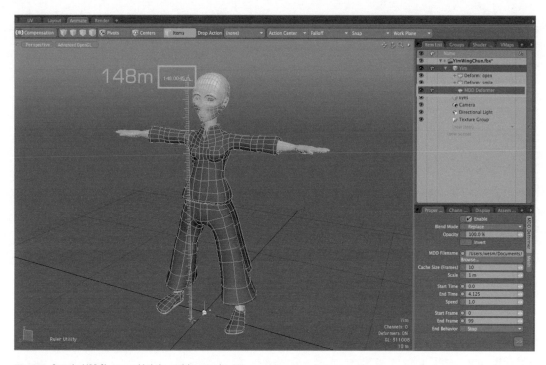

FIG 10.20 Once the MDD file was enabled, the model is resized to 148 m.

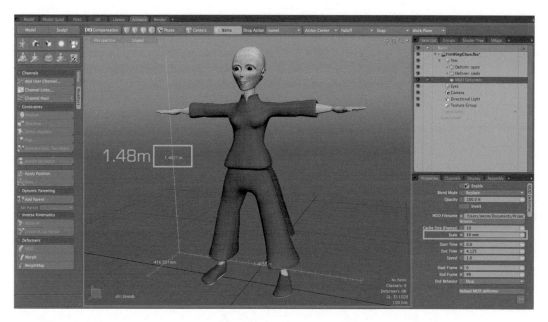

FIG 10.21 By setting the Scale parameter to a 100th of a meter, the model will be sized correctly.

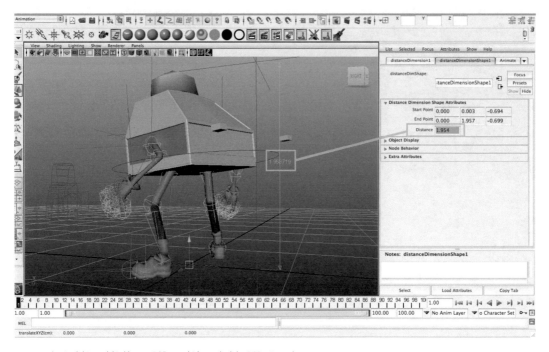

FIG 10.22 I resized this model in Maya to 1.95 cm, which matched the 1.95 m in modo.

Source: Wes McDermott.

character, as shown in Figure 10.22. I resized the model to 1.95 cm, which would translate to 1.95 m when the MDD was applied in modo. My thought process for scale in Maya is to think in generic units. For instance, I wouldn't say that the model is 1.95 cm tall; I think of it simply as 1.95 units tall. This helps me to not get confused when dealing with different sizes.

Summary

That brings us to the end of our discussion on exporting animation from Maya to modo. Although these examples used Maya with modo, the principles will work for other 3D applications that can export MDD files as well. The important thing to remember when working with modo and Maya is that each program is internally calculating size in different working units. Maya is internally working in meters, while modo in centimeters. As we discussed, this will cause scaling issues when importing meshes back and forth between programs. We also discussed exporting MDD files from Maya by using plug-ins. Using MDD files to bring animation into modo from Maya is a powerful way to extend your toolset.

Creating Real-time Assets

There is a lot of diversity in the type of work you can do as a 3D artist, such as architectural renderings, medical illustrations, animation for broadcast TV, or game development. For me, creating real-time assets that can be used in a game engine has been something I've been interested in for quite some time. Now, I am not a professional game artist working on the next AAA title for the Xbox 360; but working as a 3D artist/Multimedia developer, I often get opportunities to use gaming technologies to build interactive training simulations.

In my job, I use Microsoft's XNA Game Studio, which is a game development tool that allows you to create games for Windows and Xbox 360 in conjunction with SunBurn, a feature-rich lighting and rendering engine. XNA is based off the Microsoft .Net Framework and uses Microsoft's Visual Studio, or one of the free Visual Studio Express editions such as Visual C# Express for the Integrated Development Environment (IDE).

> 📖 An IDE is a software application that provides a suite of tools to help programmers write programs. These tools include a Source Code Editor, a Compiler, and a debugger.

The best part is that there's no cost for creating Windows-based games, or for using XNA Game Studio and Visual C# Express. You can find more information about XNA at http://creators.xna.com. SunBurn is a commercial product, and more information can be found at http://synapsegaming.com.

This chapter isn't going to be about using XNA or coding games. However, I am going to discuss several topics that I found either difficult to understand, or information that pertains to creating 3D assets for my XNA projects.

Using XNA on a Mac

📖 If you are a Mac user, as I am, you won't be able to use XNA on OS X natively. However, I run XNA from my Vista Bootcamp Partition. If Bootcamp is not an option, then you should look into Unity 2.5, which is a multiplatform game development tool that you can use to publish games on Windows, Apple, iPhone, and Wii. It is available for both Mac and Windows. It's an extremely robust application, and can be easier to use than XNA because it allows you to code with Javascript; however, it is a commercial product. You can find more information about Unity 2.5 at http://unity3d.com.

My goal for this chapter is to explain the areas of creating game assets that I found confusing. I don't want to walk you through the steps of creating a simple object. I've read many books and tutorials that claim to detail creating game objects; however, they just ended up being an exercise in modeling. I was always left with the same questions. This chapter is about answering those questions.

Examples

In this section, I'm going to be discussing two examples and how they were created using modo. The first example will discuss modeling and generating a normal map for a playable character, while the second example will cover designing textures and UV layout for an environment asset. Through both examples, I will discuss the key aspects to creating game assets, such as poly count, poly size, and how it relates to texture resolution.

Tug Example

A tug is used at UPS Worldport to pull containers of shipments to aircraft loading docks. The model, as shown in Figure 11.1, was used in a training simulation to teach safe driving methods, and to aid in certification for

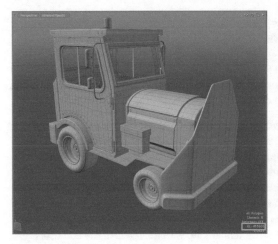

FIG 11.1 The high-res model that was initially created.
Source: Wes McDermott.

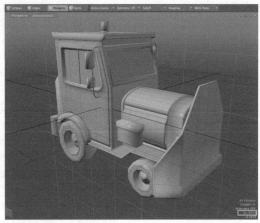

FIG 11.2 This is the low-res model that was created from the high-res model.
Source: Wes McDermott.

employees driving on the aircraft ramp at UPS Worldport. The game was created using XNA and the tug is the playable character, because a user can drive the tug from a third-person perspective.

To begin, I first created a high-res model of a tug, as also shown in Figure 11.1. I used the box modeling method and worked from a backdrop reference, as discussed in Chapter 3. I first created a high-res model because I wanted to use the high-res geometry to extrapolate a normal map from, so that I could apply it to a low-res mesh. By doing this, I can add the illusion of surface detail in the low-res model without having to add more polygons. In Figure 11.2, you can see the low-res mesh that was created. This brings me to the topic of poly count.

> 📖 A normal map is an RGB image that corresponds to the X, Y, and Z coordinates of the surface normal extracted from a high-res version of the mesh. The normal map is then applied to the low-res version of the mesh to give the appearance that the low-res mesh has more detail without having to add more geometry, and thus keep the overall polygon count low.

Polygon Budget

When building assets that will be used in a game engine, you need to pay very close attention to the polygon count because the objects will be displayed in a real-time environment. The polygon budget is the max number of polygons that each object in your scene can be comprised of. Different objects can have a different budget; for instance, you can have a budget for playable characters

and another budget for environments. However, both of these budgets will make up the overall polygon budget for the entire game. I used to get so frustrated with tutorials and books on game modeling because they would talk about the importance of using low-res geometry, but they never talked about how to determine the number of polygons the object should be built from. In this section, I'm going to discuss how the polygon budget is determined.

In the game engine, polygons are drawn each second as the game updates. For the polygon budget, you'll want to figure out how many polygons can be drawn on screen in a single frame without choking up the game engine. In order to come up with a polygon budget, you need to factor several variables, such as the central processing unit (CPU) and graphics processing unit (GPU) speeds of the end users system, and the frame rate in which you'll want the game to run at. The faster the frame rate, the smoother the game action will run. You'll need to do some benchmarking with the specs of the end users system to determine how many polygons can be displayed each frame per second and at what frame rate. The basic idea is that if you can determine how many polygons can be drawn per second and then divide that by your frame rate, you can get an idea of your polygon budget for each object.

However, it's much more technical than only being concerned with how many shaded triangles can be drawn each frame. You'll also have to keep in mind that the texture resolution, output resolution, and lighting effects all factor into the frame rate and draw speed of the engine. Additionally, you have to be concerned with CPU intensive tasks, such as collision detection and artificial intelligence, because the available resources of the CPU are going to run thin before the GPU. With the GPU, you have to be concerned with render state changes and draw calls. The frame rate of the game is very important. Let's say, for instance, you have a fast-paced game, like a first-person shooter; and the frame rate is constantly dropping, which causes the game play to stutter. You would then effectively be ruining the entire experience of the game, and it probably won't even be playable. Usually, the polygon budget is something that will be determined by the game designers—which, in my case, is me.

As you can see, the whole process of determining a polygon budget is not to be taken lightly. That's why the game designers and creators of the engine handle the task of determining the polygon budget for a project instead of the modeler. The actual game engine performance tests and coding pitfalls to be aware of are beyond the scope of this book, but I don't want to just leave you with that statement. If you're like me and are not part of a development team and are creating the content and game yourself, I'd like to share with you my process as follows.

To figure out the polygon budget for my projects, I determine where the game will be installed and get the system specs. Because I work in a controlled environment, I have a test machine that has the same specs as the training room computers that the game will be installed on. From there, I do some

benchmarking and frame rate testing to help me determine the polygon budget for project. I'm not only considering how many polygons the engine can draw, but also how the polygons are used. For instance, you have to consider CPU intensive tasks such as collision detection, as mentioned earlier. Basically, I just set up a sample scene and run it on my test system that has the same specs of the computers that the real game will run on. From this test scene, I determine how many polygons can successfully be drawn, and keep my desired frame rate. For the tug model we're discussing, I determined that I wanted to use a budget of 5,000 polygons and 1K textures, which are 1024 pixels in width. When determining a polygon budget, there isn't a magic number. It comes down to knowing the capabilities of the system running the game, such as the CPU and GPU and the engine upon which the game is built. After the polygon budget has been determined for the game, you can begin the process of building the game assets to the specs of the polygon budget.

Building the Low-res Mesh

The low-res tug model is built from the high-res version. Essentially, I used the high-res mesh as reference that I was basically "drawing" on top of. The polygon budget was constantly on my mind, so I first needed to decide where the bulk of the polygons could be used. The game will be viewed from a third-person perspective, as shown in Figure 11.3. I then chose areas of the model that are the most visible to the user, and placed the bulk of the polygon detail in these areas. In areas that are not readily visible, such as the tires, I added less detail, as shown in Figure 11.4.

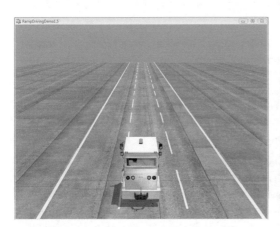

FIG 11.3 The scene rendered from the game engine.
Source: Wes McDermott.

FIG 11.4 Because the tires are not seen, I didn't have to waste a lot of the polygon budget making them round.
Source: Wes McDermott.

My process is rather simple, as I am using the basic modeling tools discussed in Chapter 3. While creating the low-res mesh, I'll want to again focus on only using quad polygons, as mentioned in Chapter 3. I can use triangles when needed, but I definitely must stay away from using n-gons as they will not be supported by the game engine. I don't need to worry about converting my mesh to triangles, because the game engine will handle this for me. I also like to stick with quad polygons, because they're much easier to work with if I need to edit the game model down the road. I will be exporting the model from modo to the FBX format, as XNA Game Studio supports FBX natively through the FBX Content Pipeline.

To begin, I placed the high-res mesh into the background and hid all of the polygons, except the ones that I currently want to rebuild in the low-res mesh. I then activated Snapping and chose Background from the Constrain To menu.

I chose either the Vector or Screen Axis modes in the Geometry Constraint menu. These modes will control how modo searches for the background geometry to constrain to. For instance, Screen Axis will locate geometry to snap to by searching in a perpendicular direction relative to the current views position. The Vector mode uses the active tool's handle as the search direction, and the vertices being translated will have a vector traveling out from its normal to find background geometry. These modes are new to modo 401 and are more precise than just using the Handle Constraint mode, which is similar to how previous versions of modo worked with snapping. These new modes compare geometry for snapping instead of simply relying on the tool handles. For example, in Figure 11.5 you can see that with Vector mode, as I move the selected polygon with the Move Tool's Y axis handle, the selected polygon's vertices snap to the background mesh's vertices. This allows me to quickly snap the selected polygon on the low-res mesh to the top polygon in the background mesh.

Another method I'll use with Snapping is take the high-res mesh and Freeze it so that it becomes very dense in polygon resolution. Next, I'll use the Pen Tool to snap quad polygons to the dense high-res background. Because the background has been frozen and thus has many vertices, it makes it easier to find a vertex to snap to. For this operation, I use Background Constraint in Screen Axis modo, with Handle Constraint active and the Pen Tool has Make Quads enabled, as shown in Figure 11.6.

Using the basic techniques discussed in Chapter 3 and utilizing Snapping to match the high-res mesh in the background, I completed the low-res mesh that will be used in the game. In Figure 11.7, you can see both the high and low-res versions of the model. The high-res model had an original poly count of over 450 thousand polygons. The low-res version has only 5,574 polygons, which came in a small bit over my budget, but it still retains the base shape of the high-res version.

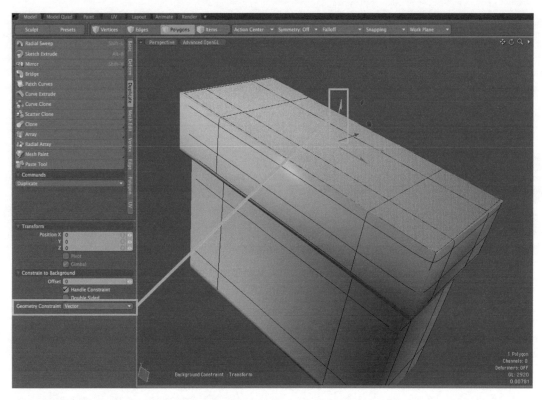

FIG 11.5 By using the Vector Geometry Constraint mode, I can quickly snap the polygons on the low-res mesh to match the high-res mesh.
Source: Wes McDermott.

After the modeling process is completed, I created the UV map. For the tug model, there will not be any texture tiling, as with the simple building example discussed later. This will mean that all of the UV coordinates will fit to the 0 to 1 space. My polygon budget that I determined beforehand also helped me to determine my texture resolution; and as I mentioned earlier, I will use 1K textures for the tug. Now, before I began mapping, I decided what the most important parts of the model will be – i.e., what is most visible to the player. I made sure that these areas take up the most space in the UV map, so that these areas of the model will be mapped with the bulk of the texture resolution. In **Figure 11.8**, you can see the layout for the UVs and that polygons that are most visible to the player have been given the most resolution in the texture map.

Now that the model and UV map are complete, we can now generate the normal map. For the tug model, I created the normal map from the high-res mesh and used modo to bake the normal map to an image.

FIG 11.6 Using the Pen Tool with Background Constraint is a good way to quickly lay down quad polygons that will match the high-res geometry.
Source: Wes McDermott.

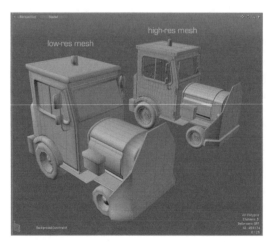

FIG 11.7 A comparison between the high and low-res meshes.
Source: Wes McDermott.

FIG 11.8 The most visible polygons in the game (highlighted) have been given the most UV space.
Source: Wes McDermott.

FIG 11.9 Large areas of the model that stick out will need to be created with actual geometry.
Source: Wes McDermott.

Creating the Normal Map

Using a normal map is a great way to add detail to the low-res mesh without actually having to add geometry, and thus keep you under the polygon budget. Parts of a model, like rivets and bolts, are perfect details that can be added in a normal map. A normal map is much like a bump map in that it creates an illusion of surface detail. However, when the model is viewed at angles, it can become apparent that there isn't any actual geometry there. Because of this, you'll want to model areas of the mesh that will stick out on the object, as shown in Figure 11.9. Ultimately, there isn't a hard and fast rule on what should and shouldn't be left for the normal map to detail. Since the normal map is a "tool" to help you reduce the poly count, you'll have to make decisions based on the polygon budget versus how close the player will come to the object in question. Experience on how your model performs in a given game engine will help you when making these types of decisions.

Baking the Map

In order to bake the normal map, the high-res mesh and low-res mesh must be occupying the same space, as shown in Figure 11.10.

From there, you add a new color texture to the Shader Tree, and place the high-res mesh in the background and the low-res in the foreground. Make sure that the UV map for the low-res mesh is selected in the Vertex Map Viewport, right-click the new texture, and choose Bake from Object to Texture from the context menu. The Bake Texture from Object dialog box will open asking for the Distance.

A normal map is encoding the shading normal for a particular point on a model, and then applying the data to another model by mapping it to the local coordinate system in its UV map. When baking the normal map, a ray shoots out and intersects the high and low-res meshes. The point of this

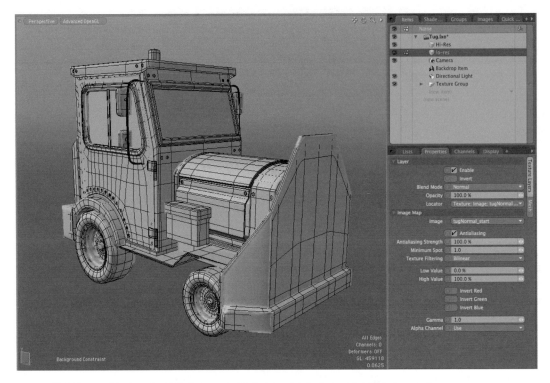

FIG 11.10 The high-res mesh has been placed in the background, while the low-res is in the foreground and the both occupy the same space.
Source: Wes McDermott.

intersection is where high-res point data gets mapped to the low-res mesh's UV map. The Distance setting in the Bake Texture from Object dialog is asking the distance the ray should travel when looking for the intersection. This is a setting I usually find through trial and error. I will look at the Grid Size to get an idea of the distance; and from there, I try a few distances to see which produces the level of detail I want to get in the normal map.

In Figure 11.11, you can see the normal map applied to the model by having Advanced OpenGL enabled in the viewport. However, there are a few problems with the normal map that was produced. The main issue is with the edges. Notice in Figure 11.12 that errors are showing up at the hard edges of the model. I can fix these hard edge errors by increasing the Smoothing Angle on the low-res mesh's Material.

Smoothing Angle

By increasing the Smoothing Angle, I optimize the mesh and get rid of the edge errors in the normal map. For the tug, I set the Smoothing Angle to 180. In Figure 11.13, you can see that with the Smoothing Angle increased, the hard edge errors are gone, but new smoothing errors have shown up.

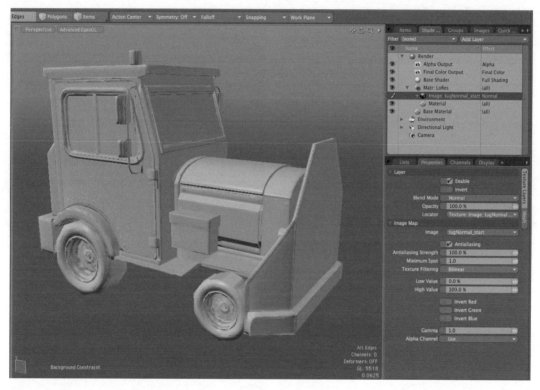

FIG 11.11 Here you can see the normal map applied to the model by enabling Advanced OpenGL in the viewport.
Source: Wes McDermott.

The problem with the Smoothing Angle and the roof of the tug is that it's trying to completely smooth over the edge where the top and sides meet. There is an edge there and I don't want to completely smooth it away, so I'll have to control how the Smoothing Angle is affecting the edges. In order to do this, I'll need to insert an edge loop close to the edge where the top and sides of the roof meet. This will stop the Smoothing Angle from trying to smooth the entire top roof polygon down across the side of the roof. Instead, it will smooth the polygon from the inserted edge loop to the actual edge where the top and side meet, as shown in Figure 11.14. I used Edge Slice to add the edge loop.

In Figure 11.15, you can see how adding an edge loop controlled the smoothing and eliminated the errors.

Over Baking Polygons

One last thing to mention when baking normal maps from a high- to low-res mesh is that you need to look out for polygons being baked as details in the normal map, which I refer to as "overbaking". For instance, in Figure 11.16, you

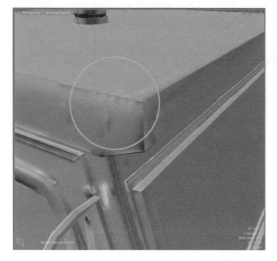

FIG 11.12 The hard edges of the model are producing errors in the normal map.
Source: Wes McDermott.

FIG 11.13 The Smoothing Angle fixed the hard edge issue, but it brought some issues of its own.
Source: Wes McDermott.

FIG 11.14 Here you can see the new area that will be smoothed due to the addition of the newly added edge loop.
Source: Wes McDermott.

FIG 11.15 You need to control how the Smoothing Angle affects your mesh by adding edge loops to specifically place where the smoothing should take place.
Source: Wes McDermott.

FIG 11.16 The selected polygons in the normal map.

Source: Wes McDermott.

can see that the selected polygons are being mapped as detail in the normal map. These polygons should be isolated in the normal map since they are modeled details, and shouldn't appear in the normal map as a detail on other polygons. They are essentially being baked twice. In Figure 11.17, you can see how the modeled back of the tug is being added to the base cabin of the tug as a detail in the normal map. Also notice that as the model is viewed at an angle, the illusion of the detail from the normal map falls apart. This is why certain areas on the back of the tug needed to have the detail actually modeled. Areas on the mesh that will stick out far enough from the base mesh that a normal map won't be able to reproduce correctly at glancing angles will need to be modeled, i.e., the back bumper on the tug.

The way to fix this is to explode your model, so to speak, so that none of the parts are in front of each other when the normal map is created, as shown in Figure 11.18.

To do this, I create a copy of my scene, and then select both the low-res and the high-res counterpart polygons and simply move them so they will be out

FIG 11.17 The back of the tug is being baked into the normal map as a detail on the cabin of the tug.
Source: Wes McDermott.

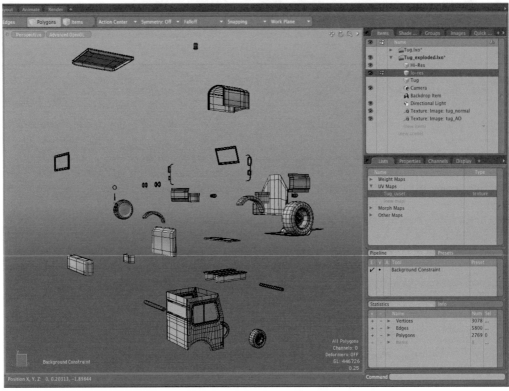

FIG 11.18 The high-res and low-res mesh have been repositioned so that when the normal map is baked from the object, polygon parts that are in front of other parts won't be baked on top of each other in the map.
Source: Wes McDermott.

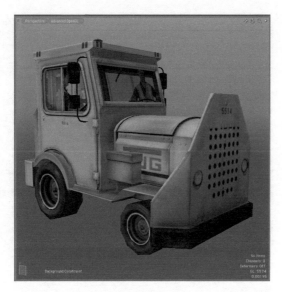

FIG 11.19 The final model with textures applied. The goofy guy at the wheel is me.
Source: Wes McDermott.

of the distance range as is set in the Bake Object from Texture Distance setting. You'll want to make sure that as the ray is sent out according to the Distance setting, it won't intersect another group of mesh items.

In Figure 11.19, you can see the final model with textures applied. To add to the color texture, I baked out an Ambient Occlusion map and multiplied it over top the color map in Photoshop. The color textures were created from reference photos I took of an actual tug. I added rust and dirt to the tug's color map using modo's Paint Tools, as was discussed in Chapter 5.

Simple Building Example

In this section, I'll be discussing the creation of a simple building that can be used as an environment asset. However, don't let the usage of the word "simple" turn you away. I will be discussing several pivotal concepts for creating environmental assets for your game projects. We will discuss topics such as working with scaling, texture tiling, and how to properly lay out and map UV coordinates, with the goal of taking a more advanced look at creating a game asset. The creation of this asset differs greatly from how the tug model was created; and the techniques used here can be used for not only creating environmental objects, but characters and vehicles as well.

Building the Model

In Figure 11.20, you can see the simple building asset that I'll be discussing. To model the object, I used the box modeling method, as discussed in the tug

example and simple extrudes and bevels—nothing mind-blowing. As with the tug example, I always kept the polygon budget in mind. However, since this object wasn't part of an actual project, I didn't really have a budget to adhere to, but I was sure to only add enough geometry and maximize my poly count. It's like a game in itself, trying to figure out how you can build an object with as few polygons as possible, but still create the illusion of detail. You have to decide what areas of the model should be built with polygons, and which details can be "faked" with a normal map.

For example, for the top of the brick wall, I wanted to have it rounded with a cement surface instead of being flat. So, I selected the top polygons and preformed a bevel to add the resolution needed, as shown in Figure 11.21.

The window is another example where I decided to actually split and bevel the geometry to make the window inset into the building, as shown in Figure 11.22. I originally thought about just creating the window by just using the texture map. In this imaginary project, I visualized the character being able to get close to the wall and, when looking up, I wanted the character to see more than just a flat texture map of a window. However, if this model was only going to be seen from afar and the playable character would never get close enough to tell that the window was just a texture map, then there would be no reason to actually build the window. The idea is to spend the greatest number of polygons where it affects the silhouette of the object; interior areas,

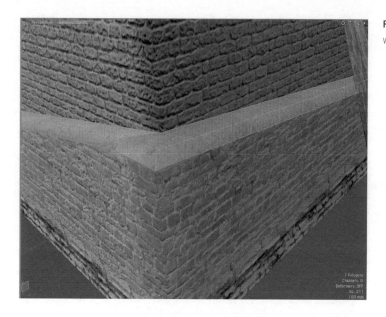

FIG 11.21 The top polygons of the wall were beveled to add the detail.

FIG 11.22 The window geometry was created because a playable character will be able to walk close enough to the wall, and the window would not be acceptable as a texture map only.

like insets, recesses, vents, ports, etc., don't need polygon detail, as they won't be viewed from glancing angles.

For the wall and sides of the building, I didn't create any extra detail through adding polygons. I decided to rely on the normal map to add the illusion of the brick, as shown in Figure 11.23.

Once the model was built, the next step was to create the UV coordinates.

FIG 11.23 I didn't model any detail in the walls of the building. Instead, I relied on a normal map to add detail.

Creating Proportional UVs

Before the texturing stage takes place, you need to create proportional UVs for the object. What this means is that the object's UVs will be scaled to match each other so that all of the UV coordinates display a texture at the same size, making the texture resolution consistent across the object's surface. To create UV coordinates, I used the Unwrap Tool (as discussed in Chapter 5) to unfold the different parts of the building, such as the wall and wood planks. All of the polygons were assigned to the same material. In the Shader Tree, I added a Checker layer; then I used this layer to gauge how a texture would be displayed on the polygons. I set the scale of the Checker layer to 100 mm for the XYZ scale, so that I could see more of the squares in the Checker layer and thus make it easier to see how the texture was being sized on the polygons. From there, I would then scale each UV island, so that the black squares from the checker patterns, which are being mapped by the UV islands, all look to be the same size and shape. I didn't want the squares to be rectangular on one UV set and square on another. They all needed to match. In Figure 11.24, you can see how the checker pattern has been scaled to be the same size on all of the UV islands, which indicates that the UVs are now proportionally scaled to each other.

Creating proportional UVs is important because if one of the UV island's scale is off, it would then cause the texture map to be sized differently on the polygons, as shown in Figure 11.25.

Notice that not only are the squares from the Checker layer larger than the other mapped areas on the model, but the normal map is affected as well.

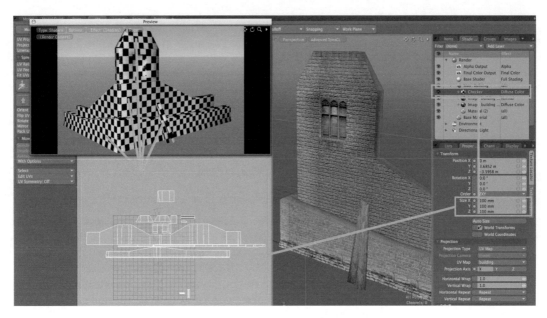

FIG 11.24 I used a Checker layer to help visualize the scale of the UVs.

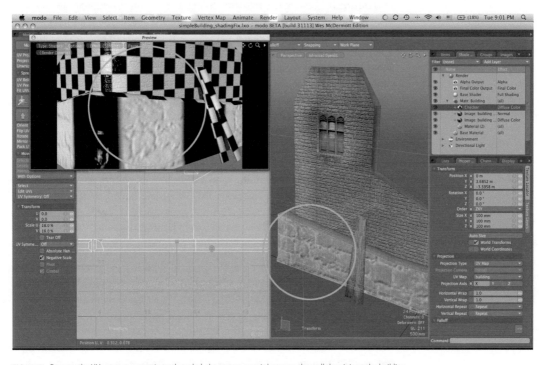

FIG 11.25 Because the UVs are not proportionately scaled, the texture map is larger on the wall than it is on the building.

Notice that the bricks in the wall are now large and blurry, whereas the bricks on the building are sharp and the correct size. The big issue is that since the UVs are not proportional, I'd have to fix this in the texture map by scaling the brick textures in the color and normal map to different sizes for each UV island in order to have them all appear to have the same scale. This would be a very big headache, and not an optimal way of painting texture maps. By ensuring up front the UVs are scaled correctly, I also ensure that the textures I create in my textures will map correctly on all of the UVs for the object. I no longer have to worry about scale. Using the Checker layer is a great way to help you visualize and scale the UVs appropriately.

Establishing the Scale

Now that the model and UVs have been created, I can start creating the texturing maps. At this point, I'd like to talk a bit about polygon size. When creating game content, you'll want to pay close attention to a polygon's size, as in the scale of the polygon in 3D space. You will need to establish a direct relationship for the scale of the polygons to the pixels in the texture map. Again, we need to go back to the polygon budget, which is our guideline for creating assets.

As I mentioned, the polygon budget will not only dictate a poly count, but will also decide the resolution of texture maps; since when conducting game engine and hardware tests, you will also need to consider the texture size that objects will be using. Texture resolution is also decided not only on hardware and game engine factors, but also on the notion of how close the camera in the game will come to the objects in the scene. If the camera will get close to objects, then the texture resolution will need to be larger than if the camera is farther away. For the simple building asset that we're discussing, I've decided that I want to use 1K texture maps, which are 1024 pixels wide. I have also determined that I want to set the ratio for polygon scale to pixels to be 128 pixels per meter. This means that every meter in 3D space will need to be mapped to 128 pixels in the texture map. For example, if I have a wall object that measures 8 meters in modo, then my texture map will need to be 1024 pixels wide, since 8 times 128 equals 1024. Now, I am saying meters, but this value is arbitrary as well. It doesn't have to be meters; in fact, it's easier to think in terms of generic units. The unit can be anything you decide.

The cool thing is that you are in control when setting the scale, unless you are working with a team; in that case, the game designers are in control. The point is, whether you are working in modo with meters and switch to Maya, you don't have to worry about converting size; because if you work in units, the only thing that matters is that everything is calibrated to match the "unit" scale that you've determined. Eight units in modo are equal to eight units in Maya, as well as eight units in XNA studio. Again, the scale is something that is determined with the polygon budget, and determined based on the project's

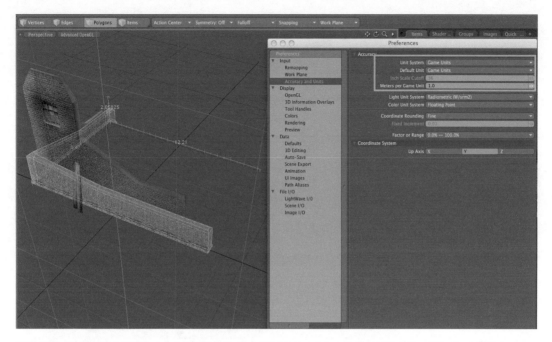

FIG 11.26 To establish my scene scale in modo, I set the System and Default Units to Game Units and set the Meters per Game Unit setting to 1.0 since I want to work with 128 pixels per meter.

requirements. In modo, I set my scene scale in the Preferences panel under the Accuracy and Units section. I set the Unit System and Default Unit to Game Units, allowing me to set the Meters per Game Unit setting (which I set to 1.0 for 1 meter, as shown in Figure 11.26).

Power of Two

A vital aspect of creating textures is to create textures with a resolution that is a power of two. Basically, this means two multiplied by itself a certain number of times. This is a restriction of graphics cards; and although it might not cause an error with one card, it might with another. It's best to always make sure that your texture maps are created within a power of two. For example, some power of two sizes would be 16, 32, 64, 128, 256, 512, and 1024. The texture rendering schemes perform the fastest at these resolutions. Digital systems are sort of hardwired with these types of numbers—that's why RAM always comes in 512, or 1024, or 2048, etc. Computers are fastest when dealing with "native" numbers.

Measuring the Scene

Now that the scene scale has been determined to be 128 pixels per meter, I will need to measure the objects in the scene so I'll know exactly how much texture space will be needed to properly cover the object. To do this, I select

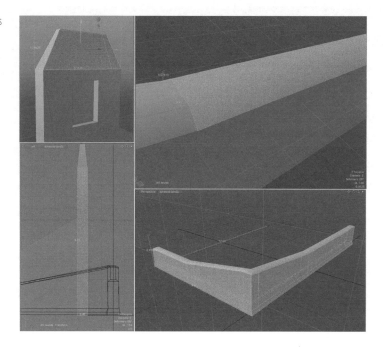

FIG 11.27 Using the Dimensions Tool is a quick way to get the size of the polygons.

the polygon area that I want to measure, and use modo's Dimension Tool to quickly asset the polygon's size. In Figure 11.27, you can see areas of the model that I measured.

In the bottom-right corner of Figure 11.27, you can see that the wall object approximately measures 12 units wide by 2 units tall. By using 128 pixels per meter scale, this translates to the wall texture needing to occupy 1536 pixels by 256 pixels. However, I mentioned that the texture size was going to be 1024 pixels wide. Since I need more pixels to cover the wall, I can set the wall UVs to tile. By doing this, I will be able to use a texture resolution of 1024, and still cover the needed space of 1536. You can see that tiling will help to reduce texture resolution. Once all of the objects have been measured, I now have enough information to design the texture sheet.

Designing the Texture Sheet

The texture sheet is the texture map that contains each texture segment for the objects that were measured in the scene. Creating textures in this manner is backwards from creating textures for characters or other objects that will utilize the dedicated 0 to 1 UV space (such as in the tug example). The process is to create the texture first, based on the measurements taken from the objects in the scene. Once the texture map is completed, it is applied to the object, and the UV islands are then "mapped" to the positions in the texture map. This process should begin by sketching out a road map to how the textures will be placed in the map, as shown in Figure 11.28.

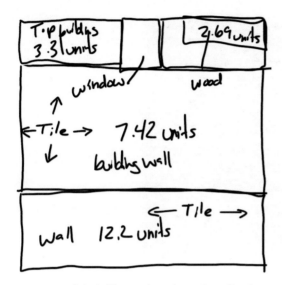

FIG 11.28 A quick sketch of the texture layout plan was done in Photoshop.

FIG 11.29 The blue lines indicate the polygons that the texture is being mapped to. This texture can be tiled horizontally.

This road map will act as a guide to how you will create the texture map. For example, in creating the wall texture, I knew that I would need to tile the texture horizontally because the measured polygon size was 12 units wide. This equates to the polygons needing to occupy 1536 pixels of the texture map, and the map that I'm creating is only 1024 pixels wide. In Figure 11.29, you can see the wall portion of the texture layout in Photoshop.

This stone texture can be tiled horizontally, which enables me to cover the 1536 pixels needed to cover the polygon size that measured 12 units with a 1024 pixel texture map. When creating the texture layout, you need to determine which areas of the map can be tiled. For instance, some areas such as the wall can tile only horizontally; but other areas may tile horizontally and vertically, as shown in Figure 11.30.

Mapping the UVs

Once the texture map has been created, it's time to apply this map to the material in modo, and then adjust the UV coordinates so they will line up with the corresponding areas of the map. Earlier, I made sure that all of the UVs were scaled to be proportional to each other so that when the map was applied, it would appear to be the same size across all of the UVs. I just need to be sure that while scaling the UVs, I always maintain the established proportion. For example, to map the wall UVs to the texture map, I moved the UVs to cover the area of the map and needed to scale them down slightly, as shown in Figure 11.31.

FIG 11.30 The highlighted areas show the way tiling has been utilized in the texture layout.

FIG 11.31 To map the wall UVs to the map, I translated and scaled the UVs to cover the wall area of the texture map, while maintaining the overall UV proportional scale.

Notice that the UVs for the wall are extending beyond the UV 0 to 1 space. I did this in order to tile the UVs. You can also see that the UVs are extending beyond the UV 0 to 1 space horizontally, because this area of the map can only be tiled horizontally.

> 📖 I don't use the Horizontal and Vertical Wrap settings on the Texture Locator to tile the texture, because these setting will not translate to the FBX file for use in XNA Game Studio. I need to physically adjust the UVs to extend beyond the 0 to 1 space in order to tile the texture.

Since a map will tile outside the UV 0 to 1 space, the UV islands for the object don't have to lie perfectly inside the 0 to 1 space. For example, when mapping the wood planks, I selected the UVs for one of the planks and moved them up in UV space until I could see that they lined up with the map in the 3D Viewport, as shown in Figure 11.32. This was done so that I didn't have the wood plank UVs overlapping.

In Figure 11.33, you can see how the texture sheet is mapped to areas on the object.

Fixing Distortion

Once the UVs have been mapped to the texture, you'll need to correct any texture distortion that may occur. For example, in Figure 11.34, you can see that the brick texture is warped because the edge in the map is slanted from the initial UV projection.

In order to fix the warping, I selected an edge in UV space and used the Align UV tool to straighten the selected edge; by doing this, the warping of the brick texture is eliminated, as shown in Figure 11.35.

FIG 11.32 On of the wood planks, UVs are extending beyond the 0 to 1 space. Since the map tiles beyond the 0 to 1 space, I can move the UVs around in UV space until they cover the appropriate area in the map.

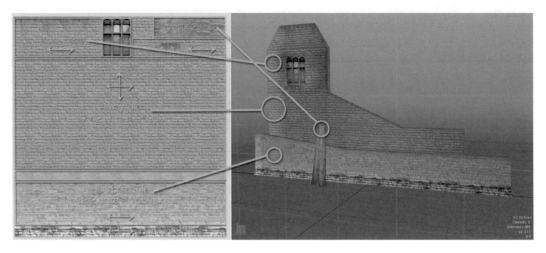

FIG 11.33 The final texture sheet applied to the object.

FIG 11.34 The brick texture is warped when first applied, and will need to be fixed.

FIG 11.35 Using the Align UV Tool, I straightened the crooked edge in the UV map, which fixed the warping in the texture that was caused by the crooked edge and thereby fixing the warping in the texture.

FIG 11.36 The back of the wall is distorted as well, due to the edges being slanted from the initial projection.

FIG 11.37 The Align UV Tool solves the issue again.

In Figure 11.36, you can see a similar distortion. The initial projection had the edges of the back of the wall slanting, which caused a distortion on the map. By using the Align UV Tool, I was able to line up the edges so that the distortion was removed, as shown in Figure 11.37.

Adding Grime to the Window

I wanted to add a bit of grime running down from the window. To do this, in the texture map I created a 3-way tiled texture where the window would be located. This area in the map holds the texture that the window UVs will be mapped to, as shown in Figure 11.38. By doing this, I was able to add some grime to the brick below the window, thus breaking up the texture and adding more detail. Since the window texture area can tile horizontally and vertically, and the grime wasn't painted on the edges where the tiles will match up, you can't see a seam where the textures come together (as shown in Figure 11.39).

Creating the Normal Map

Because this object wasn't created from a high-res model as with the tug example, the normal map will be created differently. To create the normal map, we'll rely on an external program or plug-in. In this example, I used a freeware tool for Mac OS X called NMG, which can be downloaded from http://homepage.mac.com/nilomarabese/. If you are running on a PC, you can use the freeware Nvidia Normal Map Filter for Photoshop, which can be downloaded at http://developer.nvidia.com/object/photoshop_dds_plugins .html.

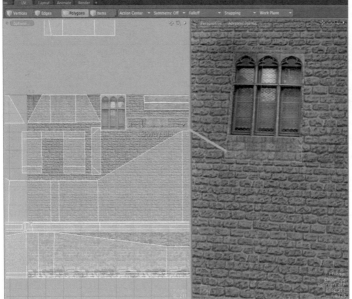

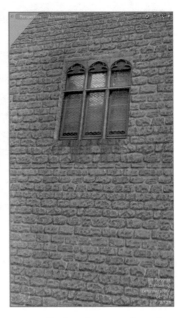

FIG 11.38 Here, you can see the selected polygon and where it is mapped on the texture.

FIG 11.39 Thanks to tiling textures, there isn't a visible seam where the window grime polygon meets up with the surrounding polygons.

NMG uses an image called a height map, which is a grayscale image that describes what details should be raised in the normal map. It's kind of like creating a bump map. I used Photoshop to create the height map. The idea is that black areas will push in or lower areas in the normal map, and white areas will protrude or raise areas. I first de-saturated the image, and then used the Burn tool to darken areas in the map that I wanted to be a crevice in the normal map, such as between the bricks. Then I used the Dodge tool to brighten the areas of the map that I want to raise in the normal map. By using the Burn and Dodge tools, I was able to quickly paint the raised and lowered areas of the height map, as shown in Figure 11.40.

Once the height map is created, I can then open this file in NMG. I set the resolution to the size of the map I want to create, which I have already determined to be 1024 pixels (as shown in Figure 11.41).

Once the normal map is created, I can check it for errors and see how well it works on the object by adding it to the object's material in the Shader Tree, setting its Effect to Normal, and changing the Viewport to AdvancedOpenGL (as shown in Figure 11.42).

FIG 11.40 I used Photoshop to create the height map by de-saturating the image, and using the Burn and Dodge tools to quickly paint the raised and lowered areas of the map.

FIG 11.41 The height map is used to create the normal map in NMG. By adjusting the scale, I can choose how much the detail in the height map is raised or lowered.

FIG 11.42 The normal map is applied in modo to see if it is working properly, and to check for errors.

Fixing Normal Map Issues

By rotating the model in the Viewport, I noticed a big issue with the shading on the normal map, as shown in Figure 11.43.

As with the tug example, the object's Smoothing Angle was set to 180. The topology of the window area was causing an issue with the way the normal map was shading the object. In Figure 11.44, you can see the original topology that was used to create the polygons around the window.

In order to fix this issue, I had to completely change the way the polygons were connected around the window. I first deleted the edges that extended from the corners of the window to the corners of the building, and then used the Edge Slice tool to add new edges from the window corners (as shown in Figure 11.45).

However, there still remain a few issues, as outlined in Figure 11.46. In this image you can see the dark shaded triangles, due to how the Smoothing Angle is smoothing across the polygons. To fix this, I again used the Edge Slice tool to add edges to the object and control how the smoothing affects the polygons, as shown in Figure 11.47.

FIG 11.43 The normal map produces shading errors that appear as dark spots on the object as it's rotated in the Viewport.

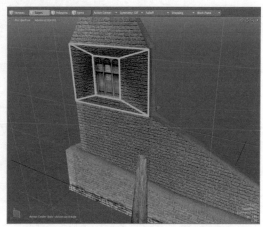

FIG 11.44 The basic polygon flow outlined here around the window is causing the normal map to shade these areas dark, as was shown in Figure 11.43.

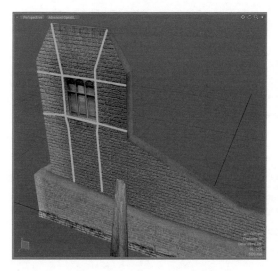

FIG 11.45 The topology around the window polygons has been changed.

FIG 11.46 The topology around the window polygons has been changed but still is producing errors, as highlighted in this image.

FIG 11.47 New edges were created to change the topology and further control how the smoothing is affecting the image.

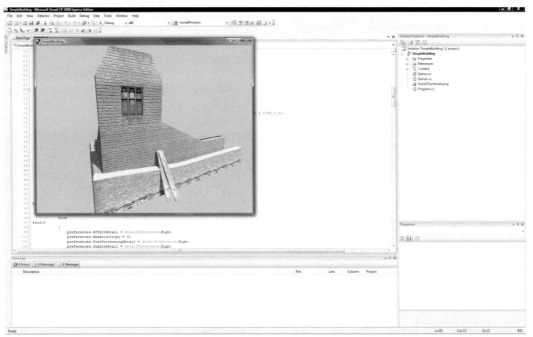

FIG 11.48 Here the simple building is being drawn in the game engine.

In Figure 11.48, you can see the simple building example being drawn using XNA and the SunBurn lighting and rendering engine.

Applying Maps using SunBurn

The SunBurn Lighting and Rendering Engine by Synapse Gaming is a tool that I use with XNA Game Studio to apply my textures and setup materials. It's

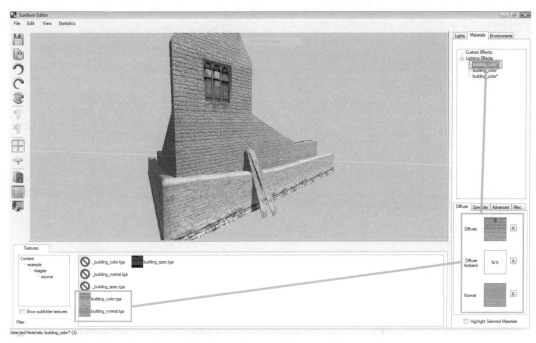

FIG 11.49 Using the SunBurn Editor, I was able to quickly apply my texture maps to the game model.

a flexible lighting and rendering engine for use with XNA Game Studio. I like it for its ease of use, and how it allows me to quickly setup HDR lighting in my game projects. However, I find that the SunBurn editor is its best feature, since it enables me to quickly setup my materials and lighting effects in a visual GUI. For example, in Figure 11.49, you see how I applied the normal and color maps to the game model using the SunBurn Editor.

Summary

In this chapter, we've discussed several concepts for creating game assets using modo. By examining two examples, I've discussed creating a playable object in the form of a tug and creating a simple building environment asset. We've also discussed the importance of the polygon budget, and how you can use texture tiling to reduce the texture resolution. However, there is more to learn on the book's resource Web site where I discuss light maps and using multiple UV sets to add dirt and grime on top of tiling textures.

Bonus Resources

This book has a companion Web site where you can find useful resources, such as specific scene files for some of the projects discussed. You will also find video walk-throughs for chapter as well as bonus videos that will further illustrate the topics covered. These videos will expand on the topics discussed in each chapter by providing a different perspective than can be covered on the printed page. The site can be found at http://wesmcdermott.com. The username for the login is rwmodo, and the password is optimus.

Index

3ds Max, 6, 269, 281

A

Action Centers, 26–28
Adaptive Subdivision, 245–248
Animation, 24, 163–186, 275–290
Antialiasing, 243–245
Aperture, 192, 194
Aspect ratio
 film, 191–192
 UV, 104–108
Assemblies, 40–43
Assembly Command, 173
Auto-Drop, 31

B

Backdrop item, 67–68
Bake, 150, 299
Baking, 278, 299–300
 texture, 150, 299–300, 305
Bend, 174, 194
Bevel, 73–75
Bit Depth, 256, 264
Blendshapes, 39, 49
Bloom, 195–198
Bokeh, 198–201, 204
Bridge tool, 75
Brush, 44, 47, 95, 141, 150
Bulge Tool, 31
Bump, 44–46, 146

C

Cage, 64, 65, 67
Camera, 8, 187–217, 275, 278
Caustics, 239–240
CCD, 206, 212
Center, 25, 26, 86, 176, 178, 183, 184
Channel, 39
 bit depth, 256
 Box, 54
 Links, 38, 168
Chromatic Aberration, 202, 217
Cinema 4D, 269

Collision, 294, 295
Color map, 138, 260
Command, 16, 52, 55
 History, 52, 55
Compositing, 196, 207, 216, 258
Constraint, 38, 163, 184–186, 278–279
CPU, 294, 295
Curves, 64, 65, 277–278

D

Deep Shadows, 229
Deformer, 165, 168–169, 285–287
 MDD, 270, 275, 279–285, 289
 Morph, 165, 168–169, 173
Depth, 249, 264, 265
Depth of field (DOF), 192–193
Diffuse, 33, 109, 134, 270
Diffusion, 220–222
Dimension Tool, 312
Direct Link, 169–173
Dirt, 139, 148–150, 162
Discontinuous UV, 125–127
Displacement, 104, 248
 Rate, 117, 248
 Ratio, 117, 248, 249
Distortion(s), 106, 194, 214, 217, 315
Dithering, 259
DOF, 192, 193, 199
DPI, 250
Draw Style, 20, 23
Driven, 168, 172
Driver, 168, 170
Dynamic, 5
 range, 254–256

E

Edge loop(s), 69, 83–85, 301
Edge Slice, 76–77
Edit Fur Map, 96
Environment, 231
EPS, 138
EXIF, 211, 213, 215
EXR, 216, 265
Extrude, 31, 73

F

F-Stop, 193
Falloff, 30, 78, 220
FBX, 270–271, 279
Film, 195, 206, 254, 255
 aspect ratio, 191–192
 Back, 190–191, 209, 212
 Gate, 190–192
Flex, 95, 158, 159
Floating point, 255–256
Flow, 80–83
Focal Length, 188–191
Form Editor, 15, 55
Forms, 15
Frame rate, 294, 295
Fur, 41–43
 Maps, 95–97
 Material, 43, 89–92, 95,
 156–158
 Vector, 95, 96
Fusion, 200, 254

G

Gamma, 257, 259, 262, 263
 encoded, 257, 260–262
Geometry Constraint, 296
GI, 229, 230, 232
Glints, 204, 206
Global Illumination, 229–235
GPU, 294, 295
Gradient, 159–162, 238
Grass, 158–161
Grime, 148, 317
Group Mask, 154–156
Groups, 35–36, 86–87, 152–154

H

Hair, 41–43, 89–97, 156–162
 Guides, 92–93
 tools, 95, 96
HDR, 234–236, 255
HDRI, 232–236, 256
Hypershade, 55

I

IBL, 232, 236
IDE, 291, 292
IES, 228
IK, 38, 173–186
 chain, 173, 174, 176, 179, 182
IKGoal, 176, 179–181
IKRoot, 179
Image Ink, 44, 46, 150, 162
Image-based lighting, 232, 236
Image-based sculpting, 47
Information, 4, 17–19, 21, 138,
 211, 213
Input Editor, 15–17
Intensity, 220, 254–257
Inverse Kinematics, 38, 173–186
Irradiance
 Caching, 230–231, 250, 251
 Rate, 230, 250–251
Item List, 34–36, 54, 165, 181, 286

J

Jitter, 44, 158
Joint, 38, 81, 173, 181

L

Lens, 193, 194, 202–206
 flares, 202–206
Light, 219–228
 Linking, 240–242
Lightprobe, 233–234
LightWave, 6, 14, 281
Lightwrap, 198
Linear, 195, 258–263, 279, 280
 space, 196, 253, 259–262
Linearize, 261–262
Link, 168–172
Locator, 117, 165–169, 174, 179, 278
Lock Boundary, 121, 129
Loop Slice, 75–76
LUT, 259, 262

M

Mask, 46, 154–156, 265
Matchmove, 216
Material, 5, 33, 36, 89–92, 95, 134, 156
 Mask, 265, 266
Maya, 7, 21, 52–55, 269, 280–285,
 288, 290
Maya2LW[2], 280, 281–282, 285

MDD, 270, 275, 279–285, 289
 Deformer, 275, 281, 285–290
Measure, 67, 191, 257, 311–312
Micropoly, 51, 248
Mirror ball, 233
Modeling, 37–43, 57–68
Modifiers, 165, 167, 175, 179, 186
ModoMotion, 282
Monte Carlo, 231
Morph Deformer, 165, 168–169, 173
Morph Maps, 39–40, 164–173
Motion blur, 206–208, 253
Mudbox, 7, 47, 114–117

N

N-Gons, 17–18, 79–80
NMG, 317–318
Normal, 27, 31, 318
Normal map, 293, 299–305,
 317, 320
Nozzle, 141, 144, 148–149
NURBS, 41, 58

O

Occlusion, 226–228
OpenGL, 24, 44, 67, 245, 300
Outliner, 35, 54

P

Painting, 43–48
Parent, 35, 167, 175, 179, 184
Perspective, 189–190, 212, 295
Photometric lighting, 228
Photoshop, 8, 44, 136, 138, 150, 200,
 204, 319
Physically based, 51, 220, 228
Physical Sky, 51
Pie Menu, 15–17, 19
Pivot, 20, 28, 305
Point Oven, 280–281, 282, 284
Polygon
 budget, 293–295, 299, 310
 Tag, 92, 153
Popovers, 15, 17
Power of two, 311
Preferences, 20–24, 67, 273
Preset(s), 21, 31, 36, 193, 236
 Browser, 5, 36, 233, 236
Preview, 51, 134, 148, 158, 162
Print, 250–251

Procedural

Procedural texture, 43, 107, 134, 244,
 271
Projection, 117–119, 125, 233, 317

R

Radial, 31, 206
Ray Tracing, 249
Refinement
 Shading Rate, 243, 244
 Threshold, 243, 244
Reflection, 44, 139, 142–146,
 204, 249
Reflector, 242–243
Relationship, 170–172
Relax Tool, 117, 120–121, 129
Render Output, 33, 259, 263–265
Render passes, 263–265
Render settings, 243–249
Replicators, 41, 86–88
Resolution, 5, 66, 75, 103, 106, 137,
 213, 236, 310
 Gate, 191–192, 209, 213
Rig, 134, 173, 224, 236
Rigging, 175, 183–186

S

Scale, 287, 289, 310–311
Screen Falloff, 78
Scripting, 52
Sculpting, 41, 43–48, 114
SDS, 58, 72
Select Connected, 70
Selection Set, 71, 92, 94, 153
Shader, 33, 153, 156, 271
 Tree, 20, 32–33, 152–156, 264
Shading rate, 153, 243, 244
Shadow, 219–228, 229
 Catcher, 216, 237
Shake, 194, 196, 204, 216, 262
Shape, 53, 60, 72, 90, 104, 223, 285
 sIBL, 236–237
Slice tool, 76, 79
Smoothing Angle, 72, 300–301, 320
Snap, 28, 296
Snapping, 26–30, 296
Soft Drag, 78
Specular, 33, 44, 135, 140–142,
 195–198, 261
 bloom, 195–198
Spherical, 118, 233, 235
Spin Quad, 81–83

Spline Patch, 63–67
Statistics, 17–19, 239
Strip, 158–159
Subdivision, 58–59, 245–248
Subsurface, 151–152
SunBurn, 322–323
Surface Generator, 87–88
Syntheyes, 216

T

Temperature, 220, 222
Tessellation, 51, 52
Texture
 Baking, 150, 299–300, 305
 Locator, 101, 117, 159, 233
 Map, 5, 103, 112, 134–152, 159, 260, 310, 313
Texturing, 2, 123, 133, 156–162, 308
Tiling, 114, 297, 305, 323
Tone mapping, 265–267

Tool Pipe, 30–32
Topology, 78–85

U

Unit System, 20, 21, 67
Units, 21, 67, 272–275, 290
Unity, 292
Unwrap tool, 117–120, 123
Up Vector, 181
User Channel, 165, 167–168, 173
User-defined channel. *See* User Channel
UV, 7, 99, 100, 104, 109, 110, 114, 117–131
 aspect ratio, 104–108
 border, 112, 115, 128
 coordinates, 100–101, 104, 110, 121, 127
 discontinuous, 125–127
 island, 110, 112, 114, 118, 128–131
 offset, 115, 117
 Relax, 120–121

 seams, 121–123
 space, 99–108
 tiles, 114–117
 unwrap, 117–131

V

Vector, 29, 95, 181–182, 296
Vertex maps, 48, 87
Visual C# Express, 291, 292
Volumetrics, 237–238

W

Weight, 24, 87
 Map, 49–51, 87
 Tool, 49
Work Plane, 24–26

X

Xbox, 291, 360
XNA, 291, 292, 322